Digital Photography FAQs

Jeff Wignall

WILEY

John Wiley & Sons, Inc.

Digital Photography FAQs

Published by
John Wiley & Sons, Inc.
10475 Crosspoint Blvd.
Indianapolis, IN 46256
www.wiley.com

Published simultaneously in Canada

ISBN: 978-1-118-27723-2

Manufactured in the United States of America

10 9 8 7 6 5 4 3 2 1

For general information on our other products and services or to obtain technical support, please contact our Customer Care Department within the U.S. at (877) 762-2974, outside the U.S. at (317) 572-3993 or fax (317) 572-4002.

Wiley publishes in a variety of print and electronic formats and by print-on-demand. Some material included with standard print versions of this book may not be included in e-books or in print-on-demand. If this book refers to media such as a CD or DVD that is not included in the version you purchased, you may download this material at http://booksupport.wiley.com. For more information about Wiley products, visit www.wiley.com.

Library of Congress Control Number: 2012940032

WILEY

Credits

Acquisitions Editor
Aaron Black

Project Editor
Amanda Gambill

Technical Editor
Haje Jan Kamps

Senior Copy Editor
Kim Heusel

Editorial Director
Robyn Siesky

Business Manager
Amy Knies

Senior Marketing Manager
Sandy Smith

Vice President and Executive Group
Publisher
Richard Swadley

Vice President and Executive Publisher
Barry Pruett

Senior Project Coordinator
Kristie Rees

Graphics and Production Specialists
Lissa Auciello-Brogan, Carrie A. Cesavice

Quality Control Technician
John Greenough

Proofreading
Evelyn Wellborn

About the Author

Jeff Wignall is a photographer, writer, and teacher from Stratford, Connecticut. He has written numerous books about photography, including: *Exposure Photo Workshop Second Edition* (also from Wiley), *The NEW Joy of Digital Photography, Jeff Wignall's Digital Photography Crash Course, Winning Digital Photo Contests, Focus on Digital Photography Basics,* and *The Joy of Photography Third Edition.*

He is a contributing editor with *Popular Photography* and *Photographer's i* (http://photographersi. com) magazines, and a frequent contributor to *Outdoor Photographer, Shutterbug, American Photo,* and the *Black Star Rising* blog (published by the legendary Black Star photojournalism agency).

You can visit Jeff's website at www.jeffwignall.com, or his blog at www.phototipoftheday. blogspot.com.

Acknowledgments

Thanks to my friend and former student Mark Allin, Senior VP of Wiley's Global Professional/ Trade business, for encouraging me to write for Wiley. Many thanks also to Barry Pruett, Vice President and Executive Publisher at Wiley, and to Aaron Black, Acquisitions Editor, for helping me turn this idea into a book (and for the fine guitar licks). Thanks, as well, to my Editor, Amanda Gambill, Senior Copy Editor Kim Heusel and Technical Editor, Haje Jan Kamps, for their help — you can't publish a book like this without a team of talented editors.

I would like to thank the following photographers for contributing their exceptional work to this book: Lisa Aliperti, Derek Doeffinger, Brett S. Foster, Robert Ganz (and sons and nephew), and Jennica Reis (and family). Thanks also to photographer Laura McElroy for sharing her expertise in zoo photography.

Many thanks also to Jon Van Gorder and John Goldhurst at Van Gorder Studios (www.jonvan gorder.com) for their knowledge and boundless generosity. Thanks also to Jim, Jesse, Ray, and Ray at Milford Photo (www.milfordphoto.com) for many years of help and friendship.

I am also grateful to these friends for allowing me to photograph them: Hart Borax, John Corvino, Marcella Eversole, Bill Fedorko, Emily Fedorko, Nick Jacobs, Lynne Perrigo, Rich Sarnecky, and Marie Spinosa from Professor Louie and the Crowmatix (www.woodstockrecords.com).

My great appreciation also to the following companies for providing photography and technical information: Canon, Epson, Eye-Fi, Fotodiox, Hoodman, HP Marketing, Ikelite Underwater Systems, JOBY, Kodak, Lensbaby, Lexar, LumiQuest, Manfrotto, Mumford Time Machine/ Mumford Micro Systems, Nik Software, Nikon, Olympus, Novoflex, Photoflex, SanDisk, Sekonic, Sigma, Sony, and Voltaic Systems.

Contents

Part I: Cameras and Gear

Part II: Basic Photography Techniques

Part III: Lenses and Accessories

Part IV: Creative Shooting Techniques

Introduction

I came up with the idea for this book while giving a talk at a local camera shop. Toward the end of the evening I asked, "So, does anyone have any questions about digital photography?" Two hours later, my voice was giving out (and the shop employees were jingling their store keys loudly), but still, the questions kept coming. In the back of my mind, I thought, *I bet I could write a book that answers a lot of these questions about digital photography.* So, I did.

This book contains exactly 365 questions about digital photography and digital cameras — one for each day of the year. It's actually a great way to take a one-year class in photography. I've tried to compile questions that appeal to a wide range of photo hobbyists — from beginners to the more advanced photographer. This book covers many photography topics, including how to choose a camera, how to set your camera for success, how to take sharp photos, how to use composition and design, how to master light and flash techniques, and much more.

These are delivered in no particular order, so if you're a flip-though-the-pages kind of reader, like me, the format of this book will appeal to you.

In this book, I cover basic questions, such as what camera resolution means, and how RAW and JPEG file formats are different, as well as more advanced queries, such as how to expose for neon signs and use wireless flash.

Of course, no book that contains such a broad range of topics could be comprehensive on each one. However, I do believe that within each answer you'll find, if not every bit of the information you need, then at least the key concepts to put you on the right path to the complete answer.

In the end, the real answers always come from trying, experimenting, and answering this question for yourself: *What would happen if...?*

If, after reading this book, you still have questions, feel free to write to me via my website: www.jeffwignall.com. I'm sure that together we can find the answer.

Jeff Wignall

Stratford, Connecticut.

> **Q** How reliable are camera reviews when it comes to choosing a new camera?

A Camera reviews are typically extremely helpful when choosing a camera or other photo gear. The major photography magazines, like *Popular Photography*, *PC Digital*, and *Shutterbug,* do a fine job of presenting a fair and balanced (to use a familiar media term) look at new equipment. Some photography magazines have very rigid and scientific ways of testing (and comparing) features, while others tend toward more subjective, in-the-field testing. Both methods are useful.

Having written for many such magazines over the years, I can tell you that the line of demarcation between editorial and advertising divisions is sacrosanct — the opinions of the writers are as free as possible from any advertising influence. In my three decades of writing for photography magazines (including all of those mentioned above), no manufacturer has ever tried to influence a product review.

The reason that camera reviews are, generally, very positive is because digital cameras are almost all of extraordinarily high quality. I've used dozens of them and, while there have been features that I dislike, physical designs that I hated, and things that, in my opinion, could have been thought out better, overall I have never encountered a digital camera that didn't shoot great, high-quality photos.

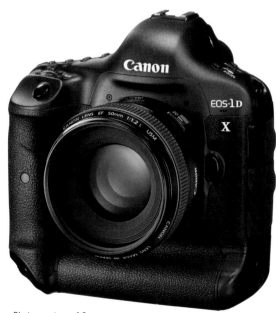

Photo courtesy of Canon.

Q What are the five most important features to consider when purchasing a new digital camera?

A There are certain features that you should look for in any digital camera. Being selective about these will ensure that you buy a camera that meets (or exceeds) your needs now, and in the future.

Consider the following when choosing a new camera:

- **Ease of use.** The more logically and conveniently the features are designed, the more fun you can have with a camera. I've owned some that, when in use, my nose kept calling up menus that I didn't want. On one model, I had to pull it away from my face to change the zoom settings.

- **Optical zoom range.** With compact or zoom cameras, the minimum zoom range you should consider is 5X. This offers a modest ability to change subject cropping without moving your shooting position. A range of up to 12X is very useful. There are some zoom cameras that feature a range of up to 36X, but that's probably excessive for most.

- **Image stabilization.** Shaky hands are more responsible for blurry pictures than anything else, so this is a feature worth owning.

- **LCD screen size.** Bigger is definitely better.

- **Camera resolution.** The number of pixels a camera has helps to define its image quality, and what size of enlargements you can make.

Photo courtesy of Canon.

Q What does camera resolution mean?

A *Camera resolution* refers to how many pixels a camera's sensor contains. Pixels (short for pixel elements) are the microscopic sensors that capture the light image formed by the lens. In the same way that grains of silver capture light images with film, pixels record the light image in a digital camera. Pixels are arranged on a digital camera sensor in what is called an array or grid.

Theoretically (all other things being equal), the more pixels a sensor has, the higher the camera's resolution and the better the image quality should be. But all things are not equal among pixels and sensors. For various technical reasons (and I cover more about this in a later FAQ), a higher pixel count does not necessarily translate to better image quality. That being said, however, pixel resolution is a fairly good indicator of picture quality.

Camera resolution is stated in megapixels — 1 megapixel being a million pixels. So, in most cases, if a camera manufacturer lists the resolution of a particular camera as having 10 megapixels, it has 10 million pixels on its sensor. The actual number of pixels is measured by multiplying the number of pixels in a vertical row by the number in a horizontal row. For example, a camera that has a pixel array that measures 4,000 pixels wide by 3,000 pixels high has 12 million pixels — or 12 megapixels.

Q How does an array of pixels record a light image, and is this something I need to know to take pictures?

A Each one of the millions of pixels (also called a *photosite*) on a digital camera sensor is designed to do one thing: record the intensity of light striking it. That light value is sent to a processor and, along with the values of the millions of other pixels and their location on the sensor, the processor creates what is, essentially, a map of tonalities of the scene you photographed. Your camera's LCD screen or your computer's display reveals that information as a digital photograph.

However, if that was all that the camera sensor did, all of your digital photos would be black and white. To create color, each of the pixels is covered by either a red, blue, or green filter — the three primary colors of the additive color system. These filters are laid out in what is called a *Bayer pattern* — a design named after Bryce E. Bayer, the Kodak engineer who invented it. In the Bayer pattern, every other sensor on the grid is green. This is because the human eye is more sensitive to green light. When you use a combination of brightness and color information from each pixel (and take additional information from surrounding pixels), a color image is born.

It might seem impossible that a simple combination of three colors can create beautiful color images, but together in a JPEG image, they create an astounding 16.7 million potential colors (256 values of red × 256 values of green × 256 values of blue). Interestingly, digital images are very similar to a painting done in the pointillism style, in which the artist creates an image made entirely of dots of paint. If you examine the image up close, all you see are dots of individual color. However, as you back away, those dots combine to create very realistic gradations and tonalities of color.

Q What is the advantage of a higher pixel count?

A The primary advantage of having more pixels is that you can make larger prints because you are working with larger files. The digital images that your camera produces have pixel dimensions that are determined by how many pixels are on the sensor. On my Nikon D90 dSLR, the maximum pixel dimension for an image is 4,288 × 2,848 pixels. Because the standard resolution for making a high-quality print is 300 pixels per inch (PPI), you can find the maximum size of the largest print you can make by dividing the pixel dimensions by 300. In the case of my D90, that would provide a maximum print size of roughly 14 × 9.5 inches.

If your camera has smaller maximum pixel dimensions, the largest enlargement that you can make will be smaller. If it has more, the maximum enlargement you can make will be larger. The optimum resolution of a print is 300 PPI, however, you can make excellent quality prints at a much lower resolution. If I lower the resolution to 200 PPI, I can make a maximum print of roughly 21.4 × 14.25 inches. Scenic shots, like the lighthouse shown here, make great wall art, so keep resolution in mind when choosing a camera if you want to make large prints.

Do more pixels mean better image quality?

"Ay, there's the rub," as Shakespeare said. It would seem that the more pixels your camera has, the more resolution it would have and, therefore, the more detailed your images would be with a gentler, more natural gradation of tones. Unfortunately, this is not necessarily true. In fact, too many pixels can actually begin to degrade image quality.

One of the problems with putting more pixels onto a sensor of a given size is that each pixel must be smaller. That is a significant issue. Cramming more pixels onto a sensor introduces the issue of digital noise — a type of image degradation that looks similar to excessive film grain. Noise is created by the electrical interference between pixels, as well as the higher level of heat that more pixels generate. The more pixels you have on a given sensor, the more noise your images will have.

In addition, the smaller a pixel is, the less sensitive it is to light (larger pixels are, by their design, more sensitive to light). This means that small-sensor cameras that have more pixels almost always produce noticeably noisy images at higher ISO speeds. This is not necessarily true if you are using more pixels in a camera with a larger sensor. The larger sensor size allows for larger individual pixels and more space between them.

Also, not all pixels are created equal. There are differences in quality of craftsmanship, so more pixels is not an indication that they'll perform better. In addition, there are other factors at work, including the quality of the lens you're using. All other things being equal, if you put a high-quality, professional glass lens on a 6-megapixel camera and a terrible plastic lens on a 12-megapixel camera, the lower pixel count with the better lens will produce the better image.

Q Are all digital sensors the same size, and does the size matter?

A Sensor size varies among the different types of digital cameras (compact, zoom, MILC, dSLR, and so on) and the physical size of the sensor can have a substantial effect on image quality. In general, it's safe to assume that a larger sensor produces higher image quality. A larger sensor means there is less pixel density. As a result, the pixels can be larger and are spread out over a larger area, resulting in less image noise. Also, larger sensors typically have a better dynamic range (the range of acceptable contrast), and are capable of capturing a much broader range of shadows and highlights.

Size varies from tiny, fingernail-size sensors used mainly in small compact cameras, to full-frame sensors that are often used in pro-level dSLR cameras. Between these two groups lies a host of various sensor sizes with obtuse designations like APS-H (Canon cameras), APS-C (Nikon DX, Pentax, Sony), and some with mathematical names, like 1/1.7 inch and 1/1.25 inch, and other names that matter little to anyone buying a camera.

Trying to figure out what size a camera's sensor is can be difficult, but as cameras escalate in features and size (from a compact to zoom to dSLR) the sensor size probably escalates, as well. This is when reading magazine reviews comes in handy — writers usually spend considerable time on sensor size. Sensor size is an important issue and worth consideration when camera shopping.

Another very significant ramification of sensor size is that it affects the crop factor of the lenses that you use with it and, therefore, their effective focal length. I cover the effects of sensor size on focal length and angle of view in more detail later on.

Basically, the smaller the sensor is, the longer the effective focal length of a given lens will be. This means that telephoto lenses have a longer effective focal length with a smaller sensor, but so do wide-angle lenses, and this reduces their effective angle of view.

Q What is the difference between CCD and CMOS sensors, and is one better than the other?

A The acronym *CCD* stands for charge-coupled device and *CMOS* stands for complementary metal-oxide semiconductor. These are the two sensor technologies that most digital cameras use to record images. There are, of course, strengths and weaknesses to each type of sensor and neither is in any way vastly superior to the other. In terms of choosing a camera, the type of chip that it uses should probably be extremely low on your priority list — if you think of it at all. Both types of sensors produce extremely high-quality images.

Until recently, CCD chips were the dominant type of sensor used in consumer digital cameras because, at the time they were developed (by Bell Laboratories in 1969) and in the few decades that followed, they produced better pictures. Since then, CMOS technology has dramatically improved and more manufacturers are using them. The sensor shown here, for example, is a 16.9mm CMOS sensor from a Nikon D5100 dSLR camera.

In terms of image quality, the light receptors on CCD sensors are larger than those found on CMOS chips. As a result, they produce higher-quality images, have better light sensitivity and, in turn, produce less noise. CCD-type sensors also tend to have a higher dynamic range and can usually handle contrast better than CMOS chips.

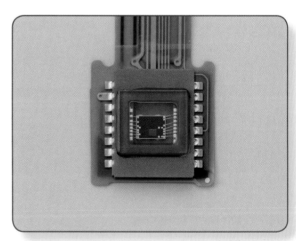

Photo courtesy of Nikon.

Q What are the advantages and disadvantages of using a simple compact camera?

A The great thing about compact cameras is that they're compact. The ability to slip a tiny camera into a jacket pocket and take it anywhere is very seductive. When you consider the superb image quality that today's compacts are capable of producing, it's no wonder they've become so popular.

Size aside, probably the most attractive feature of these cameras is their utter simplicity. In order to get a sharp, well-exposed photo, you need do little more than aim the camera and push the shutter button. They are the ultimate I-don't-need-to-know-anything-about-photography-cameras.

In addition, many compact cameras now share features that once existed only on more advanced cameras — wider optical zoom ranges, a broad choice of exposure modes, wireless download capability, and some can even go underwater. Most also have superb macro capability, which makes it easy to take wonderful close-up photos.

The downside of compacts is that they typically have a limited zoom range, fewer exposure options, and less powerful flash units that limit the flash distance. Also, as discussed previously, they all have smaller sensors and, as a result, suffer from some image-quality flaws, such as higher noise levels. Considering the convenience they provide, however, it's hard to find fault with owning one.

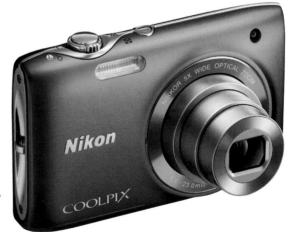

Photo courtesy of Nikon.

Q How is a zoom camera different from a compact, and what are the advantages of owning one?

A Zoom cameras (also called superzooms by some manufacturers) were often referred to as bridge cameras in the early digital days because they represent a bridge, or link, between a compact camera and a true dSLR. These cameras contain many of the advanced features of a dSLR (see the next FAQ) in a smaller package. They are intended to appeal to an audience that wants more picture-taking control, but not the expense or bulk of owning a dSLR.

Zoom cameras weigh a little more than a compact, and typically contain a larger image sensor than those found in compacts and subcompacts. Many zoom cameras (as the name implies) offer zoom lens ranges that exceed those found on compact cameras. A few even offer up 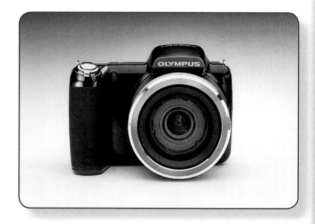 to 36X — that's a broad enough focal-length range to shoot anything from scenic shots to extreme close-ups of wildlife or sports.

One potentially significant factor when choosing a zoom camera is that, unlike many compact (and all dSLR) cameras that have an optical viewfinder, most use an electronic viewfinder (EVF). These viewfinders show you a video display of what the lens is seeing and are prone to a small degree of lag (generally, a microsecond or so) with action subjects.

What does dSLR stand for, and how is it different from other cameras?

The acronym *dSLR* stands for digital single lens reflex and the term comes from the design of the viewfinder. In a dSLR camera, the lens focuses the light image on the sensor plane (as it does in all cameras) and a 45-degree-angle mirror in front of the sensor bounces the image into a prism. The prism corrects the image (left to right and top to bottom) so that the image that you see in the viewfinder is precisely what the lens is seeing. When you press the Shutter Release button, the mirror flips up and out of the way of the sensor.

The advantage of reflex viewing is that you are always looking at your subject directly through the lens: what the lens sees, you see. This is particularly helpful with close-up work because with direct optical finders in non-SLR cameras, there is always a difference (called a parallax) between what the lens sees and what you see in the viewfinder. Another benefit is that there is never any type of lag when shooting action as there is with EVF-equipped cameras.

Perhaps the most significant advantage of owning a dSLR camera is that they have interchangeable lenses so that you can take advantage of a huge range of optics.

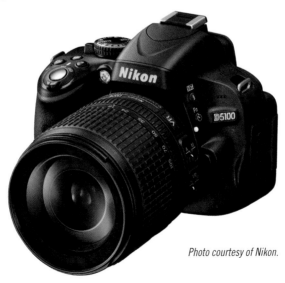

Photo courtesy of Nikon.

Q What is a MILC camera, and how does it differ from a dSLR?

A The *MILC* (mirrorless interchangeable-lens camera) is a relatively new (it hit the market around 2008) digital camera design that has gained rapid acceptance. While MILC seems to be the name that's sticking, many others were initially floating about. My favorite was EVIL (electronic viewfinder interchangeable lens). Can't you just hear that Saturday morning breakfast conversation? "Honey, I've decided that I want an EVIL camera — what do you think?"

The aim of the MILC design was to create a camera that accepted interchangeable lenses but was as convenient to carry as a compact, and manufacturers have succeeded on both counts. The less-is-more concept is accomplished by removing the reflex mirror and prism housing. Instead, an electronic viewfinder is provided for composing images.

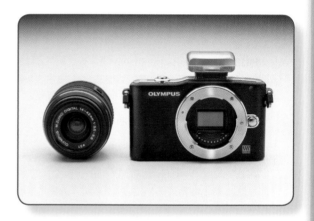

Initially, one of the attractions of the MILC design was that manufacturers were using larger sensors than those in compacts, so they were able to tout higher image quality. In many cases that is still true, but some MILC cameras now use sensors similar in size to small compact cameras — so the large-sensor advantage is not an inherent one.

However, it pays to research the particular model you're considering and compare sensor sizes. In the end, the compact size of these cameras will no doubt keep their popularity soaring.

Q What are the advantages of the MILC design?

A A number of interesting and practical benefits have evolved organically from the advent of the MILC design. For example, because the mirror has been removed, manufacturers are able to place the rear lens element and the image sensor much closer together. This has allowed the development of smaller, lighter, and less expensive lenses with very high optical quality. Because the lenses are smaller and lighter, the cameras are more compact and can fit in places that a true dSLR can't — like your jacket pocket.

Also, for the sensor in a dSLR to see the lens image, the mirror has to flip up and out of the way for each exposure. This introduces a lot of negative things like audible noise, vibration, and the likelihood of eventual mechanical wear. With the mirror mechanism removed, there is less mechanical vibration, fewer moving parts, and fewer mechanical failures to worry about.

MILC cameras are nearly silent to operate, making them a particularly good candidate for photographing in noise-sensitive settings like weddings or christenings, or just snapping photos of your new baby sleeping. If you're in the market for a small and silent camera that provides the optical versatility of a dSLR, the MILC design may offer exactly what you're after.

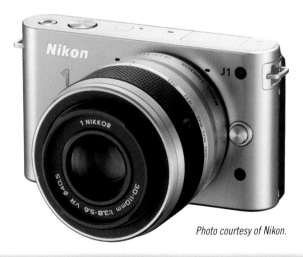

Photo courtesy of Nikon.

Q **Are there any disadvantages to the MILC camera design?**

A One of the downsides of the MILC design is that because the reflex viewing system has been removed, all of your composing is done via an LCD screen. I don't like composing at arm's length (the older you get, the longer your arms need to be to see things), and even the best LCD screens can be tough to see in bright light. Some models, like the Sony NEX-5N, shown here, have an electronic viewfinder as an optional accessory.

In a lot of ways, MILC cameras resemble a smartphone more than a camera because most of their controls are menu driven rather than operated by external physical controls. A somewhat less obvious disadvantage is that most MILC cameras focus more slowly than a typical dSLR, which (along with the inherent lag of the EVF) makes them less appealing for shooting fast action.

Also keep in mind that if you already own some SLR lenses, they won't fit an MILC without an adapter, and some won't even fit then. This is an added expense, and it might also mean that a particular lens may not provide all of the functions (like autofocus) that it would on an SLR camera.

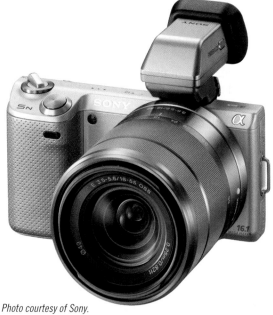

Photo courtesy of Sony.

Q **What is the difference between optical and digital zooms in compact and zoom cameras?**

A The optical zoom number assigned to a lens represents its true focal-length range based on the actual optics of the lens. To bring your subject closer, the lens physically extends to a longer focal length. The optical range is stated as a multiplication factor (5X, 10X, 36X, and so on), and this number represents the longest telephoto focal-length setting of the lens divided by the shortest focal-length setting. If a lens has a 3X optical zoom, for example, the longest telephoto setting is three times the focal length of its widest setting. If your lens has a focal-length range of 35 to 105mm, that's a 3X zoom range (105 ÷ 35 = 3).

Digital zoom, on the other hand, has nothing whatsoever to do with lens optics. The camera creates closer images by cropping them electronically. The camera then blows up the cropped portion to fill the frame. The quality of digital cropping is generally awful and it's a completely inferior way to crop an image. You can crop and get better results during editing. Even if you don't do your own editing, your local lab can crop the image for you and produce better results than those offered by a camera's digital zoom.

Q What are the advantages of using a camera with an optical viewfinder rather than an LCD screen?

A The optical viewfinder (or peephole) is, unfortunately, a dying species and most manufacturers have decided to do away with them — at least on compact cameras. From a manufacturer's perspective, taking away the optical viewing system makes cameras smaller and, therefore, cheaper to make — and most people today are used to using an LCD screen.

One of the problems with using LCD screens to compose images is that, in bright sunlight, they can be difficult to see. But perhaps an even more important issue is battery power: LCD screens soak up power like a sponge. You go through far more batteries faster with a camera that exclusively uses an LCD screen. An optical viewfinder, though, is easily viewed even on a sunny day and doesn't deplete batteries.

One advantage LCD screens have over the optical viewfinder, at least in compact cameras, is that they don't suffer from parallax issues when it comes to close-up photography. In an optical viewfinder, you often

Photo courtesy of Kodak.

see a slightly different view of the subject than the lens is seeing. However, an LCD screen shows you exactly what the lens sees.

Q What is an articulating LCD screen, and why would I want one?

A An *articulating LCD screen* means that you can lift the screen away from the camera's back, and alter its angle by tilting or turning it. You control the position by pulling, pushing, or twisting the screen until you find the best one.

One of the advantages of being able to tilt the LCD screen is that you can take close-up photos of subjects

Photo courtesy of Nikon.

that are close to the ground without lying on your belly. By tilting the screen upward, you can shoot from a kneeling or stooping position, as I did for the second image shown here.

Articulating the LCD screen to point downward can be a great thing when shooting events in a crowd, such as a parade or a concert, because you just hold the camera over your head and look up into the LCD screen. Some cameras also allow you to position the LCD screen to the side of the camera body facing the subject. This allows you to shoot self-portraits.

Q Should the type of battery a camera uses be a consideration when deciding which model to buy?

A Most digital cameras come with rechargeable batteries and a charger. Unfortunately, a lot of these cameras use proprietary battery sizes. This means that the batteries are designed exclusively for your particular camera brand and model. The problem with proprietary batteries is obvious: if it goes dead in the middle of a shoot, you either have to have a backup battery, or you have to stop and recharge. If you're planning a weeklong camping trip and there is no outlet nearby, you need to bring enough batteries to last the entire trip. Also, even if there is a handy electrical supply, you still have to bring your charger with you — that's one more thing to pack (and if you forget it, your photo-taking is done).

Some (not many) cameras accept standard battery sizes (typically AA) in either rechargeable or disposable form. Having a camera that accepts a standard battery size is particularly practical when you travel because if you run out of power, you can stop in any drugstore and load up. Of course, if you buy nonrechargeable batteries, you're tossing money in the trash each time you change them. Among disposable batteries, Lithiums cost more, but they last far longer and are worth the extra money.

Q Why are there so many types of memory cards, and is one better than another?

A Memory cards come in many formats, including CF (CompactFlash), SD (Secure Digital), SDXC (Secure Digital Extended Capacity), XQD, Memory Stick, and others. There are so many types because camera manufacturers and companies that make other digital devices haven't yet settled on a standard. In fact, it's likely that they never will because manufacturers are always trying to develop smaller, faster, and more reliable memory devices.

Photo courtesy of Sony.

SD cards are probably the most popular format because they're not only used in digital cameras, but also in MP3 players, video cameras, and other electronic devices. CompactFlash cards, which are slightly larger (they are about the size of a pack of matches) than SD cards are the second most popular. They are mainly used in dSLR cameras (although more and more dSLRs are switching to SD). A few dSLRs take both SD and CF cards. Some models have a slot for each type and even allow you to write to both simultaneously.

All digital cards are extremely dependable and while there are differences in read/write speeds, in terms of reliability and image quality, there is no difference between the various types of cards. The type of memory card that a camera uses shouldn't be a factor in deciding which camera to buy — it simply doesn't matter.

Q Is it better to use one large-capacity memory card or several smaller ones?

A In a perfect world, where memory cards are never lost, stolen, corrupted, forgotten on hotel beds, or accidentally formatted, I would say that one big memory card that could hold an entire vacation's worth of photos would be a wonderful thing. Such cards do exist — a 32GB SD holds roughly 6,416 JPEG images taken with a 10 megapixel camera — but, alas, perfect worlds do *not* exist: stuff happens.

I think it's risky to keep too many images on a single card. Typically, I limit myself to 8GB cards. I can fit just about 500 RAW images on one of these and, for me, that's a comfort zone. It would, of course, be terrible to lose that many images but, for me at least, that's not an entire week's worth of photos. Better to lose only one day's shots rather than a whole vacation's.

Photo courtesy of SanDisk.

BONUS TIP:

Carrying a portable download device allows you to empty memory cards in the field and reuse them.

Q

How do I know how many images I can fit on a memory card?

A

Estimating the number of photographs a particular memory card can hold depends on a variety of factors, including the number of megapixels your camera uses, the capacity of the card, and what file format you're using. The LCD screen on your camera tells you how many pictures the card has room to record. However, remember that if you change from one file format to another (from JPEG to RAW, for example) the number of images the card can store changes as well. Often, a table with this information comes packaged with the card. If not, though, there are a number of tables online that provide rough estimates of how many pictures you can expect to store on a card using a particular megapixel count.

The type of subjects that you shoot can also have an effect on the amount of images you can store on a card. Subjects that have a lot of smaller details — like the landscape shown here — write much bigger files than a simple scene.

Remember to reformat your card each time you start a new shooting session. If you don't do this, you'll find yourself rushing to clean off images you've already downloaded when you suddenly need more space.

Q How long do memory cards last?

A Memory cards use a type of storage called flash memory that utilizes a small integrated circuit board. Because they have no moving parts, if you take care of them, they can probably outlive the mechanical structure of your camera (and perhaps *your* mechanical structure as well). The most delicate part of any memory card, believe it or not, isn't the memory itself, but the plastic case that houses it. It's far more likely that if you handle your cards roughly (don't), the plastic casings will chip or crack before the card does — a good reason, therefore, to protect your cards when they're not in the camera.

The only wear and tear (if you can call it that) a card receives is from repeated writing and reading. For example, a professional photojournalist who shoots hundreds of photos and downloads from a card dozens of times a day for a few years might — conceivably — wear a card out. However, most cards should last through at least 100,000 write and erase cycles — that's a lot of family vacations.

Estimates from the SD association (a member organization of various card manufacturers) say that SD cards have an approximate life expectancy of 10 years — not quite as enduring as the ancient petroglyph shown here, but not bad.

Q What happens if I remove a memory card while data is being written to it?

A Memory cards are very stable storage devices, but they are susceptible to problems if they are interrupted while writing data or during sudden power drops. Most digital cameras have a small flickering LED light that lets you know that information is being written to the card. You're most likely to see this processing light flickering if you shoot a series of photos in rapid succession. This is because the camera is loading the images into its memory buffer, and then transferring them to the storage card.

Always wait until the processing light stops flickering before you either remove the card from the camera or shut it off. Also, if the batteries are running low, it's best to turn off the camera and change them before they are completely depleted. If the batteries fail while the camera is writing to the card, you could lose files.

The situation in which you are most likely to interrupt a card being written is when you are shooting an action subject, like the one shown here, with the camera set to a high burst rate. This is because the camera stores those images in its buffer temporarily, and then transfers them to the memory card.

Q What do I do if my memory card fails?

A Again, because memory cards are solid and have no moving parts, they rarely fail. In fact, I recall a funny article in a photo magazine in which a few editors mercilessly tortured memory cards in an attempt to get them to fail. They did everything from driving over them with cars and soaking them in glasses of water, to nailing them to trees. In the end, only the cards with the nail holes eventually failed. However, I don't think any of the cards were subjected to the ultimate test — being given to a two-year-old.

If a card does fail, you will likely get a message on your LCD screen that says something mildly terrifying, like *No Memory Card* or *Card Not Initialized.* If you see one of these errors, the best thing to do is shut off the camera, remove the card, and examine it. If it seems to be structurally intact and the contacts seem clean, try reinserting it. Sometimes it's just an errant electrical signal and doing this fixes the problem.

If you continue to get an error message, mark and isolate the card, and stop using it. Also, write down any error messages that you see so that you can ask someone at the camera shop (or the manufacturer) what they might mean. If it's an inexpensive card and has no important images on it, I would toss it to avoid accidentally putting important images on it.

If you own several cameras (or other electronic devices) and have a pocketful of cards floating around, make sure you've put the correct card in the correct camera or device. While some cameras may work fine with both SD and SDHC (secure digital high-capacity) cards, others may only accept SD. If you have both types, they may both physically fit the card slot, but a camera that only uses SD cards cannot read an SDHC card.

Is it possible to accidentally erase an entire memory card when it's in my camera?

Yes! If you select the Format option from the Setup menu, it asks if you're sure that you want to format the card, and it warns you that this erases all of the images. If you are sleepy or distracted and happen to agree to this query — zap! There go all of your files. You should only format your card after you've downloaded (and safely backed up) your images, and are preparing to reuse the card. Never, ever choose Yes in answer to that question unless you have already downloaded those images.

The Format option only appears in the Setup (or Tools) section of your camera's menu system. Once you begin shooting, try to avoid going to that particular area — unless you're really confident about resetting those options.

Personally, I think the Format option should be in a section all by itself and labeled *Fire Swamp* (or *Here be dragons*). However, all digital cameras provide a warning after you've selected the Format option that says something like: *This will delete all images. Are you sure?* At that point you can deselect the option, but be very careful not to hit *OK,* or there's no stopping the formatting process. I strongly suggest that any time you're going to format your cards, do it when you're wide awake and sitting at your computer — not at the end of a busy day of shooting.

I always tell students that there is next to nothing they can do in the menu options to cause any harm to either their camera or images (and it's true). The one exception is that darn Format option. I've noticed that, for some students, the desire to press *Yes* when asked if they want to format a card has an almost hypnotic power over them. For some reason, they need to see if it *really* erases all of their images.

Trust me — it does.

Q If I accidentally erase my memory card, can I recover the images?

A Few things in photography feel worse than discovering that you've accidentally erased images that you really wanted. The usual response is shock and despair. However, take heart — most deleted images (even video and image files on cards that you've accidentally reformatted) can be retrieved.

Digital image files on memory cards are like any other type of computer files in that, when you erase them, the card doesn't necessarily write over that area. Rather, it just marks that area as available territory, and only writes on that space if no other space is available. Often, you can actually restore your files. You stand a much better chance of recovering images if you deleted them on a nearly empty card. This is because the card had other space to use and, therefore, may not have overwritten the deleted files.

The best thing you can do if you realize that you have accidentally deleted photos is to stop using the card immediately. This is important because the more images you add, the more likely it is that you will overwrite the lost files. Take it to a lab and let them try to recover the images, or see if you can download some recovery software, like CardRescue, and do it yourself.

Q How can I prevent accidentally erasing a file while I'm using a memory card?

A Most digital cameras have a file-locking function that allows you to temporarily lock individual image files during image review so that you can't accidentally delete or overwrite them. Locking a file is usually just a matter of pressing a button while reviewing an image on the LCD screen. If you later try to trash or erase that file, the camera tells you that the image is locked. At that point, you can decide if you really want to erase it. If you don't, you can unlock it. For specific instructions on how to lock or unlock image files, see your camera's manual.

One thing you may encounter during an edit session on your computer is that if you attempt to trash an unwanted locked file, the trash may refuse to delete it. The computer is merely trying to prevent you from erasing a file that you have marked as protected. Before the computer will allow you to erase the file, you have to unlock it. For example, on my computer (a Mac), I can unlock files by simply selecting the Get Info option under the File menu, and then deselecting the lock icon.

Also, SD memory cards have a locking tab on the side. When you slide this tab into the locked position, it prevents the card from recording any more images while you're shooting. If you carry a lot of memory cards or are a somewhat disorganized person (guilty!), use the locking tab. This prevents you from reaching into your bag, pulling out an already full card, and reusing it.

One note of caution: the locking tabs on memory cards occasionally break off in the locked position. This means you can't write to the card again after you've downloaded the images. This is easily solved by covering the lock tab with a piece of transparent tape. The best way to prevent accidentally erasing images, though, is to only delete files on your computer during editing.

Q **Will it damage my memory cards if I write on them with a permanent marker?**

A It is definitely a good idea to number your memory cards with a permanent marker. If you also number the corresponding plastic cases, it will help you stay more organized. Markers don't hurt memory cards at all, as long as you're careful not to write on the exposed metal contacts. Since most cards are a dark color, I use a silver marker, as shown here, so the numbers show up better.

You can also use the card numbers as a reference and write down what images are on each one. It's easy to think you'll remember what is on a particular card. However, if you are on a trip or at a particularly distracting event (like a party), and you use several cards, it's easy to lose track of what pictures are on which card. Of course, this is definitely a case of *do what I say and not what I do,* because I'm rarely this organized!

Adding your initials is also a good way to keep cards separate if you're traveling with your family, and you're all using a fistful of cards for MP3 players, games, still cameras, and other devices. Accidentally erasing one of your kid's favorite music albums to take more pictures probably won't go over too well.

Q Why do memory cards have different speed ratings, and what do those numbers mean?

A You often see memory cards described as having an *X* speed designation, such as 66X, 133X, 266X, 600X, and so on. These *X* factors are intended to refer to the speed at which the cards store (or transfer) information. However, I think manufacturers have done a very poor job of explaining just what those numbers mean and yet they, of course, charge much higher prices for the allegedly faster cards.

The problem is that there is no standard way to define the speed of memory cards. These *X* ratings and different manufacturers are often referring to two different things. Some are talking about the writing speed of the card (the speed at which your camera writes images to the card), while others are referring to the read speed (the speed at which the cards can be read by your computer).

The most reliable way to judge card speed is by the transfer rate — the number of megabytes per second (Mbps) that it transfers from the card to your computer. The higher the stated transfer rate, the faster the card performs. Therefore, a card rated at 10 Mbps is half the speed of a card that has a transfer rate of 20 Mbps.

Photo courtesy of SanDisk.

Q Why is it important to have a fast memory card?

A Memory card speed is important for a few reasons. First of all, as you move to higher megapixel cameras (and/or shoot in the RAW mode), image files get larger. As a result, it takes your camera longer to write them to a memory card. Even in relatively slow-speed shooting situations (taking pictures of the kids in the backyard, for example), you may find yourself waiting for the camera to catch up. Speed becomes a much more significant factor when shooting at high-burst rates, such as action shots like the one shown here, because the images fill up the buffer much faster. If the buffer gets overloaded, the camera won't let you shoot any more photos until it moves some onto the card.

However, regardless of how fast the card speed is, a camera can only transfer data at a certain fixed speed. You can find the camera's maximum write speed in the manual. It is pointless to buy cards that have a faster write speed than your camera can handle. If you buy a card that can move data at 40 Mbps, but your camera can only write at 20 Mbps, you're wasting your money.

Q Are memory cards waterproof?

A Most older memory cards are not waterproof, but several manufacturers have started to introduce some that are. Different brands and types of cards can tolerate different amounts of liquid abuse. Manufacturers typically list test methods and waterproof levels on their websites. For example, I found this information on the SanDisk site: "SanDisk SD, SDHC, MicroSD, and MicroSDHC memory cards are tested to withstand up to 72 hours in 1m salt or fresh water."

Having a card that is waterproof might seem like a superfluous amount of protection. However, for a wildlife photographer standing hip deep in a swamp for several hours (as I have many times) or a sports photographer shooting a game in the driving rain, a card that can tolerate getting wet (when you are changing cards, for example) is a very good thing. Also, if you happen forget that you have a memory card in your pocket and jump in the pool with your jeans on, it would be nice to know that the card will survive the dunking.

But remember, just because a memory card can withstand the water doesn't mean that your camera can. Cards must be absolutely dry before you place them inside a camera's memory slot, or you may end up with a memory card that has survived salt water and a camera that has not.

Q ## Are there memory cards available for wireless downloading?

A In the wow-isn't-that-cool department, one of the latest developments in memory cards is something called the Eye-Fi (www.eye.fi) card. It is capable of wirelessly downloading your images to your computer or your favorite online photo-sharing website.

The cards (available as of this writing in 4GB and 8GB sizes) work in the same way that any SDHC card does, but when you are ready to download your pictures, you simply turn on your camera and the photos are downloaded via your wireless network. You can also designate more than 25 photo-sharing sites as download destinations so that your friends (even if they're on the other side of the world) can see your photos without you ever having to touch your memory card.

I think, with the advent of Cloud computing, in the near future memory cards will be an option and images will move directly (and automatically) from your camera to a remote server.

Photo courtesy of Eye-Fi.

BONUS TIP:

If you're away from home, you can set up your Eye-Fi card to transfer photos from your camera to your iPhone, iPad, or Android device.

Q Will the memory card that I use in one camera also work in another?

A As long as both cameras accept the same type of card (such as CF, SD, SDHC, and so on), you should be able to use the same card, not only with different camera models and brands, but also with different devices, such as video cameras and MP3 players. You will probably have to reformat the card each time you switch cameras because each one writes a small amount of computer code to the card to help it create properly formatted files.

Do be careful when buying different types of SD cards, such as SDHC, SDXC, and SDIO. They may look the same and even be the same physical size, but some older cameras (mainly those manufactured before 2008) may not recognize these newer variations of SD cards. Ask a camera dealer or read the camera's manual before you buy a variant of the SD card to make sure that your camera accepts it. Also, some cameras, such as the Sony A65 shown here, accept more than one type of memory card. In this case, both SD and Sony Memory Stick cards can be used.

Photo courtesy of Sony.

> **Q** What is the first thing I should do before using a new camera?

A The first thing I tell my students to do with a new camera (and you might find this amusing) is to put on the neck or hand strap. I get terrified when I see people using expensive cameras with no strap, and I have to bite my lip to keep from saying something. Next, make sure that the batteries are charged and inserted properly — nothing works until the camera is powered up.

Most importantly, I strongly suggest taking an hour or two to sit quietly with the camera and read the manual. Even if you are an experienced new-camera person, an hour spent studying the manual greatly accelerates your knowledge of the camera's controls and gives you a lot more confidence when using them. By the way, you'd be shocked to know how many people don't realize that most new cameras come with a manual. Shame on manufacturers that don't ship cameras with a printed manual!

Don't be afraid of hurting anything on the camera; it's a much less delicate instrument than you might think. Other than smudging the lens or the viewfinder with your thumb (don't do that) or dropping the camera (you won't if you put the strap on), there is little you can do to cause harm to a camera. Dials were made to be turned, buttons were made to be pressed, and as long as you observe my dad's prime rule about all things mechanical — don't force anything to do what it doesn't want to do — you'll be fine.

As you study the manual, identify each control using the diagrams and, before the session is over, gently insert a memory card, turn on the camera, and shoot a few pictures. Once you get those first photos taken, the camera will seem far less intimidating. If you have questions about a particular control or menu item that is not clearly explained in the manual, look at online user forums about your particular camera.

Q Why is it important to set the clock before I start using a camera?

A One of the first things that you should do once you feel comfortable with navigating your new camera's menu system is set the clock. The primary reason for doing this is so that the date and time of each photo are included in the metadata that is embedded within each picture file.

Because most of us can't remember what we had for lunch yesterday (today, in my case), remembering when we took a particular photo is pretty much a lost cause. Was that the Florida trip in 2008 or the Christmas trip in 2011? Having the date and time embedded in the image data makes these questions a

thing of the past. Also, there are some image-organizational software programs that allow you to sort pictures by date, so you could conceivably use this data to organize your entire photo collection in chronological order.

Incidentally, your camera has a small internal capacitor that remembers the date/time settings so that they are not lost each time you change the camera's batteries.

Many cameras also offer a date stamp feature that enables you to print the time and date right on the image, although I'm not sure why someone would want to do that.

Q What are the most important menu options that I should be able to find quickly?

A The menu system in most cameras can be a bit intimidating to navigate, especially if you're new to digital photography. In reality, however, you will probably only use a handful of the menu options on a day-to-day basis. The important thing is to know how to access those functions quickly. It can be frustrating if you need to quickly change the ISO and find yourself fumbling with menus for 10 minutes.

There are five menu settings that you need to change most often, so it's worth learning how to navigate to each of them quickly. I suggest making a cheat-sheet on a 3 × 5 inch card, and carrying it in your camera bag, wallet, or purse. When you find that you are no longer referring to the card, you've gotten to know your camera better. Here are the five items I suggest that my students get comfortable using:

- **Memory card format.** You should know how to clear a memory card before each shooting session so that you can take advantage of all of its space. There's no point in having an 8GB card loaded when only 2GB are available.

- **File format.** Ultimately, you may only use one file format (RAW or JPEG), but there will be times when you want to quickly switch from one to the other.

- **White balance.** Again, while you may use the Auto mode in most situations, there will be times when you want to match the white balance to a known light source or intentionally use the wrong setting for creative effect.

- **ISO speed.** While the Auto setting is good for general usage, there will be situations in which you need to manually raise or lower the ISO.

- **Histogram.** This is typically found in the review menus but you should know how to switch from basic image review to the histogram display. If your camera has an integrated clipping warning, learn to activate it.

Q Why does my camera have a Custom Settings menu?

A The Custom Settings menu options are a way to fine-tune and personalize your camera controls, either for your particular shooting style or to match specific types of subjects. These custom controls help you create shortcuts for a wide variety of settings, including things like:

- **The size and placement of the autofocus (AF) area.** This is the part of the viewfinder the camera uses to focus.

- **White balance.** You need to adjust this setting for very specific color temperatures.

- **Exposure bracketing parameters.** This is adjusted according to how many exposures per bracket you want.

- **Turning the AF-assist illuminator on or off.** This light helps the camera focus in very dim lighting situations.

The beauty of the custom settings is that, once you are familiar with what they can do, they help you design a set of shooting controls that are not covered by the camera's default settings. For example, I often shoot concert photos in dark nightclubs and the AF-assist illuminator, which sends out a visible beam of light to assist with focusing, is distracting to performers, so I have to shut it off. Something like this is easy to do if you've set up a custom function.

Also, with some cameras, you can set up groups of custom functions, and then just call them up for a particular subject. If you occasionally photograph sports, for example, you could have one group of custom settings that automatically provide the highest frame-per-second shooting and a continuous autofocus option. While using the Custom Settings menu requires a bit of time studying the camera's manual, you will find them addictive once you start using them. These settings can vastly expand the flexibility of your camera controls, and they enable you to design a camera specific to your unique shooting needs. Always keep a list of the custom functions that you've set and navigation notes about how access them quickly.

Q How do I reset my camera menus to their default settings?

A A digital camera's menus are a bit like a corn maze: The farther in you go, the farther in you get. Often, it may seem like the only way out is to click your heels three times and chant: *There's no place like home*. Magic red slippers aside, there is a very simple method for finding your way back to digital Kansas.

On all digital cameras, there is a reset command that returns all menu settings to their default positions. On some cameras, this is a simple menu option and on others it requires pressing a combination of buttons in tandem for a few seconds. On most Canon cameras, for example, there is a Clear Camera Settings menu option that resets all menu items. On most Nikon dSLRs, on the other hand, it's usually a two-button maneuver. On my Nikon D90, I can reset all menu options (except for the Custom Settings menu options) by holding down the Exposure Compensation and AF buttons for two seconds. The reason for having a somewhat awkward two-button solution is obvious: it keeps you from resetting things inadvertently.

While I rarely revert to full default settings, I think that it's always a good idea to take a few seconds at the end of your shooting day to reset things like Exposure Compensation and white balance while you're thinking of them. Many times I've set a high ISO speed to shoot in a dimly lit situation and forgotten about it, only to find myself shooting in bright sunlight the next day at an unnecessarily high ISO speed. I do use the reset commands if I've been shooting something unusual, like a high-speed action subject that called for setting changes.

Knowing how to reset your camera is particularly useful if you happen to share your camera with several other users. You don't want to discover too late that one of your compatriots has changed a key setting.

Q What is a firmware update, and how do I take advantage of it?

A *Firmware* is the software that runs your camera. Very often, after a camera is released to the public, the manufacturer issues a firmware update that essentially upgrades the camera's operating system. The reasons for updates vary from flaws in the original software (fairly common), to adding or expanding features.

Installing a firmware upgrade is pretty simple. In most cases, you can just go to the manufacturer's website and find the download area for various updates. All that you have to do is locate your particular camera model, download the software, connect your camera to your computer, and install the software. It's not half as scary as it sounds. Just be sure to read all of the instructions online before you attach your camera.

In order to be alerted when a firmware update is available, it's a good idea to register your camera and provide the manufacturer with your e-mail address. Notices of upgrades go out automatically, but you'll only get them if the manufacturer knows where to send them. If you don't want to provide your e-mail address to the company, many technology-related sites (like http://cnet.com) also have pages devoted to firmware, so you can check there for updates to your particular camera model. It's a good idea to check for updates soon after you buy a new camera, and then once or twice a year.

Before you download any firmware update, make sure that you know which version your camera is currently running. Usually, the manufacturer's download webpage shows you how to locate the version number. I also like to read online forums to see what other users think of certain firmware updates.

There are also independent software companies that sell *hacks* or expanding camera firmware, and some of the options they offer are kind of cool. Just make sure that you're dealing with reputable (and well-reviewed) software before you install it.

Q

My camera manual seems like it was written in a foreign language — where can I find a better source of information?

A

Actually, your camera manual was written by an engineer. That is, an engineer who is also a technical writer, which is why manuals can be a bit more complicated to understand. I speak from experience. However, don't blame the writer. Camera manuals have to squeeze a ton of information into a booklet that could easily be several times larger (and many layers more complex). But who would buy a 6 oz. camera that comes with a 3 lb. manual? I can see the Amazon reviews now: "Camera is great, manual is being used to hold up corner of porch."

Fortunately, photography book publishers are aware of the vast disconnect between camera manuals and camera buyers, and they've filled that void with some very useful and accessible books. The Wiley *Digital Field Guides*, for example, are written by fun authors, like Charlotte K. Lowrie, J. Dennis Thomas, John Krauss, Alan Hess, and others. These writers use their knowledge and love of photography to turn technical lead into entertaining and informative gold. Also, unlike most camera manuals, they use photo examples to show, as well as tell.

Often, a simplified explanation for each camera control is all that's required, and it can make all the difference in the world to the reader. If there is a guide available for your camera, it's a very worthwhile investment.

What are file formats, and why do some cameras offer more than one?

A *file format* is, essentially, a method of encoding the information used by various digital devices (not just cameras, but also scanners and computers) to record, organize, and transmit data. Formats provide a standardized language to describe the same thing — in this case, a digital photograph. Without such standardization, of course, camera and computer manufacturers would all develop their own unique languages, and we would have digital chaos. It would be akin to having a global meeting at the United Nations without any translators.

Computer people and digital graphic designers have dozens of graphic file formats (JPEG, RAW, PNG, GIF, and BMP, to name a few), and each has its own specific uses, advantages and disadvantages. Occasionally, you might run into unusual file formats when you download images, and some may even require special software to view.

In the camera world, manufacturers have settled on using two primary file formats: JPEG and RAW. A third format called TIFF (Tagged Image File Format) was used at one time as a recording format in digital cameras, but now it is mostly used only for post-processing file storage. If you happen to buy an older digital camera, you may find that it offers TIFF as a recording format (my Olympus C5050 — a fantastic camera that I still own — offers the TIFF format).

You can, of course, freely change file formats during the editing process — saving a JPEG image as a TIFF file, for example, and vice versa. JPEG Images that are repeatedly saved under the exact same file name degrade with each successive save. This is why many photographers save final images as a TIFF, which is a lossless format. TIFF files will not be damaged no matter how many times you open and resave it with the same file name.

In addition, of course, many digital cameras now use a variety of formats for recording high-definition video.

Q What does JPEG stand for, and what is it?

A The *JPEG* (pronounced *jay-peg*) is by far the most common file format used in digital cameras. The acronym stands for Joint Photographic Experts Group (though it's not likely anyone will ever ask you that), which is the somewhat geeky committee that devised it (www.jpeg.org).

A JPEG is a type of digital compression. It compresses your image files to a smaller size so that more of them can fit on your memory card (and your computer's hard drive). Because JPEG images are smaller, they are also faster for your camera and your computer to deal with. In fact, the primary advantage of shooting JPEG images is that they take up very little space and move quickly through your memory devices.

However, as with old soup cans (or anything else that gets compacted), some of the structural integrity of the original is lost during the compression process. When using JPEG compression to shrink photo files, your camera tosses away a lot of pixels that it considers to be either redundant or unnecessary. If it thinks that three red pixels at a certain point in the image file of a red rose provide the same image quality as five red pixels, it saves space by ditching those extraneous pixels. Because these pixels are lost during in-camera processing, JPEG is referred to as a *lossy* format.

In most cases the pixels that are tossed during compression really are expendable and the quality of JPEG images is extremely high. The problem is it's the camera — not you — that decides what is worth keeping. This makes some photographers (this one included) highly uncomfortable.

However, one of the benefits of using a faster format is, if you are using high-burst rates (as you likely would when photographing sports), your camera's internal buffer is better able to keep up with the smaller files. This is why photojournalists use the JPEG format almost exclusively.

Q In addition to speed and smaller file size, what are some of the other advantages of JPEGs?

A One of the primary advantages JPEG images offer is that they can be printed directly from your memory card without the need to do any post-camera editing. This means that you can either pop them directly into a desktop printer that has a card slot, or drop them off at the local quickie lab to have them printed for you. This isn't possible with the RAW camera format because the image requires processing in order to print it (or e-mail it, post it to a website, and so on).

However, in order for JPEG images to be print ready, a certain amount of in-camera processing must take place before the images are written to your memory card. As the images are processed by your camera, things like color saturation, contrast enhancement, and sharpening are added to the files. Whether you want it to or not, your camera is going to enhance every file that you shoot. Your camera's manual will explain what adjustments you can or can't control in JPEG processing.

If you're mainly using your images to go from camera to computer (to e-mail or post them on the Web, for example), then JPEGS not only speed up that process, but they also make the images look much better.

Q What is the RAW file format, and how is it different from JPEG?

A Images recorded in the *RAW* format are stored exactly as they were captured. There is no tweaking of these files in any way — which is where the word *raw* comes from (and, surprise! It's not an acronym). RAW files contain all of the information that the camera's sensor saw, and none of it is manipulated or deleted.

The most common analogy for RAW files is that they are digital negatives. This is a great comparison because, with a film negative, the camera produces a light image on film that is the starting point for making a print. The photographer then reinterprets that scene in the darkroom. When you shoot an image in the RAW format, you don't commit to things like color, contrast, or brightness until you edit the image.

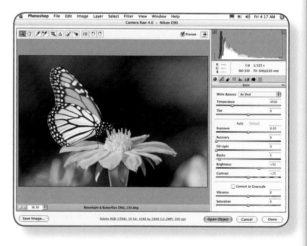

In order to get all of the potential beauty out of each file, each image must be put through a conversion process using special editing software. The beauty of this process is that it gives you the opportunity to revisit several key aspects of the file, including exposure, color saturation, white balance, and sharpness. You are free to use each of these technical choices as if you were standing there, camera in hand, reshooting the image.

Q What is the downside of shooting in the RAW format?

A There are a few small prices to pay for all the creative glory the RAW format provides, although, given the creative flexibility it provides, I consider the drawbacks to be minor. One obvious downside is that, as they come out of the camera, RAW files lack the rich color saturation and high level of sharpness that JPEG files have and, by comparison, they can look kind of lackluster. Once you bring them into the RAW interface software, however, the realm of creative possibilities is wide open, and the end product will likely far outshine any JPEG image.

Also, because there is no in-camera compression (and thus RAW is referred to as a *lossless* format), the file size is substantially larger. Larger files take up more memory card and hard drive space, and they are also much slower to move through the camera. For example, in my Nikon dSLR, I can fit over 700 JPEG files on an 8GB memory card, but I can only fit roughly 520 RAW images. Your camera's LCD screen updates the number of available frames each time you change formats.

In terms of memory card space, this is really not as much of an issue because cards are relatively cheap and you can reuse them. However, file size does become a more serious issue with hard-drive space because you probably will save all of your good files. I now have 4TB worth of external hard drives on my desk and if I get any more, the cats won't have a place to sleep while I work.

Finally, as I previously mentioned, if you shoot sports or other action subjects that require high-burst rates (frames per second), then the RAW format is not a good option because the camera's memory buffer will constantly be overloaded as images wait to be written to your memory cards. I have occasionally had to switch out of the RAW mode with fast subjects for this very reason.

Q What does the menu option image size mean?

A On most digital cameras, when you set the file format to JPEG, a submenu of *image size* options appears below the main setting. These are usually provided as pixel dimensions (width × height) but they are also sometimes described by the actual file size (for example, my Olympus SP810 offers choices at the full resolution at 14 MP or six lesser resolution settings). The important thing to remember is that the more pixels an image contains, the higher the image quality.

On my Nikon D90 dSLR, I'm given the following size options and the maximum print sizes at 200 dpi for those dimensions:

- **Large: 4,288 × 2,848 pixels (21.4 × 14.2 inches).**
- **Medium: 3,216 × 2,136 pixels (16.1 × 10.7 inches).**
- **Small: 2,144 × 1,424 pixels (10.7 × 7.1 inches).**

If you shoot in the JPEG format, I suggest that you always shoot at the largest file size and the lowest compression setting. Memory cards are very inexpensive, so it makes no sense to lose the opportunity to make large prints from a file by choosing an image-quality setting that is too low. On most cameras, there are no image size options in the RAW format because the camera always records at the highest sensor resolution.

What is the difference between the image quality and image size settings?

In addition to the *image size* options, most cameras also have a secondary option called *image quality.* This controls how much compression is applied to each image. The more compression, the smaller the file size; and the smaller the file size, the lower the image quality. I believe that the concept of this option is left over from the earlier generations of digital cameras when memory cards were expensive, cameras had slower processors, and computers had slower speeds and less memory space. In order to save space, and speed up cameras and editing, camera manufacturers give you the option to reduce the image file size. Compression choice is typically divided into the following three levels:

- **Fine.** This choice offers the least compression and the highest image quality.
- **Normal.** The midsize degree of compression. It is most suitable for making small prints.
- **Basic.** This is a high-compression setting. It produces images that are essentially only useable for online sharing or e-mail.

Some cameras only offer two choices: Fine and Basic. Again, I think that the idea of intentionally downgrading image quality to save a few bucks on memory cards seems somewhat ludicrous. You can always shrink the file size in editing — the ideal place to adjust image size and quality.

Q

Why does my camera have the ability to record JPEG and RAW images at the same time?

A

Most dSLR (and some MILC) cameras allow simultaneous recording of both JPEG and RAW files. While this does chew up even more memory card space, it can be a useful option in certain situations. For example, if you are photographing an event, like a wedding, and you want to get a gallery of photos onto the web quickly afterward, you can use the smaller files. This allows them to download to your computer and upload to a gallery very quickly without much editing. Photojournalists often use this method so that they can provide their editors with images quickly, but have a higher-quality file for archival uses.

However, because you also have RAW captures for each shot, you can also create very high-quality prints from these files. More importantly, you can make corrections to things, like exposure and white balance, which you can't necessarily do (or do as well) with the JPEG files. For this reason, I consider the RAW file to be a kind of quality backup feature — if the JPEG image is nice but the file needs work, the RAW file is there for the rescue.

When you write dual files like this, you slow down the machine quite a bit. However, as long as you're not shooting a fast-action situation (such as, sports or wildlife) the extra seconds won't matter. Also, because you are recording two images for every frame that you shoot and one of them is a RAW file, you burn through memory cards much faster. In the high-quality JPEG mode and using an 8GB card, my Nikon D90 can shoot roughly 1,000 images. In the RAW mode, I can shoot slightly over 500 images. If I record both JPEG and RAW images simultaneously, I can only record 355 images. I would need three times as many memory cards to capture the same number of images when recording both formats as compared to only shooting JPEG files.

Q What is the purpose of the ISO setting?

A The *ISO setting* adjusts the sensitivity of your camera's sensor to light. The higher the ISO setting, the more sensitive it is. Increasing the sensitivity means that you can continue to shoot in situations in which there isn't much light, such as an indoor public aquarium. All cameras have a default ISO setting (typically ISO 64, 100, or 200) and that's the setting that you should use for optimum image quality when the light allows.

The beauty of having an adjustable ISO is that you can alter the sensor's response to light on a frame-by-frame basis. Suppose that you're walking along the Seine in Paris in bright sunlight and shooting at your camera's default speed of ISO 200. You have lots of light, so using the default setting gives you optimum quality and plenty of exposure flexibility. A few moments later, you step into Notre Dame (as I did to

shoot the photo shown here) and you want to continue shooting. Because you can't use a flash to shoot in places like Notre Dame (and it wouldn't do you much good anyway — it's too big of a space), your only option is to increase the ISO. I shot this photo at ISO 1600.

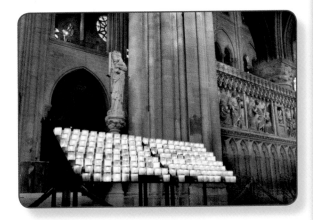

Q My camera has an automatic ISO setting, so why would I want to set it manually?

A All digital cameras have an auto setting for ISO, and the camera adjusts the sensitivity of the sensor based on the ambient lighting conditions. If the camera detects that you are shooting in bright sunlight, it sets the camera to the default (low ISO) setting. If the camera recognizes that you are working in a dimly lit situation, it raises the ISO. In most situations, this is a pretty safe shooting mode and it saves you from having to think about resetting the ISO number.

The primary reason that I prefer to set my own ISO speed is because the camera doesn't know my creative intent. I don't want the camera to automatically set a high ISO just because there's very little light. For example, when hiking in a relatively dark forest setting, I used a low ISO to shoot the stream shown here. I did this so that I could select a long (1 second) shutter speed setting in order to intentionally blur the motion of the water. If I had let the camera select a higher ISO while I was using the Programmed Auto exposure mode, it would probably have provided a faster shutter speed than I wanted and would not have allowed me to blur the water.

Q What kind of preparations should I make before an important shoot?

A One of the essential things you should think about before any important shoot is what you will be photographing and which camera controls need special attention. Will there be a lot of action shots (such as at a baseball game) that will require fast shutter speeds and continuous focusing modes? Or will you be hunting for landscapes where sharpness, depth of field, and color saturation will be the most important technical issues? By thinking about your future subjects and visualizing the shooting situations, you can focus on the controls and settings that will best serve you.

Each time that I pick up my camera, I go through every control and make sure that it's set correctly: ISO, white balance, and the focusing, exposure, and metering modes, and so on. It's tragic to lose a great shot because you had the wrong white balance set or because you were using the wrong metering mode. I strongly suggest that you make a handwritten checklist of key settings and — like a pilot — make a preflight check of all systems. I also always pack my camera manual in my shoulder bag or vest because, inevitably, a question about a setting will arise while I'm shooting — especially if I'm using a brand new camera.

OLYMPUS

DIGITAL CAMERA

E-PM1

OLYMPUS

EN Basic Manual...............3
Thank you for purchasing an Olympus digital camera.
Please read these instructions carefully.
The camera you purchased is provided with the CD-ROM Instruction Manual.
For detailed information on all features and Provisions of warranty, please refer to the CD-ROM.
Adobe Reader is required to view the Instruction Manual.

FR Manual de base............31
Merci d'avoir acheté un appareil photo numérique Olympus.
Veuillez lire attentivement ces instructions.
L'appareil photo que vous avez acheté est livré avec le manuel d'instructions sur CD-ROM.
Pour des informations détaillées sur toutes les caractéristiques et les conditions d'obtention de la garantie, reportez-vous au CD-ROM.
Adobe Reader est requis pour afficher le manuel d'instructions.

ES Manual basico..............59
Le agradecemos que haya adquirido una cámara digital Olympus.
Lea atentamente estas instrucciones.
La cámara que ha adquirido incluye el manual de instrucciones en CD-ROM.
Para más información sobre todas las características y las condiciones de la garantía, consulte el CD-ROM.
Se necesita Adobe Reader para poder visualizar el manual de instrucciones.

Q What is the correct way to hold my camera?

A It might seem like a minor consideration, but holding a camera correctly not only helps you produce a vastly higher percentage of sharper photos, but it also keeps you from getting fatigued.

If you're using a camera that has an optical (peephole) viewfinder, you can support it by laying it in the open palm of your left hand, and operating the controls with your right. With a camera that has an LCD screen, you're pretty much forced to hold it at arm's length. For those of us who are a bit older, it might seem like you need longer arms than nature provided, but you probably only need some reading glasses to see the image more clearly.

With a dSLR, MILC, or zoom camera, the best method is to stand with your feet slightly apart, and your elbows pressed into your body as you grasp and support the camera with your left hand. Press the camera against your cheek or forehead to steady its body. If you're using a long telephoto or zoom lens, you may have to support the camera body and lens from underneath. Keeping your elbows pressed against your body takes a lot of stress off of your shoulders and allows you to shoot for longer periods of time.

Q Why should I use my camera's neck or wrist strap?

A If you've ever heard the sickening thud of a $1,000 lens hitting the pavement, you already know the answer to this question. Tragically, I've heard that sound (just once) and it left an indelible caution stamp on my mind. I was taking the camera off of a tripod and, had I only put the neck strap on before I loosened the camera, I would not have this dark memory. I now use a neck strap each and every time I handle a camera; I even leave it on when the camera is on a tripod.

I recently spent a day at the Statue of Liberty and between shooting my own photos, I saw dozens of people with expensive cameras shooting with the neck strap dangling freely. I was dying to tap these people on the shoulder to warn them of the dangers of this. Sure enough, later on I saw a beautiful video camera take a nosedive onto a sidewalk. Surprisingly, it seemed to survive.

Using a neck strap is particularly important when you're climbing over rough or rocky terrain, as I was to shoot this photo at Acadia National Park in Maine. It leaves your hands free to steady yourself if necessary.

Q When shooting vertically with my compact camera, should I position it so that the flash is at the top or the bottom?

A If your camera has a flash that is at the left end (and not in the center) of your camera body, it can sometimes make a difference. A student of mine pointed this out and she was correct: If you hold the camera so that the flash is at the bottom (essentially, below the lens), then you are lighting your subject from below, rather than from slightly above.

This doesn't create quite the same scary effect that you achieved as a kid when you held a flashlight under your chin to create a ghoulish face. However, if the flash is your primary source of lighting, you will notice that the shadows are going up instead of down. When the camera is held so that the flash is on top, shadows are aimed down and look more natural. If the flash is in the center, of course, the orientation of the camera won't matter.

BONUS TIP:

Shoot two photos — one with the flash at the top and one with it at the bottom. If you don't see a difference, carry on.

Q Why should I turn off my MILC or dSLR camera when I'm changing lenses?

A The danger of leaving your camera turned on when you change lenses is that, because the sensor is charged, the electrostatic charge could potentially draw dust into the camera. The dust won't actually land on the sensor because there is a glass, low-pass filter in front of the sensor to protect it. However, any dust that lands on this filter will show up in your images. I always tend to err on the side of caution and shut off my camera before I change lenses. It takes no extra effort and, even if it did, it keeps the dust out, so it's worth it.

There are some cameras that have an automatic dust-removal system. This cleans the sensor each time that you turn on the camera. So, if you turn the camera off before you change lenses, and then turn it on again, you ensure that the sensor is cleaned after each lens change. If you leave the camera turned on and dust enters it at that point, the sensor won't be cleaned until the next time you turn the camera off and back on. Some cameras have a menu option that enables you to turn on the sensor cleaning option if you think that you have gotten dust on it.

Q What precautions can I take to keep dust off the sensor?

A There are actually several things that you can do to minimize the risk of dust getting into your camera when you change lenses. The more dusty and windy your environment is, and the more exposed to the elements you are, the more important it is to protect your camera. Take the following precautions:

- **Have your lens ready.** When changing lenses, make sure you have the one you want to attach out and ready before you start the process. This way, the sensor is exposed to the elements for the shortest amount of time possible.

- **Work near a safe, flat surface.** If possible, change lenses near a flat surface (such as a picnic bench) onto which you can quickly put the lens that you're removing.

- **Sit down if possible.** If there is no flat surface available, then, at the very least, sit on a rock so that you can use your lap to hold things and act as a safety net.

- **Try to change lenses in a sheltered spot.** Step into a doorway if you're working in a city or get into a car if you're on location.

- **Point the camera body down.** This prevents things like pollen and dust from falling into the open camera.

- **Check the rear element of the lens for dust.** Blow dust off of the camera before you mount the lens (and before you open the camera body).

- **Try not to speak (or sneeze).** You don't want anything spraying into the camera.

- **In a dusty environment, use a bag.** If you're in a dusty area on a windy day, change lenses while holding the camera in a plastic bag. I often notice dust on my sensor after I've been shooting in the desert for a few days.

- **Keep your camera bag clean.** This prevents transferring dust from the bag to the inside of your camera.

Q How do I know if there is dust on the camera sensor?

A Dust on a camera sensor appears as small dark spots or blobs, particularly in solid areas of light tones, such as a light sky or a light-colored wall. There can be moderately severe dust on a sensor, and you won't see it if there is a lot of dark areas, details, or textures in a photograph. For example, you might shoot a photo that has a lot of sky and see the dust spots and, a few minutes later, you could shoot a photo of a leaf-laden tree and not see the dust at all.

You see dust more prominently if you shoot at smaller apertures, such as f/16, rather than wider ones, like f/4.0, because it's simply more in focus. At wider apertures, dust tends to disappear (or, at least, be less obvious). If you want to test your camera to see if you have a dust issue, just shoot a photo of a clear sky or a white wall with the lens set to a small aperture. Afterward, blow the photo up on your computer screen. If there is dust there, you'll see it.

Dust is not the dark force that it's often made out to be in online forums, though — it's very simple to get rid of in editing.

Q How do I remove dust from the sensor?

A Dust rarely reaches the sensor of a digital camera because there is a low-pass filter in front of the sensor to protect it. The dust that you see in images is actually on that filter. Cleaning dust from that filter is not particularly difficult and there are tons of products and kits on the market designed to make the chore easier. There is, however, some risk that you could damage the filter (particularly with liquid cleaning methods) or even the sensor itself — an expensive mistake.

The first step in cleaning a sensor is to carefully examine it (there are special magnifying loupes on the market specially designed for this). Performing this examination (and the cleaning itself) requires that you lock the mirror in the up position so that it makes the sensor area available. You must make sure that your battery has a good charge when you do this. Otherwise, the mirror can fall down during the cleaning and cause a cleaning brush to damage the shutter.

Once the mirror is locked up, use a bulb-type blower to dislodge any obvious dust. You must, of course, be supremely careful not to touch the sensor with the bulb blower. Using a bulb-type blower may be all that is required for a few specs of dust. If it's more prevalent, you may need to use a brush and cleaning-fluid system. The process involves using a slightly dampened brush to gently wipe the sensor from one side to the other to remove any visible dust particles. This takes a bit of coordination (not to mention confidence), so it's a good idea to get a demonstration at a local camera shop, or at least watch an instructional video on YouTube first.

If you have any doubts about doing this yourself, it's probably a good idea to have a camera repair shop do the cleaning for you. This often only costs as much as a good cleaning kit, and you'll know your camera is safe.

Q How and why should I clean the glass surfaces of my lenses?

A Lens cleaning is something that should be done as infrequently as possible. The front (and the rear on interchangeable lenses) surface of most camera lenses has a thin, protective coating that is delicate and easily damaged. You're better off with a smudge or some dust on a lens than a scratched lens coating.

Preventing your lenses from getting dirty is far better than cleaning them after the fact. For lenses with a threaded front, the best prevention is to put clear UV or skylight filters on them. These have no effect on exposure and protect the front lens surface.

If you do get dirt or a fingerprint on a lens (and this goes for compact or zoom-camera lenses, too), the first thing you should do is blow off any loose material with a blower bulb (Giottos makes good, inexpensive blowers: www.giottos.com). Avoid canned, compressed air because there is always a chance of a discharge of propellant landing on the lens.

The only time I am forced to clean a lens is when I get caught shooting in the rain without a lens filter. This is what happened while shooting the rainbow shown here. Had I not cleaned the lens surface, the droplets would have dried and left marks.

How can I prevent condensation from forming on the camera lens?

Condensation only becomes a problem when going from a cold place to a warmer one — and usually it only happens on cold surfaces. If you've been out shooting snow scenes, for example, and then go back into a warm room, condensation will likely form on the lens or filter (or, more rarely, even inside the camera). Condensation can also occur if you go from an air-conditioned room out into a warm day. This happens often in places with subtropical climates, like Florida, when the air conditioning is cranked in the car (or hotel room), and it's hot and humid outdoors.

Condensation goes away by itself (usually in 20-30 minutes, maximum) if you give your equipment time to adjust. It's pretty rare to change venues and start shooting immediately, so waiting for condensation to go away is usually not an issue. You can lessen the chances of condensation forming if you put your gear back into a shoulder bag before changing environments. Even putting your camera into a sealed plastic bag during the transition helps because the condensation usually forms on the plastic — not the camera.

Q What precautions should I take when shooting near the ocean?

A The most dangerous, corrosive element you can expose your cameras to is salt water. Dropping it into salt water is the absolute worst, water-related thing you can do to a camera (and it's a goner if you do). However, even the spray from a wave or moist ocean air can leave a salty, potentially corrosive film on your gear. I live near the ocean and, while I've yet to lose a camera to the sea, some damage has occurred just from salt getting into the mechanical controls.

On a calm, dry day, the most you probably need to worry about is getting splashed or handling the camera with salty hands. If you always dry your hands before you handle your camera, you'll prevent the transfer of any salt from your fingers to the camera.

On windier days, I keep my camera in a zipped plastic bag when I'm not shooting. If the sea is really kicking up, I use a zippered bag with a hole for the lens as a protective housing. If you take your camera near salt water often, consider investing in an inexpensive water housing.

Finally, it's always a good idea to wipe the exterior of your camera gear down with a clean cloth after you leave the beach.

> **Q** What are some other tips for protecting my camera gear?

A Camera gear is, generally, not as fragile as you might think because the manufacturers know that you're going to subject it to a certain amount of abuse. However, that being said, there are certain precautions that you can take to extend the life of your gear and avoid expensive repairs. I've done just about every bad thing you can do to a camera and, occasionally, I've (literally) paid the price, but here are some easy steps you can take to safeguard yours:

- **Don't handle your camera when using bug spray or sunscreen.** Also, don't press a camera against your face if you are wearing either of these.

- **Don't set your camera down on a beach towel.** This is like inviting someone to kick sand into it.

- **Don't leave your camera charging at the edge of a table.** This is courting disaster because the kids or the dog could accidentally knock it off.

- **Never leave your camera in a hot car.** If you absolutely must, then wrap it in a light-colored towel or T-shirt, and place it in a dry cooler or on the floor of the car — not in the trunk.

- **Remove the batteries.** Always remove them from camera and accessory flash units if you aren't planning on using them for more than a few weeks. Batteries aren't likely to corrode or leak, but better to be safe than sorry.

- **Keep your camera in your shoulder bag while driving.** Don't leave it sitting on the seat of your car. A sudden stop could send it flying — and that's not safe for you or the camera.

- **Don't keep any liquids in your camera bag.** Carry your water bottle in a separate bag.

- **Keep front and rear lens caps on.** Cover all of your lenses when they're in your bag, and always use a body cap on your dSLR or MILC camera body.

How does autofocus (AF) work?

There are essentially two autofocus technologies used in today's cameras. The type that your camera has depends largely on what type of camera it is. Most compact cameras and most (but, not all) MILCs use a contrast-measurement focusing system. This type of autofocus gathers its focusing information directly from the image sensor. This system is used in less-expensive cameras because it uses simpler technology and is, therefore, cheaper to manufacture.

Contrast systems operate on the basic premise that as sharpness increases, so does the contrast between adjacent pixels on the image sensor. The camera focuses by moving the lens back and forth until it detects the highest point of contrast, and then sets the focus at that point.

Most dSLR cameras, on the other hand, use phase-detection focusing systems. These use a separate focusing sensor located in the base of the camera. It would take an advanced physics degree to truly understand how they work, but basically dSLR cameras have a semi-transparent mirror in front of the image sensor (the mirror that sends the image to the viewfinder). Some of the light coming into the camera passes through the mirror, reflects off of a secondary mirror, and is then passed to a separate autofocus sensor. A beam splitter divides the light coming from opposite sides of the lens into two separate beams, and the camera then analyzes and compares them to help it set the focus. This system, while more complex, is fast and allows for high-speed continuous focusing modes — something that compact cameras cannot do.

The one exception to the phase-detection systems in dSLR cameras is the dSLRs that have a live view capability. Because the reflex mirror is flipped out of the way during the Live View mode, these cameras have a secondary contrast-detection system built in. They switch to this method of focusing when the Live View mode is in use.

Q What is the difference between my camera's autofocus (AF) modes?

A Most dSLRs, as well as some MILC and zoom cameras, offer a choice of at least two autofocus (AF) modes: *Single-shot* (different companies call it different things — Nikon calls it AF-S and Olympus calls it C-AF) and *Continuous* (also called *servo* by some manufacturers).

In the Single-shot mode, the camera begins to focus when you press the Shutter Release button halfway. It signals you when sharp focus has been achieved. In this mode, until the camera finds a point of sharp focus, it won't let you snap the picture. This is a good mode for shooting still subjects, like a tree or a landscape.

In the Continuous AF mode, the camera also begins to focus when you press the Shutter Release button halfway. However, in this mode, the camera takes the picture whether it finds a sharp focus or not. This mode is intended for use with moving subjects, like planes or at sporting events, because it allows you to shoot even if the subject is moving and absolute focus has not been achieved.

Because action subjects are in motion, you might never get a photo of them without Continuous mode. The downside is, because the camera allows you to shoot regardless of whether it has the subject in sharp focus, you are apt to get a lot of blurry photos.

Q If autofocus (AF) is so accurate, why would I ever want to focus manually?

A As accurate as autofocus (AF) is, there are many situations in which focusing manually is the only way to precisely capture your subject. With close-up photography, because the area on which you want to focus is often so tiny, like the image shown here, the autofocus often has trouble identifying it. For example, if you want to focus on the antennae of a butterfly, your subject may fly away while you wait for the autofocus system to focus on that tiny area. Also, close-up subjects are often obstructed by other objects, such as leaves and grass, which mislead the autofocus system.

Sports photographers frequently use manual focus to focus sharply on an area where they anticipate action to happen. If you're photographing a baseball game and you expect a big play at third base, it's often better to manually focus on that base and wait for the action. This eliminates the lag time that occurs while the autofocus system catches up. Another benefit of using manual focus in action situations is that, the same as the Continuous AF mode, the camera fires when you press the Shutter Release button.

Switching to manual focus is normally done by moving a switch on the camera, the lens, or both.

Q **What are some other situations in which manual focus can save a shot?**

A Manual focus comes in handy in any situation in which there is an obstruction between you and your subject. For example, in the shot of the wild horse shown here, there was a lot of tall scrub between the horse and myself. I knew from experience that the autofocus (AF) system would see the grass and not the horse because the grass was closer.

Manual focus is also required when you photograph through glass, whether you shoot from the inside out or outside in. If you're shooting from the inside out, be aware that most glass has dirt and smudges, and these can negatively affect the autofocus. If you're

shooting birds at your feeders through the kitchen window, the autofocus system will likely see those blemishes and try to focus on them instead of the feeder beyond. At the very least, the lens will wrestle with finding the best point of focus.

When photographing from the outside in — shooting a store window display, for example — the window might have contrasting reflections that fool the camera. Similarly, if you're photographing exotic koi fish in your backyard water garden, you may need to shut off the autofocus in order to focus on the fish rather than the surface of the water.

Q Why does my camera emit a bright beam of light when I focus in a dimly lit room, and can I shut it off?

A As great as it is in most lighting situations, autofocus is relatively useless in dimly lit settings, like around a campfire. Both types of autofocus systems use contrast to focus, so when the lighting is low, there often isn't enough contrast for the camera to see the subject. For this reason, most digital cameras have an AF-assist illuminator (or AF-assist beam) that projects either a visible beam of light or an invisible beam of infrared light onto your subject. This provides enough illumination and contrast for the camera to focus even in complete darkness.

However, there are two problems with using an AF-assist Illuminator. One is that it usually has a maximum range of about 10 to 12 feet. This distance is fine when taking photos in a small space (such as photographing your cat napping under the bed), but pretty useless in any larger venues. The other issue is that the visible beams can be intrusive for human subjects. I often photograph concerts in dimly lit clubs, like the image shown here, and the beam of light can be quite distracting to performers.

Some cameras have a custom function for turning off the beam, but then you lose the usefulness of the light when it's time to focus.

Q When looking through the viewfinder, how can I tell where in the scene the camera will be focused?

A When you look through the viewfinder (or at the LCD screen) on your camera, you see a pattern, or grid, of focus-area indicator marks. These are commonly referred to as *focus points*. The camera focuses on whatever is behind the active focus points (see the next FAQ for more information). Therefore, it's important that you pay close attention to which parts of your subject are covered by one or more focus points. If you're taking a head-and-shoulders picture of two friends, for example, and the central focus point falls between them (as opposed to one of their faces), your camera is going to focus on the background. As a result, your friends will be out of focus (and probably none too happy with your photography skills).

The number of focus points can range from a single central mark in a simple camera, to a larger group, ranging anywhere from three to 51 or more points. Generally, the more sophisticated the camera, the more focus points it has. The primary reason for having a choice of focus points from which to select is that you can set focus more easily on off-center subjects — like a flower set off to the extreme edge of the frame, for example.

Q If there are multiple focus points, how does the camera know which of them to use?

A While having a lot of focus points in the viewfinder provides the capacity to focus on a specific point in a wider area of a particular scene, this does not mean that you necessarily must keep all of them, all of the time. In fact, most cameras (particularly dSLRs, which have more sophisticated focusing capabilities) give you the option to decide which focusing points you want to use, or to let the camera decide for you.

However, this means that you must tell the camera which of them to use to focus. In order to do this, cameras that have a larger array of focus points have a choice of autofocus (AF) area modes (which, by the way, are not to be confused with autofocus modes). Different manufacturers use different names for them but, basically, they include the following:

- **Single or Manual Point AF.** With this area mode, you manually select the focus point. You use the Command dial to tell the camera where in the frame you want the lens focused. That focus point then lights up or darkens so that you know it's in use.

- **Auto-Area AF.** The camera selects the important area based on various subject-recognition criteria, including the size of the subject, color and contrast patterns, the presence of skin tones, face-detection technology, and so on.

- **Dynamic AF.** You select the starting focus point, but if the camera detects that the subject has moved or is moving, it uses information from adjacent focus points to try to find a sharp focus. This mode may be limited by the type or model of lens that you're using because it relies on information supplied (in part) by the lens to detect motion.

Q Does a camera with more AF focus points take better pictures?

A Whether you get better pictures with more focusing points really depends on the type of subjects that you're shooting. If you're photographing a landscape or portrait, a small array of points (three or five) is fine because it's often part of the main subject, and is meant to be in (or near) the center of the frame. For example, if you're shooting a close-up of a friend's face, odds are part of it will be close to the center, so a central gathering of focus points works fine. In essence, with most stationary subjects, like a landscape, you really only need a single focus point to get the job done — although having more certainly won't hurt.

With moving subjects — such as the acrobats shown here — a wide pattern of focusing points is far more important. This is because with more advanced autofocus systems, the camera is able to pass the subject off from one focus point to the next and adjust focus accordingly. For example, if you follow an eagle as it flies from the left to the right, it's nearly impossible to keep it in the exact same position in the frame and on just one focus point. But when using a multiple-point array, each focus point sends contrast and distance information to the camera's focusing sensors, and the camera can thereby track the subject within the frame.

Q Why would I want to lock focus on a particular point, and how do I do that?

A Once the camera detects and sets the point of sharp focus, it's possible to lock the focus, and this can be very useful. For example, if you're photographing a close-up of a friend's face and waiting for her to smile, it's nice to have the camera pre-focused while you wait for that moment to arrive.

Focus lock is also a particularly useful feature when you're taking close-up photos. For example, if you're photographing a butterfly that is repeatedly returning to the same zinnia blossom, it's much simpler for you to lock focus on a specific part of the flower (provided there is no wind) and simply wait for the butterfly to return. Because it is apt to stay for only a few seconds, not having to focus really helps you get a higher percentage of sharp photos. You can also change the zoom setting, while still maintaining that one point of focus.

The simplest way to lock focus is by using the Shutter Release button. On virtually all digital cameras, you activate the autofocus by pressing the Shutter Release button halfway, and then the camera sets the focus. As long as you keep that button halfway depressed, and you and your subject stay in the same position, the focus remains locked. To get a sharp photo, just press the Shutter Release button the rest of the way down. If you're new to photography, learning to keep that button halfway depressed, and not taking pictures you don't mean to take, may require some practice.

More advanced cameras may also have a separate focus lock button. This allows you to lock the focus, and then remove your finger from the Shutter Release button — which can save a lot of finger cramping (and accidental exposures). Typically, the focus lock button also locks the exposure, but there may be a custom function that can separate those two locking features — see your camera manual for more detailed information.

Q What are some other reasons for using the Focus-lock feature?

A One of the problems with having a central focus point in all cameras (and even those with multiple focus points have one large central point) is that people tend to stick the main subject there as if they're hitting a bull's eye with a dart. In fact, it's almost as if the central focus point is telling you that your subject should be there.

The truth is your subject can go anywhere in the frame that you want, and often an off-center position is more dynamic. The focus-lock feature can help you place it there and keep it sharply focused. In this photo, I used the focus-lock feature in the Shutter Release button to create a more pleasing composition.

Q Why is there a diopter control next to my optical viewfinder, and for what is it used?

A Most dSLR cameras (and some others with an optical viewfinder) have a *diopter control* that lets you sharply focus the image in the viewfinder. If you've ever had an audible or illuminated sharp focus alert tell you that the lens is focused but you still thought the image looked fuzzy, it is probably because you have the diopter set wrong for your particular vision. However, this is an easy fix.

The control works similar to the gizmo that an eye doctor uses when testing your eyesight: *Is this one better? How about this one?* This is essentially the test you have to give yourself. Typically, the control is a small wheel that is immediately adjacent to the viewfinder window (which makes turning it and keeping your eye pressed against the viewfinder quite a trick at times). To adjust the sharpness of the image, continue looking through the viewfinder (with or without your glasses, if you wear them — although, I find it's easier without) and turn or move the diopter control until the image looks sharp. It's also important to block out as much extraneous light from the viewfinder as possible so that you can more easily judge the sharpness. A product that I've found extremely useful for blocking out light in these situations is the HoodEYE Eye Cup by Hoodman. It can be rotated to the left or right to accommodate both left- and right-eyed shooters.

Again, you must be certain that the lens is focused correctly before you set the diopter — otherwise, you won't know if it's you or the camera. For this reason, I tend to put the camera in manual focus and set it on a tripod so that I know the lens is sharply focused. Also, putting your camera on a tripod (or a flat rock) frees up your right hand so that you can adjust the control (unfortunately for lefties, most cameras are designed for right-handed photographers).

Q

What is the selective focus technique, and when would I use it?

A

Although many subjects look good when there is a lot of depth of field and everything is in relatively sharp focus, there are times when you might want to limit the focus in a scene to a very narrow area. This technique is known as selective focus. You create this effect by using longer focal-length lenses in combination with wider apertures, and then focusing precisely on the part of the scene that you want in sharp focus. Lens-to-subject distance is also a factor when restricting depth of field — the closer you are with any given lens and aperture combination, the more shallow the area of sharp focus will be.

By limiting sharpness to a specific region of a subject, you focus a viewer's attention toward a specific part of the image. However, because you are limiting what is going to be in sharp focus, you have to select the point of focus very carefully. For example, in portraits of people and pets, the eyes should be the area of sharpest focus — which is exactly the technique I used when photographing my cat in the image shown here. Focusing on the eyes in a portrait also distracts viewers from the fact that parts of the face might be slightly soft in focus.

Q

Will my manual-focus SLR lenses work with my dSLR camera body?

A

For many photography veterans, the manual-focus lenses collected over the years represent a fairly substantial investment. Tossing all of those just because you've bought a dSLR seems like a bitter financial pill to swallow — and it is. If you're in this group, you're not alone. This is a hot topic in online photo forums — there are even entire groups dedicated to using older, manual-focus lenses.

In addition to the obvious financial consideration, there are a number of other reasons that growing numbers of photographers are clinging to their vintage lenses. For one, a lot of photographers (myself included) believe that some of these old lenses are simply sharper than their current counterparts — particularly the prime (non-zoom) lenses. Also, some of my manual-focus lenses are faster (that is, they have a faster maximum aperture) than the newer ones. There are also some photographers who just prefer the tactile feeling of twisting a lens barrel to focus as opposed to pressing a button. Another reason some photographers prefer using older lenses is because you can often find bargains on them at flea markets and online.

The ease with which you can adapt your old lenses to a new camera body depends on the brand of camera. For example, most Pentax dSLR bodies accept virtually all of the older Pentax lenses. The other alternative is to buy an inexpensive adapter (about $10 to $30 on eBay). Of course, just because you can connect your old lenses to the camera body doesn't mean that they'll magically have autofocus — they won't. Also, they may not activate some metering functions, and they will not record EXIF data to your files.

Before you try to put any old lens on your expensive new camera body, make sure that you go to the manufacturer's website and check the lens compatibility charts. Also, never force a lens onto a camera body because it can damage the body's lens flange and electrical contacts.

Q Why does my long zoom lens rack back and forth without ever finding a sharp point of focus?

A If you've ever used a very long telephoto or zoom lens with a long maximum focal length, you've probably noticed that when you aim it at something, it hunts back and forth through its entire focusing range. This is also common with macro lenses when photographing flowers, such as the image shown here. Longer lenses have a much narrower field of view. As a result, they have a tougher time finding an area with enough contrast to set the focus quickly. However, racking puts a lot of wear and tear on the lens focusing mechanisms and drains batteries.

This problem is more apt to happen with slow telephoto lenses (that is, those with a relatively small maximum aperture, such as f/5.6) because the lens allows less light to reach the focusing sensor. To some degree, subject and camera movement may also trigger the lens to rack back and forth because the focusing sensors are having a hard time identifying a defined pocket of contrast to help them focus.

To help solve this problem, many lenses now have a Focus Limiter switch that restricts the distance range through which the lens can seek focus. Some limiters work for a single distance range (50 feet to infinity), while others offer a series of ranges.

Q Why does my camera have trouble focusing in low light or on foggy days, and how can I help it focus?

A Fog and mist are tough subjects when it comes to using autofocus for one simple reason: the lack of contrast. Without a distinct edge of dark tones against light to latch onto, your camera searches in vain for something to help it focus. This is an inherent flaw in a system that needs contrast to focus, but it's pretty easy to get around.

One way to help your camera find a sharp focus is to look for a small pocket of contrast (a dark tree trunk in a landscape, for example) or a bold area of color (such as a red buoy in a river), and see if the camera focuses on that. Even if the edge that you use isn't your main subject, you can find something that is approximately the same distance away from you and focus on that. Next, simply lock the focus and recompose the scene.

The other solution, of course, is to switch to manual focus and that is exactly what I did to photograph the boats shown here. Had I waited for the lens to hunt and peck or focus on its own, the boat would have been out of range before I got a shot off.

How can I focus through a fence?

The poet Robert Frost wrote, "Good fences make good neighbors." However, when it comes to good photography, fences can be very annoying because they obstruct your view. Also, because autofocus systems try to focus on the closest object, this means you get a lot of nice photos of sharply in-focus fences, like the image shown here. There are some tricks for shooting through them, however, and these techniques can be very useful at places like the zoo, where you run into lots of fences.

If you are standing close to a fence, you might be able to aim the central focusing point at a distant subject and see if the autofocus system focuses on that. This sometimes works. However, a more reliable way is to switch to a relatively long telephoto lens or zoom setting, and then switch the lens to manual focus. Next, simply focus on the background object and the fence should disappear.

That is exactly how I got the fence to disappear in the second shot shown here. I switched to a longer zoom setting, put the camera in manual focus, and focused on the boat. The actual focal length that you need depends on how close you're standing to the fence and how far away your subject is.

Q How can I create a dreamy, soft-focus look?

A Perhaps because I'm a fan of impressionistic painting and early pictorial photography, I've always loved the look of soft-focus pictures. Back in the 1960s, we created the soft-focus look by smearing a thin layer of petroleum jelly on an old UV lens filter. It was easy and the effect was nice, but it was also messy and somewhat difficult to control the degree of the effect.

Today, you can buy inexpensive soft-focus filters in varying degrees of density. Often, they come in sets of multiple strengths and you simply attach them to the front lens element. They are available in either the screw-on glass type or a square resin, which you can mount to the lens with an adapter. Some cameras, like my Olympus SP810-UZ, have soft focus built in as a special effect, and that's what I used to create the pond scene shown here. All you have to do is select that special effect and shoot. It's easy and a lot of fun.

Soft focus is particularly well suited to portraits and landscapes, although it tends to work best with longer focal-length lenses at wide apertures. If you use wide-angle lenses or small apertures, the extra depth of field tends to diminish the effect.

Q What is the primary cause of blurry photos?

A If you gained all of your photography knowledge from reading lens reviews in online forums, you might think the main cause of blurry photos is poor-quality lenses. People spend a tremendous amount of time online discussing and comparing the optical quality (or lack thereof) of each new lens that comes out.

The truth is most lenses made today are blazingly sharp. Most blurry photos are the result of one of the following common (and easily solved) shooting errors:

- **Shaky hands.** Unsteady hands are the real culprit behind most blurry photos. Making an effort to keep a steady grip will improve your images.

- **Using a shutter speed that is too slow.** Long exposures leave the shutter open too long, and allow for either the subject or the photographer to move.

- **Not enough depth of field.** Too little depth of field means that the near-to-far zone of sharp focus is too shallow. Solve this by using a wider lens and a smaller aperture — or moving farther away from your subject.

- **Poor focusing techniques.** This can be anything from focusing on the wrong part of the scene to using the wrong autofocus mode.

- **Not using a tripod.** With stationary subjects, a tripod is the true path to better sharpness.

Q

What is the minimum shutter speed I can use with a handheld camera to avoid camera shake without using Image Stabilization (IS)?

A

To a certain degree, the answer to this question really depends on how steady your hands are. A few other factors to consider include the focal length of the lens you're using, whether the subject is moving at all, and if you have something to lean on to steady your hands.

Before Image Stabilization (IS), the age-old formula for minimum shutter speed was to try not to handhold a camera at a shutter speed longer than the reciprocal of the focal length of the lens that you were using. In other words, if you're using a wide-angle lens of about 28mm, then you can probably safely handhold the camera at a shutter speed of about 1/30 second.

For example, I was able to shoot this photo inside the ancient Mission San Xavier del Bac at a shutter speed of 1/30 second with a 28mm lens by using the back of a pew to support my elbows. But if you were to switch to a longer lens, say 200mm, you probably wouldn't want to use a shutter speed any slower than 1/200 second. You can stretch that one shutter speed, maybe two, if you have very steady hands or something against which you can prop the camera.

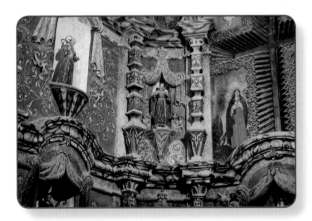

Q What is the lowest shutter speed I can use with Image Stabilization (IS) and still get a sharp picture?

A *Image Stabilization*, or IS as it is commonly known (different manufacturers have different names for it), is a technology used to reduce the effects of camera shake to allow you to get sharper images at slower handheld shutter speeds. Though most photographers think of it mainly for shooting longer exposures handheld, it also improves the sharpness of photos shot at fast shutter speeds. When I first started using a zoom camera with Image Stabilization, I was pleasantly surprised to see an immediate improvement in sharpness, even at very fast shutter speeds of 1/400 and 1/800 second.

The number of shutter speeds that you gain in terms of slower shutter speeds depends on the camera model and, to some degree, the focal length of the lens. Typically, you will likely see a gain of 3 to 4 stops — a huge advantage, particularly in low-light situations. For example, if you shoot without Image Stabilization with a 60mm lens, you wouldn't want to go slower than 1/60 second. But with Image Stabilization, you can handhold that at shutter speeds up to 3 or 4 stops longer — roughly 1/8 or 1/4 second. I photographed the sheep shown here in a barn handheld at 1/8 second and got an acceptably sharp photo.

Q How does Image Stabilization (IS) work?

A What I like most about Image Stabilization is that, regardless of *how* it works, it does so beautifully. I feel a certain amount of liberation in having one thing about cameras that I don't have to think about. If someone told me it was nothing more than magic, I'd be pretty satisfied. That being said, though, how it *does* work is kind of fascinating.

There are two kinds of Image Stabilization systems: Lens based and those that are built in to the camera body. Lens-based Image Stabilization uses motion sensors (specifically, gyroscopes) to detect motion and then shift a floating lens element to correct for that motion. One of the advantages of a lens-based Image Stabilization system is that by the time the light comes through the lens and hits the autofocus sensors, it has already been corrected for the motion. As a result, focusing, particularly in dim light, is better. Also, if you have an optical viewfinder, the image that you see in the viewfinder is already stabilized because it is corrected as it enters the lens.

The downside of lens-based Image Stabilization is that it makes the lens a bit heavier and bulkier. You also have to buy it with each new lens, which makes them even more expensive. In addition, not every focal length that you want is available with Image Stabilization. Lens-based stabilization can also drain a lot of battery power.

In-camera systems use motion sensors to detect camera motion, but they correct it by shifting the image sensor. The nice thing about this kind of Image Stabilization is that once you own the body, it works with any lens that fits on that body, so you only have to buy it once. Additionally, non-IS/non-VR lenses are smaller and lighter, which can potentially lessen fatigue and reduce camera shake. The downside of these systems is that the image in the viewfinder is not stabilized because the stabilization happens at the sensor.

Q Why should I shut off Image Stabilization when I'm using a tripod?

A Some manufacturers recommend that you turn the Image Stabilization system off when your camera is mounted on a tripod (as it would be when capturing night shots like the one shown here) because, if left on, it can actually create sharpness issues rather than solve them.

The reason this happens (and this is one of those esoteric things understood mainly by engineers) is because the Image Stabilization system has moving mechanical parts. For example, lens-based IS systems have a floating lens element that continuously moves in response to the camera's motion. These parts are in motion as they attempt to detect and stop camera shake. Some cameras are able to detect when they are mounted to a tripod and automatically shut the system off.

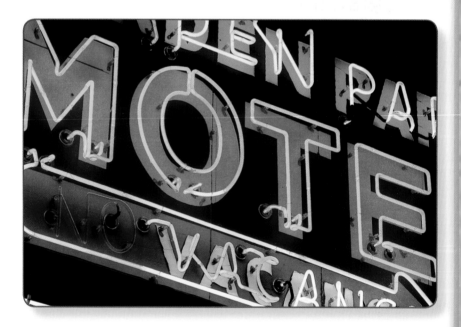

Q Why does my long telephoto/zoom lens have a tripod collar?

A The reason that telephoto and some zoom lenses have a built-in tripod collar is largely an issue of balance. These lenses are typically longer and heavier than others. Using such a heavy lens on your camera, and then mounting it on a tripod with the tripod socket in the base of the camera body increases the risk of damaging the flange where the lens joins the body. This is more weight than the flange is designed to support.

Perhaps more importantly, if you do mount the camera using the camera-body socket, the lens and camera will be out of balance. If you don't have the tripod head firmly tightened and you let go of the camera, you might hear a very loud (and expensive) WHACK as the camera tilts forward and the lens crashes into a tripod leg. Typically, the lens collar is centered and by mounting the lens at its center you spread the weight more evenly.

Another benefit of most lens collars is that they let you change the orientation of the camera from horizontal to vertical. You can do this by loosening the collar and turning the camera. This makes for much faster changes than having to readjust the entire tripod head to switch from horizontal to vertical.

Photo courtesy of Nikon.

Q Isn't a tripod kind of old-fashioned as there are now image-stabilized cameras?

A As wonderful as Image Stabilization is, it is not a substitute for a tripod. Stabilization may solve the issue of camera shake, but there are other issues it doesn't rectify. Anyone who has ever taken one of my workshops or classes knows that I think the only path to serious photography is using a tripod almost all of the time. Here are some of the reasons why:

- **Slower pace.** Using a tripod slows you down and gives you time to consider your subject more carefully when shooting images like the one shown here.

- **Time exposures.** You can't make sharply focused time exposures without a tripod. You also can't use any camera below a certain shutter speed (probably 1/8 second), even with Image Stabilization.

- **Comparison pairs.** A tripod allows you to make comparison shots with the exact same framing. If you want to experiment with different amounts of sharpness or longer/shorter exposure times, you need a tripod to identically match the compositions.

- **High Dynamic Range Imaging (HDRI).** If you are experimenting with High Dynamic Range, you need to make identical shots of the same scene. This is impossible to do without a tripod.

- **Comfort.** A tripod saves wear and tear on your arms and shoulders, leaving you less fatigued.

Q

What is a monopod, and in what situations would I use one?

A

A *monopod* is, for lack of a better description, a one-legged tripod — yours are the other two legs. In fact, a monopod is essentially just one leg of a tripod with a mount at the top for attaching your camera. If you use it carefully, you can get surprisingly good results with a monopod at very low shutter speeds. I've found that if I brace the monopod against a firm object (a bench or a rock wall, for example), I can shoot exposures as long as 1 second and have them come out totally sharp.

One of the great things about monopods is that they are often allowed where tripods are not. In Times Square, for example, you're almost certain to get moved along by one of New York's finest because tripods aren't allowed there without a permit. But I've shot there dozens of times with a monopod and no one has said anything. I've found the same to be true at formal gardens (such as Longwood Gardens in Pennsylvania, shown here), zoos, and other public places. While a tripod is considered a tripping hazard in those places, using a monopod is no different than carrying a cane.

Q Are there any other accessories that I can use to stabilize my camera when using a long lens?

A Over the years I've shot in a lot of situations in which neither a tripod nor a monopod was exactly what I needed, nor, in some cases, were they allowed. Some days, I was just too lazy to carry a tripod. Because I grew up in an era long before Image Stabilization, I had to find other ways to steady my camera — often with very long lenses in borderline lighting situations. Here are some accessories and tricks for getting sharper photos without a tripod:

- **Beanbags.** These are frequently used by wildlife photographers because they can go places (like the roof of a Land Rover on safari) where you could never use a tripod. Better still, you can carry them empty and fill them with sand on location.

- **Mini Tripods.** Mini or table-top tripods are tiny (around 1 foot tall or smaller) tripods that fit in a vest pocket or your shoulder bag. The Gorillapod system features an entire line of diminutive tripods with unique, jointed, flexible-leg systems that allow you to adapt them to almost any terrain or surface.

- **Photo Clamps.** All-purpose clamps are heavy duty and universal. They can be adapted to almost any cylindrical (bicycle handlebars) or flat (a picnic table) surface to hold a camera using a standard tripod attachment.

- **Gun stock supports.** Shoulder stocks, like the Bush Hawk (http://bushhawk.com), are basically a rifle stock that has been adapted to hold a camera and a long telephoto lens. This is a favorite among bird and wildlife photographers.

- **A friend's shoulder.** I photograph a lot of air shows and, in crowds, I've found that a friend's shoulder makes a handy camera rest.

- **Your sweater.** Rolled up sweaters make a great camera support on the ground, a rock outcropping, or even your car window. I've shot some of my best bird photos in marshes in Florida using a rolled-up sweater to hold my 400mm lens.

Q **Why am I still getting blurry images when using a tripod with long shutter speeds?**

A Because I do a lot of night photography, this particular issue is one that I've grappled with many times over the years. It can be extremely frustrating to go to the extra trouble of carrying a tripod to Manhattan or Las Vegas, only to come back with less-than-perfectly focused images. But if there is a problem, there must be a cause, so somewhere in your system there is a breakdown.

One thing that can cause unsharpness, of course, is the lens. I've learned the hard and expensive way that some lenses are simply not as sharp as others. It's tempting to stop a lens down to its smallest aperture to maximize depth of field with certain types of subjects, such as a nighttime city scene, but often these small apertures are also the least sharp. Worse, lenses that are very sharp at one lens-to-subject distance might be less sharp at another. The best advice I can give is to study reliable lens tests in magazines and online.

Also, if you use a dSLR, there is a certain amount of vibration created in the camera by the action of the mirror going up and down as you make the exposures. The best way around this is to use your mirror-lock feature to lock the mirror in the up position once you compose the scene. This often solves a lot of sharpness issues with long exposures.

Finally, it's important with long exposures to use a cable release to fire the shutter or use the self-timer. This eliminates the possibility that your touch is causing the camera vibration. Some cameras have a delay built in to the self-timer to give the mirror time to settle down before the shutter opens. Similarly, it's a good idea on windy days to remove the camera strap to prevent the wind from blowing it and causing camera vibration.

Q How does using a lens shade help me get sharper images?

A One of the best accessories that you can use to make your photos appear sharper is one that comes with the lens for free: the lens shade. Despite the fact that manufacturers include lens shades in the box, it's surprising how many photographers don't bother to use them sometimes — or at all.

The purpose of a lens shade is to block extraneous light rays from coming into the lens. These aren't the light rays that you're using to take the photo (it would be kind of tough to take a photo without those), but the rays coming in from the edges of the lens. Light coming in from the sides of the lens causes lens flare, as shown here. It also reduces the contrast and color saturation of your images. Because image sharpness is largely a matter of contrast, any loss in contrast reduces the apparent sharpness.

Using a lens shade is particularly important on bright sunny days when there are lots of reflective surfaces around you, like the beach or on a snowy day. In the same way that you can see better on a bright day if you cup your hands around your eyes to block out extraneous light, a lens shade helps keep unwanted light out of the lens.

Q

Will using a lens filter make my photos less sharp?

A

Whether a lens filter causes a loss of sharpness really depends on the quality of the filter and the type of material from which it's made. The highest quality filters are made from optically pure glass, and they range from moderately to extremely expensive (the best cost hundreds of dollars). Several manufacturers make high-quality resin filters that are less expensive and very close to glass in their optical purity. There are also inexpensive plastic filters on the market, although, it's not a good idea to use a cheap filter on an expensive lens.

High-quality optical filters of glass or resin won't reduce sharpness or image contrast — provided that you use only one filter at a time and that you keep them clean. That being said, any time that you add additional glass elements to a lens you increase the likelihood of things like flare and internal surface reflections (reflections between the front element of the lens and the rear filter surface) that are sometimes called *ghosting*. These problems are compounded if you stack more than one filter on at a time — such as putting a polarizing filter over a protective ultraviolet (UV) filter. Stacking introduces multiple surfaces onto which internal reflections can propagate.

Q How does the lens aperture that I'm using affect lens sharpness?

A New photographers are often surprised to find that an expensive new lens is not equally sharp at every available aperture. As most pros know, however, there is often a perceptible shift in image sharpness depending on the aperture in use. All lenses have certain *optimum apertures* at which they perform their best, as well as those at which they are least sharp.

The sharpest apertures vary from lens to lens, but as a rule of thumb, most lenses are at their sharpest when they are closed down between 2 and 3 stops from their maximum aperture. For example, to get the maximum sharpness for the image of the pumpkins shown here, I stopped down my f/2.8 lens to a shooting aperture of f/8.0.

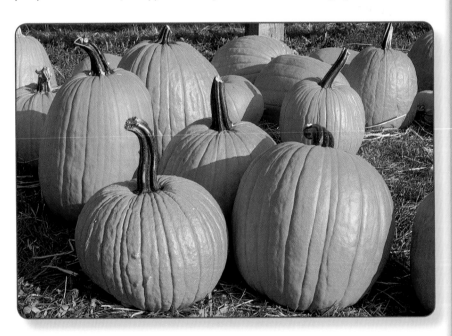

Q How can I find out which apertures are the sharpest for a lens?

A There is actually a simple and fun way to test all of your lenses. All that you need (in addition to your camera and the lenses that you want to test, of course) is a tripod and a newspaper.

To perform the test, tape a sheet of newspaper to a wall where it is evenly lit (facing a north-facing window is good). Next, place your camera on a tripod (use a spirit level to be sure that the camera and the wall are completely parallel). Shoot a series of exposures starting at your widest aperture, and closing down one full f-stop for each frame (remember to make the corresponding changes in shutter speed to keep the exposures consistent). Continue shooting until you've shot one exposure for each aperture.

Finally, download your files and keep all of the frames open on your computer screen. Compare the results using the metadata to keep track of which aperture goes with each shot. As you compare the results, you'll see obvious — and often surprising — differences in sharpness from aperture to aperture.

You can do the same thing outdoors with any subject that has easily discernible detail, such as the image shown here of the side of a barn.

Q Should I leave the ISO at a higher setting as that allows for shooting in more types of lighting situations?

A In many shooting situations, a higher ISO setting does provide much more exposure flexibility. It offers you the ability to set a higher shutter speed (to stop action or control camera shake, for example) or to use smaller apertures (for more depth of field). In situations in which you need either (or both) of those options, the ability to switch to a higher ISO is very handy.

However, the downside of using a faster ISO is that the higher the speed, the more *image noise* created, as in my shot of Monument Valley shown here. Noise is a grain-like texture pattern that leaves random color speckles across the image area.

With most cameras, noise is least obvious at the default ISO speed (typically between ISO 64 and ISO 200, depending on the model), and it remains fairly acceptable at speeds of up to ISO 400. Once you get above that, however, the noise becomes increasingly more apparent. At speeds above ISO 800 (particularly with small-sensor cameras, like compacts), it often becomes a distracting flaw.

Remember also that if you try to use high ISO speeds in very bright, sunlit situations, your camera may not be able to find a suitable combination of shutter speed and aperture to control the light.

> **Q** What is the difference between all of the light meters on my camera?

A While many simple digital cameras have only one type of light-metering system, the more sophisticated ones often have three metering options. Each of these metering modes is suited to particular kinds of subjects. Once you understand their differences, you'll find them very useful for adapting to changing shooting situations. Switching from one metering method to another is usually just a matter of pressing a button and/or turning a dial. Here are the three types of meters:

- **Matrix metering.** Also known as *multi-segment* or *evaluative* light metering, this is the standard type of light meter found in all digital cameras. Chances are if you have a compact camera this is the only type of meter available. Matrix meters divide the frame in a set pattern of segments and, using a set of algorithms in the camera's software, compare various parts of a scene and set the exposure accordingly.

- **Center-weighted metering.** These meters measure the light from the entire image in the viewfinder, but they are *weighted* to give preference to the subject matter that falls (roughly) in the center of the frame. Center-weighted meters typically skew their readings for an oval-shaped area that divides the scene by a ratio of 70/30 or 60/40 (with the higher number being the percentage of the frame given the most importance), and give less importance to the edges of the frame.

- **Spot metering.** Using an even smaller central area of the frame (often as small as 3 percent of the image area), this type of metering takes precise light readings from small but significant parts of a scene, while ignoring the rest of the subject. They are also capable of isolating small areas in more distant views, such as a lone sheep grazing on a mountainside.

If your camera has all three metering options, it's worth taking the time to experiment with them because knowing how and when to use them can often save an exposure.

Q Which light meter provides the most reliable way to measure light in normal situations?

A Matrix meters are, far and away, the simplest and most reliable way to meter the vast majority of scenes that you photograph, including everything from close-ups and portraits to broad landscapes, like the one shown here. In fact, these meters are so sophisticated they are able to create nearly flawless exposures from the most complex subjects. Even most pros freely admit that they rely almost exclusively on Matrix metering.

Matrix meters divide the entire frame into a series of regions that can include anywhere from half a dozen large segments to hundreds of tiny ones. The camera then compares the brightness from this grid of tonalities to thousands (sometimes tens of thousands) of sample exposures that have been programmed into its onboard computer. The camera then makes educated assumptions based on the arrangement of those tonal areas.

For example, if the camera detects a thin, vertical, medium-toned subject surrounded by a large bright area, it might correctly assume that you are photographing a person standing on a bright, sandy beach. It then compensates to be sure that the figure is correctly exposed.

More sophisticated Matrix meters are also able to use information supplied by the lens and take other things, like the distance to the subject and its color, into consideration.

Q When would I use the Spot or Center-weighted metering modes?

A As reliable as Matrix meters are, there are still a few situations that can fool them. For example, if your main subject is particularly small in the frame, the meter has trouble detecting and identifying it. This is particularly true with exceptionally bright or dark backgrounds. If you photograph a friend sitting on a beach towel on a bright, sandy beach, the meter may be fooled into underexposing your friend.

Switching to either the Spot or Center-weighted metering mode in these situations enables you to tell the meter which parts of the scene are most important. In the case of the Center-weighted mode, you're not eliminating the surroundings but, rather, telling the camera that what is in the center of the frame is most important.

While photographing this mute cygnet on a muddy background, I knew that the background would overly influence the camera's Matrix meter so I switched to the Center-weighted mode. From experience, I knew that adding an extra stop of exposure (with the Exposure Compensation feature) would expose the swan perfectly.

Similarly, with even smaller subjects — a distant skier on a snowy hillside, for example — you can take a reading directly from the subject's clothing, or even her face, and get an accurate reading.

Q If I measure only a small portion of a scene, and then switch to a wider view, is there a way to lock in the close-up reading?

A Whenever you use the Center-weighted or Spot metering mode to take a close-up reading of a subject, it's important that you lock in that reading if you decide to change your composition. If you don't lock the reading, you might recompose the scene and the camera then automatically alters the exposure settings. For example, if you take a Center-weighted reading of a flower, like the one shown here, but then recompose the scene without locking the exposure setting, the camera reads whatever is in the center of the frame after you recompose it.

Provided that your subject remains the same distance from the camera, the simplest way to lock your meter reading is to keep the Shutter Release button partially depressed. Once you have the meter reading (as long as you don't lift your finger from the Shutter Release button), both the exposure and focus remain locked.

On more sophisticated cameras (like most dSLRs), there is often a separate exposure-lock button that locks the meter setting. The advantage of this is that you are free to change your focus point or zoom setting while keeping the exposure settings locked. Another option is to switch to a Manual exposure mode (if the camera has one), and set the exposure according to the meter reading.

Why would I need a handheld light meter?

Despite the convenience (and accuracy) of light meters that are built in to digital cameras, there are a surprising number of photographers who still prefer using handheld light meters. Handheld meters are just that — handheld tools used to measure light. They existed long before the built-in type. In fact, for generations, they were the only way to measure light. While the concept might seem outdated today, many pros still swear by handheld meters.

Some photographers use handheld meters simply because they're using cameras that pre-date light meters. However, even for digital photographers, handheld meters can provide some interesting capabilities, including the ability to read specific areas of a scene from just a few inches away. I used a handheld Spot meter to take a close-up, reflected-light reading of this bright flower against a dark background. Also, certain types of handheld meters (as covered in the next FAQ) enable you to measure the light falling on — rather than reflecting off of — your subject.

Some handheld meters even allow you to do things like average multiple readings or accurately meter flash output.

Q **What types of handheld light meters are available?**

A Although they are all designed to do essentially the same thing — measure the light in a given scene — there are actually three types of handheld light meters available. Each type has its own unique way of measuring the light, as well as advantages and disadvantages. However, if you use them properly, they all provide accurate results.

Choosing which type of light meter is right for you is largely a matter of preference and the kind of subjects that you shoot. Interestingly, more light meters have been designed to include all three methods of light measurement, so you only have to buy one meter to have all three options. The following are the types of handheld meters:

- **Reflective.** Like the Through-the-Lens (TTL) meter built in to your camera, reflective meters measure the light after it strikes and reflects from your subject (thus the name). One benefit of this type of metering is that you can typically measure the light in a scene from the camera position. The downside is that your readings are completely influenced by the reflective qualities of your subject and you must know how to interpret such readings.

- **Incident.** This type of meter measures the light *falling onto* your subject. To use this type of meter, you place it between the light source and your subject. The benefit of this style is that the readings are not influenced by the reflectance of your subject. The drawback is that you usually have to be able to approach your subject with the meter to measure the light falling onto it.

- **Spot.** These work exactly the same as your in-camera spot meter. They are used to provide very precise reflective readings of tiny areas of your subject. As with built-in meters, they perform best when trying to meter a tiny area in a much larger scene, such as a gray mouse creeping across a snowy windowsill.

Q What is a middle tone?

A The concept of *middle tones* is at the very core of all exposure theory, and it's a term you encounter often as you read about the topic of exposure. The term originates in black-and-white photography, in which the range of tonalities in a given scene is divided into a series of ten equal gray steps ranging from pure white to pure black. *Middle gray*, or *18 percent gray* as its often called, is the tone that lies midway between those two extremes (in the Zone Theory of exposure, this is referred to as Zone V). Theoretically, in an average scene, half of the subjects are brighter than this and half are darker. The reason it's called 18 percent gray and not 50 percent gray is because such measurements are based on a logarithmic scale rather than a linear one.

Understanding what mid-tones are is very important to the theory of exposure because all light meters are designed to assume that everything that you are metering is just that — a middle tone. No matter what the subject is — a black sheep or a white cat — your camera assumes that it's a mid-tone and sets the exposure accordingly. If your subject happens to be a mid-tone, of course, then your exposure will be dead on. However, if your subject is brighter or darker than middle gray, you have to make some adjustments to place it back where it belongs in terms of tonality. For example, adding exposure makes the mid-tone lighter and subtracting it makes it darker. This is the entire theory of metering and exposure in a nutshell.

Of course, no good theory goes unchallenged. A growing number of voices are offering evidence that most meters are, in fact, calibrated to a reflectance of 12 to 14 percent rather than 18 percent. For a more thorough explanation of exposure theory, see my book, *Exposure Photo Workshop*, also available from Wiley.

Q Are all mid-tone subjects gray?

A When you first begin to study the subjects of exposure and light metering, it's natural to think that all middle tone subjects must be gray. After all, as covered previously, all meters are calibrated to see the world as a middle-gray value. But you can find mid-tone areas in almost any color. The term mid-tone simply means that a particular area of a scene is reflecting light that is roughly halfway between the brightest and darkest tones — whether your subject is a basket of multicolored fruit, a landscape, or even a portrait.

Of course, it's much simpler to spot mid-tones when a scene has been reduced to a palette of grays in a black-and-white photo, but with practice you can train your eye to discern mid-tones in any scene. One trick is to try to mentally eliminate all of the brightest and darkest areas, and then look for a part of the scene that isn't either. Odds are that if you do that, you will be looking at something that is very close to a mid-tone. Learning to see mid-tones in color subjects is an enormous aid for knowing which parts of a scene to meter to get the best exposures. Of course, all colors reflect light in different amounts of intensity, so it takes some experience to recognize a middle tone in subjects with different levels of brightness.

Q

What are the safest subjects to meter and get a good exposure?

A

In almost any scene, there are many common subjects that provide good mid-tones that you can use as metering shortcuts, even in complex lighting situations. Metering directly (using your Center-weighted meter) from one of those subjects provides a good overall exposure. The trick, of course, is to know which subjects reflect an average amount of light so that you can spot them quickly and meter with confidence.

Some of the best mid-tone subjects are obvious: A stormy gray sky, weathered barn wood, or even the dark gray bark of a tree. In this shot of desert flowers, for example, I took a reading of the blue sky behind them.

The following are all good subjects for metering:

- **Dark blue skies.** Northern skies in particular, on a clear day, provide a near perfect mid-tone.

- **Light green foliage.** Green leaves or an evenly lit summer lawn (as shown here) are great metering subjects when shooting landscapes.

- **Red brick buildings.** An old factory or schoolhouse made of red brick is also ideal.

Q How do I meter a subject when the sun is behind it?

A Metering when the light is coming from behind your main subject is tricky because it's difficult to keep the camera from being fooled by the brightness of the background. The more intense the background lighting is — and the more of the frame it takes up — the more difficult the situation becomes.

The trick to getting a good exposure reading is to meter the important areas of your subject while excluding as much of the bright background as possible. If you're taking a portrait on a bright sunny day, for example, and the sun is behind your subject, your subject's face will grossly underexpose if you don't exclude the background when metering. One way to exclude the bright background is to move physically closer so that the subject fills the frame. Another method is to use your Center-weighted meter (or in extreme cases, the Spot meter) to meter only the shadowed areas.

You can do the same thing in a broader scene, like a landscape, by metering from the parts of the scene in which you want detail. However, this often means sacrificing some of the background area to overexposure. When photographing this cactus plant, I metered the dark side and intentionally let the background overexpose.

Q What is a gray card, and how do I use it when metering?

A gray card is exactly that — a gray sheet of cardboard (typically 8.5×11 inches) that has been precisely calibrated to reflect 18 percent of the light striking it. They are inexpensive, and you can find them at most camera shops that service professionals. A gray card offers a perfect mid-tone for metering and nearly flawless exposure readings, even in very complex situations. They're small and light enough to carry in a backpack, or you can cut one into a few pocket-sized pieces and carry it in your jacket pocket.

The beauty of using a gray card is that you give the meter a perfect mid-tone from which to measure the light. Your meter readings are then much more consistent because they are no longer affected by the bright highlights or deep shadows in the scene.

Gray cards are particularly useful when shooting nearby subjects, such as portraits or close-ups, because you are able to physically place the card in the same lighting that is hitting the subject. They are also useful in landscape photography when your scene is dominated by a lot of dark (large shadows) or white (a snowy landscape) tones because they won't fool your meter. Obviously, you can't physically place a card in a distant scenic landscape, but you can place it in a patch of light that is similar to the primary light in your scene, and then take a reading.

Using a gray card is simple: Place it in the same light as your primary subject, fill the frame with the card, and then take your meter reading. Make sure that you do not shadow the card with your body. After you take this reading, you can either use your Exposure-lock feature to hold those settings or you can use the Manual exposure mode to set the exposure that your meter indicated.

Q Do light meters see colors or just brightness levels?

A As bright and vibrant as the world appears to your eyes, your camera's light meter is colorblind. It sees the world as medium gray. By ignoring the colors of various objects, your meter is able to concentrate on one issue: how much light (on average) is reflected from this scene? It doesn't matter one hoot if you're measuring the light reflected from a red rose, a gold sky at sunset, or a basket of lemons — to your meter, they are all a dull, drab gray.

However, that being said, keep in mind that certain colors reflect more light than others. For example, a white dress reflects much more light than a red one, and that is the basis of how meters measure light: They look at the amount of light reflected from a scene, and then create a reading based on brightness, not color.

BONUS TIP:

To see how the world looks to your light meter, take a shot of a colorful scene, and then convert it to black and white.

Q What is Through-the-Lens (TTL) metering, and what are its advantages?

A Through-the-Lens (TTL) metering is the way that virtually every digital camera measures light. Light is measured after it has passed through the lens. In most compact digital cameras, the metering is done on the image sensor. In most (but not all) dSLRs, there is a separate light-measuring sensor built in to the base of the camera. It is often part of the autofocus sensor.

One of the great things about Through-the-Lens (TTL) metering is that, because the light is measured in the camera, the angle of view the meter sees is the same as that of the lens. If you are using a wide-angle lens, the light is measured from a wide angle of view. However, if you switch to a telephoto lens (or change the zoom setting to a longer focal length), the meter only measures light from that reduced viewing angle.

Another benefit of Through-the-Lens (TTL) metering is that if you have a filter mounted to the lens, the meter sees the light *after* it has been filtered. This means that you don't have to make any compensation for the filter. In the shot of the rock butte shown here, I used a polarizing filter, which absorbs about 1-2/3 stop of light. However, the meter automatically compensated for this.

Q What is the Zone System?

A The Zone System is an exposure theory and technique developed by famed photographers Fred Archer and Ansel Adams (my personal photographic hero) around 1939-40. After many years of experimenting, Archer and Adams wanted to create an exposure system that would not only quantify a lot of the elements of exposure, but also provide a simple teaching tool. Since its creation, thousands of photographers have used the Zone System as their working method of exposure.

Essentially, the Zone System divides scenes into a series of 11 values of gray. These range from pure black to pure white (they are described as Zones 0, I, II, III, and so on). At the center of these tonality steps is Zone V and, as covered previously, this is also known as *middle gray*. Knowing that everything their meters read was at Zone V, Archer and Adams realized that by adding or subtracting exposure from that reading, they could create a linear shift in the values of a scene — making it either darker or lighter.

Interestingly (and those of you with a scientific bent are probably loving this), each step in the Zone System represents either a doubling or halving of exposure from the previous or next zone (depending on which way you're going). Therefore, if you meter a subject, say Caucasian skin in sunlight, you know that the meter will read it as middle-toned Zone V. If you want it placed where it belongs at Zone VI, you simply add 1 stop to the exposure (either by slowing the shutter speed 1 stop or opening the lens one f-stop) to place it there. Of course, all of the other values in the scene are shifted as well.

Although it was developed for use as a system for exposing and printing black-and-white negatives, the underlying theory is just as reliable in color and digital photography.

Q What is a good exposure?

A At its most basic, a good exposure is one that captures the full range of tonal values in a scene, like the landscape shown here. It is neither too light nor too dark. However, a photograph may not capture all of the tones in a scene the way that your eyes see them. This is because the sensor of a digital camera has a narrower dynamic range (the range of lights to darks) than your eyes. The human eye can see approximately 10 to 14 stops (up to 24 stops if given time to adjust to the lighting), while most digital cameras have a maximum range of about 10 stops.

A scene that gets too little exposure is said to be *underexposed*. These shots appear somewhat darker (depending on how much they are underexposed) than they do in person. When scenes are underexposed, the shadows tend to clog up and the detail is either lost or bunched together in the darker parts of the scene.

A scene that is *overexposed* is one that has too much light. These shots look lighter than they appeared to your eyes. When a scene gets too much light, highlights wash out and lose detail, while shadows and darker regions of a scene lose their richness.

Q

Is there such a thing as a right or wrong exposure?

A

It is easy to explain what a correct exposure should look like. It should have details in both the shadow and highlight regions, as well as a nicely exposed range of middle tones. The truth is, though, that exposure is subjective. Manipulating exposure — often to extremes — is one of the primary ways in which photographers interpret the world around them. Anyone who looks at a Picasso painting from his Cubist period knows that there is nothing *right* about them — but neither is there anything wrong.

It is impossible to definitively say what is a right or wrong exposure because no two people looking at the same scene perceive it in exactly the same way. A photograph that is obviously under- or overexposed might be regarded as a mistake by one person, while it is exactly what the photographer saw in her mind's eye.

For example, you may look at a misty, cloud-shrouded harbor like the one shown here and see a light and cozy scene. Another person, though, may regard the same scene as gloomy and foreboding. By adding 1 or 2 stops of exposure to your meter reading, you can capture your creative vision, while the other person can subtract exposure to capture his. Often, experimenting with extremes of exposure is a good way to discover your own vision of the world.

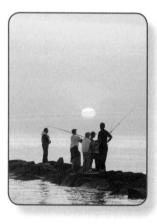
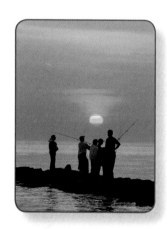

Q If my camera is so highly evolved, why doesn't it take great exposures all of the time?

A One of the fantasies in which many photographers indulge when they buy a new camera (and this includes professionals) is that, as they now have the latest in hotshot metering and exposure systems, all of their exposures will be stunningly perfect. Unfortunately, perfect exposures aren't something that you can buy — as my miserably underexposed image shown here proves.

Yes, to some degree, cameras have evolved to a point where the camera does much of the heavy lifting for you. However, getting great exposures still requires a bit of work on your part.

Most of the time, the reason that you don't get what you want from an exposure is not the fault of the camera. The camera can't make a lot of key decisions for you. For example, it can't tell you when to use a lot or a little depth of field. Nor can any camera tell you when to intentionally underexpose a scene to create a low-key image. It also can't tell you how long to leave the shutter open to record motion the way that you want it.

These are choices that you have to make. If you try to analyze why you are unhappy with your exposures, chances are you will find a way to improve these decisions.

Q What is the purpose of the histogram feature, and how do I use it?

A All but the simplest of digital cameras have a histogram feature. Its purpose is to provide a graphic representation of all of the tonalities in a given shot. You can access the histogram during playback and it is a far more accurate way to judge exposure than looking at the image on the LCD screen. Once you're familiar with how to read the graph, you can use the histogram to check exposures with just a quick glance.

A histogram looks like a black-and-white cross section of hills and valleys which show you the distribution of tones in the image. The vertical lines to the left (the peaks of the hills) represent the shadow areas of the image. The far left part of the graph indicates areas that are pure black. The areas on the right represent the highlights, while those at the extreme right edge indicate areas that are pure white. Between these two extremes is where all of the other tonalities that make up an image lie. The taller the peaks, the more pixels there are for that particular tone.

For most scenes, what you're after is a relatively even distribution of tones across the graph; however, this isn't always the case. A relatively flat scene (a foggy landscape, for example) has all of its peaks bunched up at the middle because, with no true shadows or highlights, it lacks any contrast.

The one thing that you particularly want to avoid is vertical spikes against the far-right border because these represent areas of highlight that have no detail. Of course, in some cases there may be small areas without detail, such as a patch of sunlight in bright snow. However, in most scenes, it's best to avoid completely burned-out highlight areas.

Incidentally, you can also find the histogram feature in your image-editing software. This allows you to keep an eye on the dynamic range of the image as you edit.

Q Can I use the histogram to change my exposures?

A Although the histogram feature is extremely valuable in terms of judging exposure, it doesn't have any controls that allow you to alter an exposure. The graph simply shows you the range of shadows and highlights as your camera recorded them. It's up to you to use your exposure controls to make exposure changes.

For example, suppose that you are photographing a lighthouse scene and, upon reviewing the histogram, you notice that there are highlight peaks bunched up against the right edge of the graph. Those lines represent bright white areas in the photograph that contain no discernible detail, such as white clouds. Because the histogram shows you that those highlights will wash out at that exposure, you can reduce it to add more detail there.

Similarly, if you notice peaks of shadow areas against the left edge of the histogram, those lines represent dark shadows with no detail. If you want to bring out the detail in shadowed areas, open the lens, slow the shutter speed, or do both. This adds exposure and, thereby, lightens those areas.

However, remember that sometimes the contrast in the scene may be more extreme than your sensor can handle. In some cases, because you can't extend the dynamic (or contrast) range of the sensor, you have to sacrifice either highlight or shadow detail. A better solution, of course, is to return to the scene later in the day when the lighting has softened and there is less contrast.

Frequently, you must take histograms with a somewhat large grain of salt. If you photograph a silhouette of a tree against a bright sky, the tree may well be pushed to the left edge of the histogram (it is black, after all) while the sky may show no detail at all. These extremes are natural for some subjects and don't represent an exposure error.

Q Why did the white subject that I photographed appear gray in the image?

A White subjects are one of the trickiest things to expose correctly. This is because, while you want to retain sufficient detail in the white area, you also want it to *look* clean and white. It's a fine line.

The reason that bright white subjects — such as snow, white roses, wedding gowns, or swans — turn gray is because the camera's light meter is calibrated to see and record the world as a medium tone. To your camera's light meter white subjects are gray, so when they appear so in a photo, the meter is doing its job. With most white subjects, adding 1 or 2 stops of exposure from the suggested meter reading renders them white, while retaining sufficient detail.

Q If I take a meter reading from a black subject, will it come out gray?

A When it comes to photographing black subjects, a lot of people are surprised to find, when they look at their files, that the rich blackness has disappeared. I first noticed this when shooting a freshly paved, jet-black road winding through the Nevada desert with my first digital camera. When I shot the pictures at the metered exposure, the roads were a perfect middle gray. The photos, though, looked horrid. I realized that, just as with slide film, in order to get the blacks to appear black, I had to override the meter recommendations and subtract 1 or 2 stops of exposure. Once again, this isn't a flaw in your camera or your metering system. The meter is programmed to see *everything* as a middle gray.

Q How can I correct white and black subjects during exposure?

A Once you accept that your camera's light meter wants to record all metered subjects — including all-white or all-black subjects — as mid-toned, finding the solution for recording them correctly is relatively easy. You either add light to make white subjects brighter or you subtract exposure to make them darker.

The simplest way to add or subtract exposure is by using the *Exposure Compensation* feature (see your camera manual to find out where it is and how to set it). This feature lets you add or subtract exposure from the metered one, regardless of what exposure or metering mode you're using. Typically, you can adjust exposure anywhere from 3 to 5 stops in 1/3 increments.

For example, if you photograph a landscape after a fresh snowfall at the metered exposure, the snow will more than likely record grayer than you'd like. By adding 2 stops or so of exposure with the Exposure Compensation feature, you can return the snow to its true appearance. Similarly, if you're photographing a dark subject and it is recording too light, just subtract a stop or two of exposure. The exact amount is largely a matter of experience and experimentation.

Q How do I expose for a subject that has a very bright or dark background?

A Whenever your main subject is surrounded by a particularly light or dark background, you have to be careful not to let that influence the meter reading to the point that it adversely affects the exposure. In fact, this is the type of situation that can fool even the best light meter.

For example, if you photograph a friend sitting on a towel on a bright, light-toned, sandy beach, there is a very good chance that the sand — not your friend — will be correctly exposed. Similarly, if you photograph someone standing in a patch of sunlight in front of a deep-shaded background, it's likely the meter will be overly influenced by the dark surroundings.

The best way to combat this situation is to use Center-weighted (or Spot) metering to take a close-up reading exclusively from the important subject area, and then lock in that meter reading. That is the technique that I used to photograph the bleeding heart flowers shown here against a very dark background. I took my meter reading directly from the blossom in the center. You can use the same technique if you are photographing a friend's face as he leans against a white wall.

Q What is a specular highlight?

A *Specular highlights* are those extremely bright *hot spots* that occur on shiny surfaces whenever a bright light source reflects in that surface. You often see specular highlights caused by the sun reflecting off of car windshields, fenders, or water. These highlights can be interesting with the right subject, though, because they often exaggerate the feeling of light intensity or heat, such as when included in a sunset over water. Also, the catchlights in someone's eyes are also specular highlights, but they are often quite attractive.

The best way to meter with specular highlights is to simply exclude them when you meter. When photographing the gold dome shown here, I aimed the lens at the blue sky, locked in that reading (by holding the Shutter Release button halfway down), and then recomposed the scene.

You don't have to worry about how specular highlights will expose because true specular highlights always grossly overexpose. The important thing is to expose correctly for your subject and let the highlight burn out — which is what it's going to do no matter what. Incidentally, if you check your histogram for any shot that includes a specular highlight, you will see that part of the graph is pushed up against the right margin.

Q What is a clipping warning, and what is its purpose?

A I've had a lot of students approach me in the past few years with the same question: Why are parts of my images blinking at me on the LCD screen? The reason is that they have inadvertently turned on the *clipping warning* or *clipping alert*. *Clipping* is a term that is used to describe an area's brightness in a subject that falls off the far-right end of the histogram. The camera is warning you that these areas of the scene will record without any detail. On many cameras, this is an alert feature that you can turn on or off. It blinks (usually in red or black) in the areas where too much exposure is being received.

The clipping warning is a fantastic tool when you're photographing subjects with a lot of contrast and bright highlights. It not only alerts you immediately if part of the subject is overexposed, but it also shows you which parts of the scene need exposure correction. The cure is simple: reduce exposure until all (or at least most) of the blinking stops. There are certain things, like the specular reflections discussed previously, that simply cannot be controlled or fixed. However, if you really want the shot, just ignore them and go for it.

Q Can I fix most exposure mistakes in editing?

A One of the most alluring aspects of digital imaging is the ability to seek forgiveness for almost all technical sins — including exposure. Even the most basic of image-editing programs have at least one tool for fixing exposure flaws. High-end programs, like

Photoshop, have a multitude of tools for fixing exposure, including Levels, Curves, and a dedicated Exposure tool. There are also numerous add-on programs for Photoshop that can expand your exposure-fixing options.

If you shoot in the RAW format, not only can you fix many exposure problems, but you can also literally revisit the original exposure and reset the in-camera exposure levels of the original file. By sliding the Exposure Setting slider left or right, you can fix under- and overexposure errors across a range of several stops. It's an amazing facility and the reason that I shoot 100 percent of my photos in the RAW format.

BONUS TIP:

If you can't do your own editing at home, many camera shops have self-service editing kiosks that allow you to make exposure corrections.

Q As I can fix most mistakes in editing, why should I bother paying attention to exposures when I'm shooting?

A I have spent much of my teaching and writing career espousing the virtues of getting the image right in the camera. However, even I have to admit that there are few mistakes made in exposure that can't be fixed (with enough elbow grease) in editing. However, this question always makes me think of a plumber asking, "Why should I install the pipes correctly now? I can always get paid to fix the leaks later." Unfortunately, most of us aren't getting paid to fix exposure leaks later — it's just more hard work that we shouldn't have to do. Editing takes time — time that you could use to shoot more photos (or bake a pie).

There are many practical reasons for getting exposure right the first time. In addition to the time and energy factor, you should also consider that whenever you edit a photo (other than the initial edit of a RAW image, which is the exception) you destroy some of the pixels. Examine the before and after histograms and you'll notice gaps in the graph. Those white vertical lines are pixels that the program has discarded and you can't get them back.

Also, just because you can change the exposure in terms of darkness or lightness doesn't mean that you can revisit things like depth of field or the motion qualities of your subject. You can't. If you inadvertently photograph a landscape scene at a wide aperture because you weren't paying attention to the exposure, you end up with a very shallow depth of field and no amount of editing can change that.

Editing is a profoundly useful tool when it comes to fixing flaws in specific areas of an image, or when you want to alter or enhance the mood of a scene. But when it comes to making creative decisions about your exposures, the time to do that is before you press the Shutter Release button.

Q Other than the ISO, what are the primary camera settings that control exposure?

A As complex as the exposure process seems at times, there are really only three settings that control how much light reaches the sensor: The ISO (which regulates the sensitivity of the camera's sensor), the lens aperture, and the shutter. Every exposure that you make is created with a combination of these three settings.

The lens aperture is an iris-shaped opening in the camera lens that controls how much light reaches the sensor. As the diameter of the opening increases, so does the amount of light allowed into the camera. The size of the aperture opening is referred to as the *f-stop.* It is controlled either electronically or, on older lenses, by a mechanical ring known as the *aperture ring.*

The most important thing to remember about f-stop settings is that the smaller the f-number is, the larger the lens opening is and, therefore, more light is allowed to enter the camera. The larger the f-number is, the smaller the opening is and, therefore, less light is allowed into the lens. Therefore, an aperture with a small number, such as f/4.0, lets in a lot of light while an aperture with a larger number, like f/22, has a smaller diameter and lets in less light. This seemingly illogical bit of math probably confuses more people than any other aspect of exposure.

One way to visualize the relative size of apertures is to think of them as slices of cake. If you cut a cake into four slices (f/4.0) you have four very large slices, but if you cut it into 22 slices (f/22), they are substantially smaller.

Shutter speed controls *how long* the light is allowed to enter the camera. The longer the shutter is kept open, the more light that reaches the image sensor. All cameras use a standard selection of shutter speeds that typically range from 30 seconds or so at one extreme, to speeds as brief as 1/4000 or 1/8000 second at the other.

Q Do all lenses have the same number of apertures?

A All lenses use the exact same sequence of *whole* f-stops. The basic f-stop numbering pattern looks like this: f/1.8, f/2.0, f/2.8, f/4.0, f/5.6, f/8.0, f/11, f/16, f/22, f/32. The actual number of total f-stop settings, however, varies from lens to lens — some have more aperture settings than others. Also, because digital cameras set their apertures electronically, many also offer intermediary or partial stop settings (half or third stops) in addition to whole f-stops. These partial stops offer more precision when setting exposure.

Each number in the traditional f-stop sequence represents what is referred to as a *whole stop*. As you move from one whole f-stop to the next, you either double or halve the amount of light entering the lens. For example, if you move from f/11 to f/8.0 (a smaller number but a larger opening), you double the light entering the lens. Conversely, if you move from f/11 to f/16 (a larger number but a smaller lens opening) you halve the amount of light reaching your sensor. Incidentally, the physical size of the aperture only doubles every other stop. However, the area of the opening doubles (or halves) with each whole-stop change, thus the light intensity gathered doubles or halves from each stop to the next.

The reason that different lenses have a different aperture range is that some lenses have larger maximum apertures (such as f/1.4) in order to let in more light. Having a larger maximum aperture allows you to shoot at faster shutter speeds in lower light levels because the lens is allowing more light to reach the sensor. Some lenses also have smaller minimum apertures (f/45, for example), but they still represent full-aperture stops. Having a smaller minimum aperture means that you can potentially create more depth of field when necessary.

The thing to remember is that regardless of how many f-stops a lens may have, the sequencing of whole stops is always precisely the same.

Q What effect does changing the length of the shutter speed have on my images?

A Because shutter speed controls the amount of time that the sensor is exposed to light, it can have a very creative effect on how motion is recorded. Shutter speed selection means almost nothing when it comes to recording stationary subjects, like a landscape or a building. However, it can radically alter the way that you record any subjects that are in motion. To select the shutter speed that you want to use, just set your camera to the Shutter Priority exposure mode.

How long of an exposure you use with moving subjects really depends on your creative intent — whether you want to freeze the subject or exaggerate the motion — and, of course, the speed of the subject. The longer the shutter remains open, the more time that motion records and the more blur you create. Conversely, the shorter the exposure time (and the higher the shutter speed), the less time it is seen by the sensor and the more the action freezes.

The best way to get a feel for how different exposure times work with various subjects is simply to experiment, and then compare your results to the shutter speeds that you used. I used a very brief shutter speed of 1/640 second to freeze the action of the windsurfers shown here, but I used a relatively long exposure time of 1 second to blur the waterfall.

Q What other effect does changing the aperture have on my images?

A In addition to regulating the flow of light, the f-stop that you choose (or that your camera chooses for you) is also one of the most significant factors in controlling the amount of near-to-far focus, or *depth of field*, in a given scene. Because what is or isn't in focus profoundly affects the appearance of your pictures, it's important that you understand how that choice changes the look of a particular subject.

Several factors affect how much depth of field an image has but, all other things being equal, the smaller the f-stop the more depth of field there is, as in this shot of a dock.

The larger the aperture (the smaller the f-stop number) is, the shallower the depth of field will be. If you are photographing a landscape and want everything from near to far to be in sharp focus, you must set a small aperture, such as f/22. If you want to restrict the region of sharp focus, as in this shot of a dragonfly, you can set a larger aperture, like f/2.8.

The amount of depth of field radically changes when you change the f-stop. Each time that you step down 1 stop (f/11 to f/16, for example), you double the range of near-to-far sharpness. Each time that you open the lens 1 stop, you cut the amount of depth of field in half.

Q **Is there a right or wrong degree of depth of field?**

A While it's certainly important that your primary subject is in sharp focus, how much of the rest of the image appears sharply focused is entirely a creative decision. A lot or a little — it's completely up to you. While some subjects work very well with maximum near-to-far sharpness, others have more impact when you severely restrict the zone of sharpness.

Landscapes, such as this harbor scene, often work best when everything from near to far is in focus because it allows the eye to wander across the scene without any abrupt changes in sharpness.

When you look at a landscape in real life, your eyes don't see everything in focus at once, but they do refocus almost instantaneously as your gaze shifts so that everything seems to be sharp. On the other hand, with portraits or close-up subjects, you can often draw attention to them by using a very shallow focus.

Keep in mind that the area of sharp focus in a photograph does not drop off suddenly but, rather, it transitions gradually. If you take a portrait of your cat and focus precisely on her eyes, the sharpness trails off gradually, both in front of and behind, the point of sharpest focus.

Q

In addition to aperture, do any other factors affect the depth of field?

A

While aperture is the primary setting for controlling depth of field, several other factors also contribute to how much is (or isn't) in sharp focus. Any time that you change any of these factors, the depth of field in the scene will change. Knowing how each of these affect depth of field gives you tremendous control over how much of a scene is in acceptably sharp focus. The following four factors affect the depth of field:

- **Lens focal length.** The longer the focal length of a lens, the more shallow the depth of field. Therefore, if you want to increase depth of field you can use a lens with a shorter focal length (a wider-angle lens). If you want to limit depth of field, switch to a longer focal-length lens.

- **Lens-to-subject distance.** The closer you get to your subject, the less inherent depth of field you have. To get more depth of field, move farther away from your subject, and vice versa.

- **Point of sharp focus.** A picture is sharpest where you focus the lens. Generally speaking, the range of depth of field extends one-third in front of this point and two-thirds behind it.

- **Sensor size.** Depth of field is always greater with smaller sensors.

Q How can I intentionally limit depth of field?

A Intentionally restricting sharp focus to one part of a photograph is a technique known as *selective focus*. It can be useful as both a creative tool and to eliminate (or at least subdue) bothersome clutter. This technique works particularly well with portraits, close-ups of flowers and plants, still-life subjects, or any time that you want to direct the viewer's attention to one particular part of a scene.

Selective focus works best if you set your lens to its widest aperture. The best way to do this is to put your camera in the Aperture Priority exposure mode so that you can manually select the aperture. Also, because longer focal-length lenses provide less inherent depth of field, you're usually better off working with either a medium telephoto lens (or longer) or a telephoto zoom setting. Remember, too, that the closer you are to your subject, the shallower the depth of field. If you don't like your results, try moving closer to your subject.

Most importantly, there should be no ambiguity about what you want to be in sharp focus and what you wanted blurred. If the distinction between sharpness and blur isn't obvious, it looks like sloppy focusing technique.

Q What is bokeh?

A The term *bokeh* (pronounced boh-kay or boh-kuh) is one of my favorite photographic words. The word originated in Japan sometime in the mid-1990s, and it literally means *mental haze*. But, you should definitely take it as a compliment if someone uses the phrase *good bokeh* to describe one of your photos.

Bokeh refers to the aesthetic quality of the out-of-focus area in a photo taken using selective focus. A photograph that has a smooth, silky-looking out-of-focus area behind the main subject is said to have *nice bokeh*. There is also such a thing as bad bokeh. That usually means that the out-of-focus area is not quite smooth enough or is distracting in some way.

Bokeh is dependent on several factors, not the least of which is lens design. Some lenses produce better bokeh than others. If you visit photography discussion groups online, you'll find plenty of opinions about which lenses produce good bokeh. But it also depends on things like your distance from the subject and your subject's distance from the background. In the photo of the shell shown here, I used a 300mm lens at its widest aperture (f/5.6) to toss the sea and sky out of focus and, I hope, create good bokeh.

Q

What is hyperfocal distance?

A

Hyperfocal distance is a term that is used to describe both a specific focusing distance, and a method of focusing on that distance to gain the maximum amount of depth of field. By focusing your lens at the exact hyperfocal distance, you get the maximum depth of field for any given lens and aperture combination. It's a technique that landscape photographers in particular use to ensure that everything in a scene is sharply focused.

Whenever you focus any lens at infinity, the hyperfocal distance is the nearest limit of the depth of field. Very simply, if you then reset your focus to that point, the depth of field (again, for any specific lens and aperture combination) runs from half the hyperfocal distance to infinity. In other words, if you focus on the horizon and the near limit of the depth of field is 20 feet away, and you refocus to that point, then everything from half that distance (10 feet) to infinity will be in sharp focus.

On most older (and a few newer) lenses, figuring out and setting the exact hyperfocal distance is easy because they have a depth-of-field scale etched into them. The scale features a pair of marks for each aperture. To use it, focus on infinity and then find the aperture that you are using on the scale. Next, simply turn the lens until one of the index marks for that f-number is beneath the infinity symbol on the distance scale. You are now focused on the hyperfocal distance. Look at the other mark for that aperture and that tells you the near point of sharp focus.

However, because many modern lenses don't have a distance scale, it's often impossible to use this scale-reading technique. If your lens doesn't have this scale, there are easy-to-use hyperfocal distance tools and tables available on the Internet (www.dofmaster.com), and many can be downloaded for free.

Q Do many combinations of shutter speed and aperture provide the same amount of light?

A One of the somewhat magical aspects of exposure is that for every combination of shutter speed and aperture, there are many other combinations that provide the exact same exposure. In fact, probably the single most important thing to know about exposure is that shutter speeds and apertures enjoy a completely reciprocal relationship.

Let's say that your meter gives you an exposure reading of 1/250 second at f/11. If you slow the shutter speed down by 1 stop (from 1/250 to 1/125), you expose the sensor to light for twice as long. If you stop there, you would overexpose the shot by 1 stop. However, if you also close the lens 1 stop (from f/11 to f/16), this cuts the amount of light entering the lens in half, giving you exactly the same amount of light exposing the sensor.

It doesn't matter how many shutter speeds you slow down or speed up as long you make an equal correction (either opening or closing the lens) with the aperture. This always gives you exactly the same exposure. The depth of field and the way that the motion is recorded changes, but the amount of light hitting the sensor is identical.

So, why would you do want to switch to an equivalent combination? Well, if you want more depth of field, you need to use a smaller aperture. But in order to prevent underexposing the scene (each stop you close the lens cuts the light in half), you simply slow the shutter speed. If you want to use a faster shutter speed (to stop action, for example), open the lens by the equivalent number of stops to let in more light.

Again, as long as you go in the opposite direction with the other setting by the exact same number of stops, this always allows an equivalent amount of light to hit the sensor. Magic!

Q In terms of exposure latitude, what happens when a scene has more contrast than the camera sensor can handle?

A One of the toughest problems that all photographers confront when photographing outdoors is contrast or, more specifically, *too much* contrast. The range of tones in a scene, from the darkest shadows to the brightest highlights, is known as the *dynamic range*. Compared to the broad range of darks and lights that your eyes can see at any one time, digital cameras are much more limited.

In fact, when given time to adjust to the prevailing conditions, your eyes are capable of seeing an astounding dynamic range of, in photographic terms, up to 24 stops. Most digital cameras can only record 11 stops, and operate in a range of only 6 to 10 stops. In general, a dSLR camera handles contrast better than a compact, or even a zoom, because it has a larger sensor (and, therefore, a larger photosite) which provides an inherently better dynamic range.

As you might guess, when confronted with a scene that has a broader tonal range than a camera can record, something has to give. If you meter an extremely contrasting scene and use the average reading provided by your meter (even a good Matrix meter), odds are that you will lose details in both the highlights and the shadows.

A quick glance at the histogram shows you if you are clipping (losing) highlights, shadows, or both. If this is the case, you need to make an exposure decision and sacrifice some part of the dynamic range. In this situation, it's generally a good idea to follow some age-old photography advice: Expose for the highlights and try to recover detail in the shadow areas in editing. This is because once you lose highlight detail in a scene, there is no way to recover it. Shadow detail, on the other hand, often exists even in the darkest areas of a file and can be recovered (to some degree) in editing.

Q **How can I extend dynamic range?**

A Unfortunately, the dynamic range of a digital camera's sensor is pretty much fixed. I expect this to change in the not-too-distant future, though. It's a riddle that engineers have been trying to solve since the first digital cameras hit the market. In the meantime, the following are some tricks that you can use to stretch the contrast range a bit:

- **Use a larger sensor.** If you frequently shoot high-contrast subjects, it's worth it to buy a camera with a larger sensor and one that has a broader inherent dynamic range. Read reviews for comparison studies.

- **Shoot in the RAW format.** The JPEG format tends to clip (or cut off) tonal extremes at both the shadow and highlight range more than the RAW format. Also, if you shoot in the RAW format and expose for the highlights, you can often lighten deep shadow areas in editing.

- **Use a lower ISO.** Dynamic range tends to be reduced at higher ISO settings, so when possible, shoot at lower ISO speeds.

- **Use High Dynamic Range (HDR) imaging.** This is the technique of combining several bracketed exposures into one image to vastly expand contrast range. Some cameras now offer *Enhanced Dynamic Range,* which performs a variation of this technique in-camera.

- **Use a graduated neutral density (ND) filter.** Often, the sky is far brighter than the foreground. A graduated filter lets you hold back exposure on the sky area and expose for the shadows. This prevents the highlights from clipping.

- **Shoot in different lighting.** If an outdoor scene is not dependent on the drama of high-contrast lighting, consider coming back on a slightly overcast day, or earlier/later in the day when the ambient light (and contrast) are more moderate.

- **Use reflectors or fill flash.** If you're photographing portraits or close-ups in harsh light, consider using a reflector (a sheet of white art board works well) or your built-in flash. This eliminates harsh shadows, thereby reducing contrast.

Q What is a low-key image?

A A photograph dominated by darker tones that has a limited number of light or mid-toned areas is referred to as a *low-key* image. Low-key images can have highlights. In fact, they often need the contrast of limited brighter tones to establish contrast and the richness of the darker regions. The overall tonal range, however, tends to be very subdued, such as a portrait set against a dark background or a still life made up of deep, rich colors.

Low-key photos tend to elicit a more brooding or melancholy emotional response. Due to their inherent darkness, they are also often seen as mysterious or intriguing. Our eyes tend to linger on dark-tone images because our brains are searching for clues about the missing brighter areas.

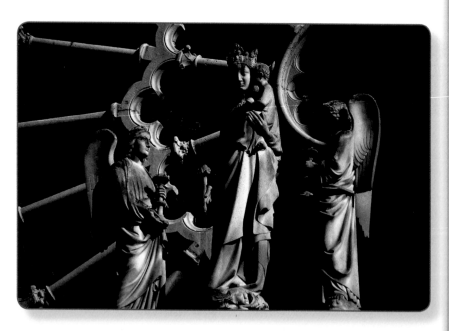

Q What is a high-key image?

A As you might expect, a *high-key* image is one in which the overwhelming balance of tones range between the middle and very lightest. When exposing for high-key scenes, I think it is fine to let some of the brightest images completely wash out because this tends to enhance the pale and romantic look of the picture. Again, it is not a fault to have a certain number of middle tone or darker areas, but high-key images do work better when their contrast is restricted.

High-key images tend to have a cheerful, upbeat, even fairytale-like quality about them. This technique is particularly well suited to portraits (especially of babies and kids) because it gives them a gentle, dream-like quality.

Q **What is the purpose of the Auto-exposure bracketing feature, and when would I use it?**

A There are many times when, despite your best efforts (and your light meter's best advice), you are still uncertain what the best exposure is for a given scene. *Auto-exposure bracketing* (or AEB, for short) is a technique that solves this problem by automatically firing off a series of several frames in rapid succession, each at a slightly different exposure. You could do this manually, of course, but that requires you to put the camera into the Manual exposure mode and change the exposure settings after each frame. This is time consuming, at best.

Using AEB, on the other hand, is easy. You simply tell the camera how many exposures (from three to seven) you want to make, and how many stops (usually, anywhere from 1/3 to 1, or more) you want between each frame. Next, press the Shutter Release button once. The camera then fires a series of exposures in rapid succession — you can choose the best frame later during editing.

You can control which setting your camera alters by selecting a specific exposure mode. For example, if you use the Aperture Priority mode, the camera keeps that aperture and varies the shutter speed, and vice versa. In these two shots of lupine flowers, I used the Aperture Priority mode. The camera used the same aperture for both shots — only the shutter speed changed.

Q Why does my camera have so many exposure modes?

A All but the simplest of digital cameras have a fistful of exposure modes from which you can choose. In fact, even many basic compact cameras have complex exposure setting options. All of these modes may, at first, seem bewildering. You may be tempted to stick to the tried and true Automatic mode. But, be brave! If you always stick to one mode, you lose a lot of the flexibility of your camera and rob yourself of creative potential.

Each of the primary exposure modes is designed to solve either a technical or creative problem. Choosing the right one is a matter of studying the situation and asking yourself some basic technical and creative questions. Are you trying to control depth of field? Is stopping action your most important consideration? Are you trying to tame extreme contrast? Once you've examined these issues, you'll find it easier to choose an exposure mode that helps you create the photo that you want — and be thrilled to have so many modes from which to choose.

You learn a lot more about a camera by using each of its controls rather than just reading the manual — doing both is a great idea, though.

Q **What is the difference between the Automatic (green) and the Programmed Automatic modes?**

A Many digital cameras have two fully automatic exposure modes: Automatic and Programmed Automatic. While initially, they might seem redundant, they're not. There are differences between them, although they are somewhat subtle at times.

Automatic mode is also known as the *green mode* because it's typically green on the exposure-mode dial. This is the all-encompassing, fully Automatic mode. In this mode, the camera sets both the shutter speed and the aperture for you. It also sets the ISO rating based on the amount of ambient illumination.

Also in this mode, the flash activates itself when the camera senses that the lighting level has dropped below what it deems acceptable for a good handheld exposure. The great fun of this mode is that you can just concentrate on the viewfinder and ignore *all* technical decisions. The obvious downside is that you surrender all creative control. In Automatic mode, you have no control whatsoever over depth of field, how motion is rendered, or the ISO setting. On most cameras, the white balance is often chosen for you as well.

Programmed Automatic mode is a little more sophisticated and offers a bit more creative control. In this mode, the camera still sets both the aperture and shutter speed for you. However, the difference is that you can (and often, must) set the ISO and white balance yourself, although you *can* put the latter in its own auto mode.

The primary advantage of this mode is that you can usually override the aperture and shutter speed combinations using your camera's Command dial. For example, if the camera sets an exposure of 1/125 second at f/8.0 and you know that you want more depth of field, you can scroll through the aperture settings to find a smaller one. Another subtle difference is that the flash doesn't automatically pop up — you have to manually flip it on.

Q Why would I use the Aperture Priority exposure mode?

A You use *Aperture Priority mode* when controlling the depth of field is your primary concern. In this mode, you select the aperture setting based on the amount of depth of field that you want and the camera selects the appropriate shutter speed. If you know that you want to restrict depth of field in a portrait, you can select a wide aperture and the camera matches it with the corresponding shutter speed for a good exposure. If you happen to be shooting a landscape or an outdoor scene, like the

Japanese bridge shown here, and you want to have sharpness from near to far, you can select a small aperture for maximum depth of field. The camera then chooses the appropriate shutter speed.

Keep in mind that if subject motion is an issue, you must keep track of the shutter speed the camera selects. If you select a small aperture and the camera sets a shutter speed that is too slow, your subject might create more blur than you desire. To counteract this, you can raise the ISO setting. This provides a faster shutter speed while retaining the desired aperture. Also, be sure to place the camera on a tripod when using small apertures to negate any chance of camera shake.

Q What is the purpose of the Shutter Priority mode?

A *Shutter Priority* is the best mode to use when photographing subjects that are in motion — whether you want to freeze or exaggerate the movement. In this mode, you select the shutter speed that you think is appropriate and the camera automatically chooses the corresponding aperture setting. This is the mode favored by sports photographers because it enables them to control stop action with fast shutter speeds. You can also use it to take long exposures of moving subjects by selecting a slow shutter speed, as I did with the shot of the waterfall shown here.

Any time that you use this mode, you must keep an eye on the shifting depth of field because, in order to create good exposures in changing light, the camera continuously resets the aperture. For example, if you select a very fast shutter speed of 1/2000 second, the camera is often forced to select a very wide aperture setting, which means almost no depth of field. On the other hand, if you select a very slow shutter speed — to blur runners breaking the tape at the finish line, for example — the camera selects a relatively small aperture, which can create a situation with too much depth of field.

Q **When would I use the Manual mode?**

A In many respects, *Manual mode* provides the maximum amount of creative exposure freedom. In this mode, you manually set both the shutter speed and the aperture. You can (and should) still consult your camera's meter to see what it suggests is the correct exposure, but you are completely free to ignore its advice. Most camera meter displays also show you how far you've strayed from the recommended settings.

Manual mode is particularly handy when you face tough decisions about contrast. If you are certain that the camera meter is going to be misled by the complex contrast in a subject, you can rely on your own experience to radically depart from the camera's suggestions. Conversely, if you're taking a portrait of your daughter in a white dress as she stands against a white wall, you may intentionally decide to make a high-key image by overexposing the scene.

Any time that you use a handheld meter, you have to use Manual mode to transfer those readings to the camera. There are also many extreme exposure situations — such as when trying to capture a carnival ride in motion, as shown here — in which the only way to set a long enough time is to use Manual mode.

Q What is the difference between the exposure and Scene modes?

A In addition to the primary exposure modes, many cameras also offer a number of *Scene modes* that are intended to be used with specific types of subjects. Basically, these modes act as shortcuts for getting good creative exposures on a wide variety of subjects that often benefit from a certain amount of exposure bias, such as automatically setting a higher shutter speed for sports subjects. On some cameras, you set the Scene modes on the main exposure mode dial. They're indicated by all of those cryptic little icons: A tiny mountain peak, a person running, a silhouette of a tulip, and so on. On other cameras, they're listed as menu options.

Scene modes are a particularly good way to spread your wings when you want to go beyond the automatic modes, but don't yet feel comfortable with the math and other settings involved with using the Manual mode. They can also save you a lot of time and fussing at crucial moments. For example, if you suddenly find yourself in a landscape situation, you don't have to ponder things like f-stops and shutter speeds. Just flip to the Landscape mode and you're off and running. Personally, I enjoy having a lot of different Scene modes on my camera because there are times when I really don't want to be thinking a lot about exposure. Also, they're just fun to play with.

One thing that you have to be aware of when using any Scene mode is that they often do more than just set the aperture and shutter speed for you. They also take over many other aspects of image capture, including things like ISO, white balance, color saturation, in-camera sharpening, and even how and where the camera focuses. With most cameras, you can't override these settings when you're using a Scene mode. Make sure that you read your camera's manual carefully so that you understand exactly what each Scene mode does.

Q **What is Landscape mode, and how does it affect my exposures?**

A The *Landscape mode* (usually indicated by an icon of a tiny mountain peak) is a quick and easy way to get sharp, nicely exposed photos of broad outdoor scenes. In this mode, the camera automatically selects the smallest possible aperture setting to achieve maximum depth of field, while still providing a shutter speed that is safe for handholding your camera.

However, it's important to be aware that when you select this mode, many cameras also automatically saturate the colors in things like blue sky and green foliage, and turn on enhanced image sharpening. Usually such enhancements are a good thing and make your prints much livelier, but you should be aware that the camera is manipulating them.

Q What are the benefits of using the Portrait mode?

A Most portraits, particularly those of the very close-up or head-and-shoulders variety, work best when you use a shallow depth of field to create a soft, slightly blurred background. *Portrait mode* makes this simple by automatically selecting a shutter speed and aperture combination that gives preference to using a wide aperture setting.

The wide aperture assures a limited depth of field that tosses the background into a soft and pleasing blur, without you having to make any decisions about aperture. Because the focal length of your lens and the distance to the subject are also contributing factors in reducing depth of field, this mode works best when combined with a moderate telephoto lens (that is, 100mm or greater in 35mm terms).

Q How does placing the camera in Close-up mode affect the exposure setting?

A Digital cameras have had a surprisingly profound effect on the popularity of close-up photography. This is partly because most of them have a built-in *Close-up* exposure mode that makes taking great close-ups much simpler. This mode (usually indicated by a tulip on the selection dial) greatly simplifies the job of taking close-up photos of things like flowers, bugs, and rare coins, by automating both the exposure and focus modes. Experimenting with close-up photos is extremely fun and doesn't require any exotic subjects. I photographed this pretty dandelion while heading out to mow the lawn and was amazed at its intricate details.

The precise ways in which Close-up mode functions depends largely on the type (and model) of the camera. With compacts or zooms, the camera not only sets the exposure for you, but it also shifts the lens into a close-focusing mode so that you can get much closer to your subject. Because such close focusing reduces depth of field, the camera's exposure system also gives priority to choosing a small aperture to maximize depth of field. In some cameras, however, Close-up mode may also disable the zoom function of your lens and limit you to one specific focal length.

Q What kind of subjects would benefit from the Night Landscape mode?

A As the name implies, *Night Landscape mode* (also sometimes called *Night Scene mode*) was designed to simplify setting exposures for twilight and after-dark scenes. It is usually indicated by a crescent moon over a building silhouette on the selection dial. In addition to landscapes, you can use this mode for shooting a broad range of night scenes, including city skylines and traffic, neon signs, spot-lit buildings, and holiday lights.

In this mode, the camera automatically sets long exposures so that you record not only the brighter areas of the scene (city lights), but also the darker background areas. Specifics vary by camera model, but usually a small aperture is also selected to provide good depth of field. Some cameras do set a wide aperture so that the camera can use a moderate ISO speed (see your camera's manual for more details).

Normally, both the flash and the AF-assist Illuminator are disabled in this mode. This is because firing the flash lights up the foreground and ruins the ambience of larger scenes like skylines. Also, because long exposures exaggerate noise, most cameras turn on automatic noise reduction. When using this mode, it's a good idea to mount your camera on a tripod or other support to help keep your images sharp.

Q What is Night Portrait mode?

A I love taking photos of friends in places like Times Square or the Las Vegas Strip at night, but if you've ever tried it, you know what a tricky business it can be. If you don't turn on the flash, you end up with a good exposure for the city lights, but your friends are in darkness. If you *do* turn on the flash, your friends are well exposed, but the background lights are grossly underexposed.

Night Portrait mode solves this riddle by combining an exposure that is long enough to record the background lights, while the flash correctly illuminates your subject. Because of the limited distance range of the built-in flash, it really has no effect on the background exposure at all, so things like neon signs, streetlights, car taillights, and so on, all look very natural.

Typically in this mode, the flash fires first and then the shutter remains open long enough to record the background. The one problem you may run into is that if you jiggle the camera at all, the background lights may show up as colorful blurs or streaks. In some cases the camera's anti-shake technology may help, but it really depends on how long of a shutter speed the camera uses to record the background. A tripod is the best solution, but because we rarely carry them around for casual pictures, you may be better off either bumping up the ISO or finding something like a car fender on which you can lean.

Also, keep in mind that any lights in motion in the background — such as cars moving through Times Square or driving down the Strip — will record as streaks behind your subject. Usually this creates an interesting and creative look by combining moving lights and a well-exposed portrait subject. Try it the next time you're out with friends; you'll have them all wondering where you learned to take such cool night shots.

Q What is the Sports mode?

A Any time that you photograph sports or any other kind of fast-moving subject (your kids dashing through the lawn sprinkler, for example) and your primary concern is freezing that motion, *Sports mode* makes setting exposure much simpler. In this mode, your camera automatically biases its exposure in favor of selecting the highest shutter speed available for the existing light.

In essence, this mode acts similar to Shutter Priority mode, with the difference being that you don't have to select the shutter speed yourself — your camera does based on the prevailing light conditions and the ISO that you've set. However, because its priority is the fastest shutter speed, the camera may sacrifice depth of field by choosing a wide aperture.

Q

What is the Museum mode?

A

Not all museums allow you to take photos, but when you visit one that does, the more discrete that you can be about it, the better. Considering that most digital cameras have a lot of things that flash, whir, buzz, and click, this is often easier said than done. For this reason, a lot of compact cameras have a *Museum* (or *Quiet*) *mode* that enables the camera to operate in a non-distracting way.

With the touch of a button (or a menu option), the camera turns off its flash, focus-assist lamp, and all operating noises. In some cameras, Museum mode is a secondary one that quells both camera noise and light features, regardless of what exposure mode you may be using.

Q How does Sunset mode enhance images of sunrises and sunsets?

A When it comes to photographing sunrises and sunsets, nature does a lot of the heavy lifting for you. Because these colorful displays are inherently beautiful, often a variety of exposures still supply interesting and pretty results. But camera engineers, being unafraid of any challenge, have come up with a Scene mode that is intended to, if not improve upon nature's drama, then at least to intensify it. Essentially, *Sunset mode* is an enhanced landscape mode that gives priority to selecting a small aperture. However, it also offers an extra twist in that it specifically heightens the saturation of reds and oranges.

Sunset mode works particularly well with a bit of underexposure because this further exaggerates the intensity of the colors. Try this mode if you're taking landscape photos during the golden hour (the hours after sunrise and before sunset) for the same reason. This mode is great if you like your colors piled on and don't do your own editing because sunsets/sunrises will come back from the lab just as vibrant as they were in person.

Q Why are lenses for digital cameras always described as being 35mm equivalent?

A The primary reason that most lenses for digital cameras are described as *35mm equivalent* is that 35mm was the format with which most photographers were familiar for the decades prior to the advent of digital cameras. Manufacturers felt that describing lenses in this way would make it easier for photographers to understand the angle of view of a particular lens.

If a photographer that has used a 35mm camera for years reads that a lens is equivalent to 105mm in 35mm, he has a good mental picture of what results that lens can produce. Of course, for the more recent generations of digital photographers, the term 35mm equivalent means absolutely nothing because they've never used a 35mm camera.

Q In terms of focal length, what does it mean when a zoom lens is marked as 5X, 12X, and so on?

A Whenever you buy a compact camera with a zoom lens or a zoom camera, the lens is described by its magnification factor: 5X, 10X, 12X, and so on. These numbers represent the ratio between the shortest (wide-angle) focal length of the lens and the longest (telephoto) focal length. So, if a camera's longest setting is 10 times the shortest, it's a 10X lens. You can establish the ratio for any dSLR lens by dividing the longest focal length by the shortest. For example, a 17-35mm zoom has a 2X zoom ratio.

This tells you very little about what that means in the real world in terms of, say, a 35mm equivalent, but camera manufacturers are in a kind of awkward spot here. The reason they avoid being more specific is because there are so many sensor sizes — not only different types but also in different brands of cameras — that just stating the exact focal length would mean nothing. The only reason that knowing the actual focal length helps is if you know mathematically how to convert it to something recognizable, like a 35mm equivalent. By giving you a comparison of 12X, you at least know the variation in magnification between the widest focal length and the longest.

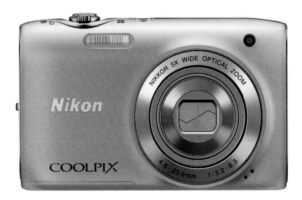

Q Is a longer zoom range better, and what is the longest range I can get in a single lens?

A Manufacturers have made tremendous strides over the last few years when it comes to creating zoom lenses that cover an extraordinary range of focal lengths. Lenses like the Nikkor AF-S 28-300mm f/3.5-5.6 G cover a range all the way from moderate wide angle to the beginning of super-telephoto. That's a massive amount of creative flexibility in a single lens and, at present, it is one of the longest zoom ranges available.

The question then becomes: Is it better to have one very long lens with a broad coverage, or a few zooms that cover smaller but more specific focal-length ranges? The answer really depends on your shooting style and your willingness (or unwillingness) to carry gear. If you like to travel light but still want a good zoom range, nothing beats a zoom with a wide-angle-to-telephoto range. Rather than spending time changing lenses, you can just keep shooting — very convenient!

On the other hand, if you like to work within specific ranges for specific subjects — such as wide-angle lenses for landscapes and a telephoto zoom for wildlife — and you spend a lot of time shooting those subjects, it's worth owning a few separate zooms. There is no point in carrying a 28-300mm lens every day if you're mainly going to be working in the wide-angle range. You're better off owning a dedicated wide-angle zoom because you can probably get broader wide-angle coverage, along with a faster lens of better optical quality.

I carry three zooms with me: a 10-20mm wide angle, an 18-70mm, and a 70-300mm. With these three lenses, I can cover everything from 10mm to 300mm, and that is a huge range for three lenses. Before zooms, I often had to carry six or eight lenses to cover the same range. I also own a 28-200mm lens for days when I only want to carry one.

Q **What is a tele-extender?**

A A *tele-extender* (some manufacturers call them *teleconverters*) is a supplemental lens accessory that is used to extend the focal length of a lens. They are generally used with telephoto or longer zoom lenses, and are commonly used by wildlife and sports photographers. Tele-extenders mount to the camera between the body and the lens. In most cases, they retain all of the electronic communication between lens and body, but make sure that you confirm this with the salesperson before you buy.

You can buy tele-extenders in several strengths. The most popular strengths are 1.4X and 2.0X, but 1.7X and 3X are also available. The number represents the magnification factor of that particular extender and remains constant regardless of the lens that it's magnifying. For example, if you have a 300mm lens with a 1.4X extender, the lens is equal to a 420mm. Similarly, if you attach one to a zoom lens, you magnify the entire zoom range so that a 70-300mm lens becomes a 140-600mm with a 2X extender.

One of the biggest attractions of tele-extenders is that a very good one is a lot cheaper than buying a longer focal-length lens. While a teleconverter may cost you a few hundred dollars, it's likely that a new lens in the focal length that they provide when combined with your old lens might cost a few thousand dollars. They are also a relatively inexpensive way to find out if you need those long focal lengths often enough to justify a much more expensive new lens.

Also, you can adapt a tele-extender to any of your lenses, so you only need to buy one and it will fit all of your lenses. In addition, tele-extenders are small and lightweight (typically only an inch or two in depth). As a result, they are much more convenient to carry in the field — especially when hiking or trekking to photograph wildlife.

Q Do tele-extenders degrade image quality?

A Any time that you tinker in any way with the construction of a well-designed lens, you are degrading the quality of it. But in the case of tele-extenders, that degradation may or may not be a factor in the quality of your photos. A tele-extender is, in effect, a magnifying glass that goes between the lens and the camera body, so you are definitely messing with the lens design. Also, whenever you use an extender, you lose some light (the manual that comes with the extender will cover the amount) and the effective maximum aperture gets slower.

With these cautions in mind, here are some facts to consider when choosing or using a tele-extender:

- **Less magnification is better.** Tele-extenders that offer magnifications of 1.4X and 1.7X are much sharper, and have better color and contrast than those of 2X or 3X. In fact, it's probably wise to avoid 3X entirely — I've never read a good review of a one.

- **They are sharper 1 stop down from wide open.** If the adjusted effective maximum aperture of an f/4.0 lens is, say f/5.6, try to use an aperture of at least f/8.0.

- **Stick with the lens brand.** Buy extenders that are the same brand as the lens that you're using. Third-party extenders are not as sharp.

- **They are better with prime lenses.** Tele-extenders are far better with prime lenses than with zooms. If you plan to use one with a zoom, use a 1.4 or 1.7 extender, or test more powerful combinations before buying.

- **Check stabilization.** Make sure that the extender you're buying works with your camera's Image Stabilization (IS) system, particularly if the stabilization is in the lens.

- **Use a tripod.** Camera shake and focusing errors increase dramatically with focal length. Use a tripod when you magnify the focal length, especially at higher magnifications.

Q What does maximum aperture mean?

A Whenever you read about a lens, you see two numbers mentioned: The focal length (in millimeters) and the *maximum aperture*. A lens marked as a 100mm f/2.8 means that its focal length is 100mm and its widest aperture is f/2.8. The longer the focal length of a lens, the smaller the maximum aperture is likely to be.

This is because while a very long lens can, theoretically, have a wide maximum aperture, the front element needs to be substantially bigger in order to gather enough light. This makes lenses with a wide maximum aperture much more expensive to manufacture and, therefore, more expensive to purchase.

Q Why does the viewfinder on my dSLR stay bright even when I'm using a small aperture?

A The viewfinder remains bright because all modern lenses have what is called an *automatic diaphragm.* This enables the lens to remain at its widest aperture throughout viewing. The lens closes down to the *taking aperture* only when you press the Shutter Release button, and it returns to the wide-open position immediately after the exposure.

The closing and re-opening of the aperture happens so quickly that you are never even aware of it. The auto-diaphragm feature is particularly helpful in dimly lit shooting situations — such as indoors or outdoors at night, like the image shown here — because it keeps the viewfinder image bright enough for you to focus and compose carefully.

Additionally, if your camera has a Depth of field preview button, it overrides the automatic diaphragm feature. This lets you view through the taking aperture so you can see the actual depth of field that will be recorded by the sensor.

BONUS TIP:

If you shoot a lot at night, invest in lenses with a large maximum aperture. They provide a much brighter viewfinder.

Q Why does the maximum aperture get smaller as I increase the focal length of my zoom lens?

A Many zoom lenses have a range of maximum apertures. For example, a 70-300mm may have a range of f/4.0-f/5.6. This is called a *variable maximum aperture*. Using a variable aperture allows designers to keep lenses lighter, smaller, and more affordable to produce (and buy).

The f-numbers represent the maximum aperture setting at each end of the zoom range. In this case, the aperture at 70mm could open as wide as f/4.0, but at 300mm the aperture closes down to f/5.6. The lens loses approximately 1 stop of light as you zoom from the shortest to the longest focal length.

Why? Any f-stop is determined by the ratio between the focal length of the lens and the apparent size of the lens opening when it's viewed through the front lens element. Because this *apparent* size shrinks as the lens focal length gets longer (as it did when I zoomed from a wide focal length to a telephoto setting to take the images shown here), the maximum aperture is *effectively* smaller. In reality, the physical size of the aperture remains the same.

Q Why are some lenses described as being fast?

A If you hang around with a group of photographers long enough, the subject of lens speed inevitably comes up. Lens speed refers to the maximum aperture of the lens. Those with a large maximum aperture are referred to in photography slang as *fast*. For example, a lens with a maximum aperture of f/2.8 is considered faster than a lens with a maximum aperture of f/4.0. This is because it lets in twice as much light and allows you to use a shutter speed that is 1 stop faster, which is where the term fast originated. However, just as faster cars, horses, and yachts are more coveted and expensive, so too are fast lenses.

Fast lenses are not inherently any better in terms of sharpness than slower lenses, but they do have one distinct advantage: brighter viewfinders. Because the maximum aperture is larger, they let in more light and, therefore, the viewfinder image is substantially brighter when you're composing. If you're shooting in bright daylight, this doesn't make much of difference. However, in dimmer lighting — such as when shooting stage shows, holiday lights, city skylines, or scenes like the one shown here — it helps because the additional light makes it easier for your camera to focus.

Q What is a cropping factor, and what effect does it have on the focal length of my lens?

A Lenses for 35mm cameras were designed to fully cover a frame of 35mm film from edge to edge (although the image cast by the lens is circular — not rectangular). Because the size of many digital sensors is smaller than the 35mm frame of film, they use a smaller portion of that image and, therefore, have a smaller angle of view. You can see a simple demonstration of this by cutting two circles of different sizes into a piece of paper and laying each one over the center of a print — obviously the smaller opening shows you a smaller portion of the image or a smaller angle of view.

This difference in the angle of view means that when you use lenses designed for use in 35mm on a camera with a sensor that is smaller than a frame of 35mm film, your lenses have *effectively* longer focal lengths. The true focal length doesn't change, of course. The difference between the angle of view in 35mm and in the sensor size you're using is called the *cropping factor*. If your camera has a cropping factor, it will be listed in its manual. Typically for dSLR cameras, they are either 1.5X or 1.6X. A 300mm lens with a cropping factor of 1.5X, for example, is now a 450mm lens.

Q Why are some lenses referred to as normal?

A Some lenses are referred to as *normal* because they share approximately the same angle of view as your eyes. As a result, images taken with a normal lens often feel a bit more natural because they closely mirror the way that you see the world, as in the image shown here.

The focal length of a normal lens is approximately equal to the diagonal of either a frame of film or a digital sensor. In 35mm equivalent terms, this usually means a focal length of about 50mm (although there are normal lenses that actually have an equivalent range of anywhere from 45mm to 55mm). Lenses that are wider than normal are called *wide angle* and those that are even longer are called *telephoto*.

Q What is a fisheye lens, and for what is it used?

A If you've ever seen a goofy photograph of someone's face in which the nose is hugely distorted and seems like it's about to come bursting through the lens, chances are it was shot with a *fisheye* lens. Fisheye lenses are ultra wide-angle lenses that produce a sweeping 180-degree angle of view. Because of their very short focal lengths, these lenses have an almost unlimited depth of field even at very wide apertures.

There are actually two types of fisheye lenses: Circular and full frame. Circular fisheye lenses produce a round image that has a 180-degree angle of view in all directions. These images are wildly distorted because they're round, but you can buy software that converts the circular image to a rectangular format.

The full-frame fisheyes cover the entire frame and produce a rectangular image. They also have a roughly 180-degree angle of view, but only diagonally (corner to corner). The images are still quite distorted, and the horizon in outdoor shots is curved either up or down if it's not kept in the dead center of the image.

Fisheye lenses come in a few different focal lengths depending on whether they are designed for DX or full-frame formats.

Q What is a prime lens, and are they sharper than zoom lenses?

A A *prime* lens is any lens that has a single focal length, and they are available in every focal length from wide angle to super telephoto.

While there are exceptions, in general a good prime lens is almost always sharper than a zoom. This is due largely to the fact that the elements in a zoom lens move (to change focal lengths) while those in a prime lens are fixed. One disadvantage of prime lenses is that if you want to get a closer (or wider) view of a subject, you either have to hoof it to another vantage point or change lenses. In order to fill the frame with these Mexican pots, I had to walk closer to them.

Prime lenses are particularly sharp (and sought after by pros) in both the macro and super-telephoto ranges. They also usually have much faster maximum apertures. It's vastly simpler (and cheaper) to make a prime lens of, say, 200mm with a maximum aperture of f/2.8 than it is to make a zoom with a similar maximum focal length.

Also, some prime lenses (particularly, the shorter ones in the 50-100mm range) are offered at fast speeds of up to f/1.2, which is unheard of in a zoom.

Q Do all lenses have an optimum aperture that is sharper than the others?

A Most lenses have what professionals often refer to as a *sweet spot* — an aperture where the lens performs at its absolute best in terms of both sharpness and contrast. Usually, this aperture is about 2 or 3 stops smaller than the maximum aperture. So, for a lens that has a maximum aperture of f/2.8, it is likely sharpest at an aperture of either f/5.6 or f/8.0. I used an aperture of f/8.0 to make this architectural shot as sharp as possible.

With zoom lenses, however, the sharpest aperture may vary by focal length, so it's worth it to run a series of comparison tests. To do this, simply shoot a series of pictures at several focal lengths. Your camera's metadata records the actual focal length and aperture, but it's still useful to take notes as you go.

Lenses are least sharp when they are used wide open or at their smallest aperture. At the smallest aperture (f/22, for example), lenses suffer the effects of diffraction or a distortion of the light rays created by passing through a small opening. Often, using such small apertures is necessary to gain maximum depth of field, but you have to accept a certain degradation of sharpness with such tiny lens openings.

Q Why should I use the lens shade that came with my lens?

A Using a lens shade improves the color, contrast, and even the sharpness of all of your photos, both indoors and out. By blocking extraneous light from hitting your front lens surface (particularly from the sides), a lens shade significantly cuts down internal lens reflections.

Using a lens shade can also:

- **Eliminate or reduce lens flare.** Lens flare is common when shooting in a brilliant sun, as well as indoors when shooting spotlighted stage acts.

- **Keep lenses and filters clean and dry.** When working in the rain or a dusty environment a shade keeps the front lens element or filter clean and dry.

- **Protect the lens or filter.** I've single-handedly kept a few filter and lens companies in business by banging their products into door frames. It's much cheaper to replace a lens shade than a $100 filter or an even more expensive lens.

BONUS TIP:

It's important to use the correct lens shade on the right lens. If the shade is too long, it will vignette the image.

Q What is the longest zoom range I can get in a zoom camera, and how good is the quality of extreme built-in zooms?

A It seems like any time you pick up a photography magazine these days, you find out that some camera manufacturer has stretched the focal-length range of its zoom camera lenses to previously unheard of limits. Today, zoom cameras with ranges of 10X or 12X are commonplace — several manufacturers even offer zoom ranges of 24X and 36X (currently the longest available in a zoom camera). With a 36X zoom lens, the longest telephoto setting is 36 times the widest focal length. I have a 36X on my current zoom camera (an Olympus SP810UZ). It is the equivalent (in 35mm terms) of a lens that goes from 24mm to 864mm — an extraordinary range by any standard.

While there is no question that certain quality sacrifices are made when such a long zoom range is created, these are usually relatively minor and only noticeable at the extreme ends of the range. For example, edge sharpness is often softer with long zoom ranges and there may also be some minor issues with shape distortion. However, considering the extraordinary flexibility of such long zoom ranges, I am willing to live with those flaws. You can almost always compensate for the minor quality lost by using good techniques, such as a steady tripod, careful focusing, and using a low or moderate ISO speed.

Q Can the lenses from one brand of camera be used on another?

A One of the problems of exclusively buying a particular brand of MILC or dSLR camera is that you tend to accumulate a bag full of lenses over time. As a result, you often find yourself locked into that particular brand when it comes time to buy a new body. However, it is possible (with certain limitations on some models) to use lens adapters to mount a lens of one brand to the camera body of another. With some adapters, you can even use the lens from one camera format on the body of another format, such as using a medium-format lens on a dSLR, or using a dSLR lens on an MILC.

Pricing for lens adapters ranges from the fairly inexpensive (search eBay) to the *very* expensive. Generally, the more you pay, the more electronic communication you retain between body and lens. Also, the higher up the price ladder you go, the better the engineering between lens and body.

Photography magazines regularly review new adapter models and provide the latest info. Here a few things you should be aware of when it comes to using a lens adapter:

- **Mixing formats.** You can get lenses that allow you to cross-pollinate formats. However, because of certain engineering differences, they may not allow you to focus at all distances (some may lack infinity focus, for example).

- **Adapters add bulk.** Some are larger than others, but all add bulk and weight.

- **Not all functions are available.** Some adapters support auto-exposure and some don't.

- **AF-assist Illuminators.** Some adapters activate the focus-assist lamp in the viewfinder, but others don't.

- **No auto aperture.** Many adapters don't activate auto-exposure. This means that you're forced to view at the taking aperture or manually open the lens to focus at full aperture, and then close down. However, the latter only works on lenses that have an aperture ring. One manufacturer that makes adapters with aperture rings is Novoflex (www.novoflex.com).

Q Why would I use a lens filter?

A To some degree, lens filters are less necessary with digital cameras than they were with film cameras because some of their effects are easily duplicated (and often with better results) during editing. For example, most color corrections made by filters are simple to do in editing, but *only* if you edit your own photos. Even if you do your own editing, there are still many good uses for filters, and the effects of certain types (like polarizing filters) cannot be duplicated in editing. The following are some of the primary types of lens filters and their uses:

- **UV/Haze.** Although these are marketed to reduce excessive ultraviolet light or haze from outdoor scenes, their value for that is debatable. However, they do provide excellent protection for the front element of your lens.

- **Warming and cooling**. These are used to alter the overall color balance of an image. Warming filters can add a feeling of warm morning or afternoon light to a landscape. Cooling filters can give daylight filters a twilight or overcast feeling. Most of these shifts and corrections can, however, be made in editing, and with far greater precision.

- **Polarizing.** This type of filter is used to darken skies and remove reflections. I cover these in more detail later.

- **Neutral density (ND).** These filters reduce the amount of light entering a lens. They are great when you want to make very long exposures in bright light — to blur the water in a waterfall, for example.

- **Graduated neutral density.** These filters transition from clear at one side to dense at the other.

- **Special effects.** If you can envision it, someone has made a filter for it — star effects that turn bright point light sources into stars, wild colors, fake rainbows, image softening — the list goes on and on.

- **Close-up.** This type of filter is an inexpensive way to reduce the close-focusing range of any lens.

Q

How do I know what size filter to buy?

A

Lens filters come in two formats: The type that screw onto the front rim of the lens, and the type that slip into a slotted frame that screws onto the lens. The sizes of the round, screw-on filters correspond to the front diameter of the lens and are expressed in millimeters (49mm, 52mm, 62mm, 72mm, and so on). This size is usually inscribed on the front ring of the lens.

The square or rectangular slide-in filters typically come in one size that is large enough to fit most lenses. These slip into a holder that mounts to the front of the lens. The only variable is the size of the adapter ring that mounts the holder to the lens.

Q If the diameters of my lenses are all different, do I have to buy a filter for each one?

A If you own several lenses for your dSLR or MILC, chances are that they each have different front diameters. Unfortunately, it's impossible to buy one size of each filter and fit it directly to all of your lenses. But this doesn't mean that you have to own redundant filters. The solution is to use adapter rings made specifically for this purpose, such as those from Fotodiox (www.fotodiox.com).

Buy the largest size that you need (unfortunately, larger filters do cost more, though), and then buy adapter rings that allow you to step down to the smaller-sized lenses. For example, if your largest diameter lens has a 72mm thread, then you can buy that size and step it down to fit any of the smaller lenses.

Photo courtesy of Fotodiox.

Q

Do I need special filters to take underwater pictures?

A As colorful as some of the plants and creatures that exist in the sea are, a lot of that color is lost in photography because water acts like a giant filter that absorbs most of the warmer (red, yellow, and orange) wavelengths of light. This causes most subjects to look overly blue or blue-green to both your eyes and the camera's sensor.

To complicate things even further, color underwater is absorbed in two ways: By the distance between the surface (and, therefore, the sunlight) and your subject, and the distance between your lens and your subject. The deeper you are and the farther you are from your subject, the more blue or blue-green your subject appears. At a depth of about 25 feet virtually all red light is gone.

The best way to restore accurate color is by placing a *color correction* filter over your lens. These come in various colors and their intensity is generally indicated both by the color and density. Density is indicated in increments of 10, and it typically ranges from CC10 to CC50. The most common color for underwater correction is magenta (usually just referred to as *M*) with those in the CC10M to CC30M range being the most useful.

Q **What is the quality difference between plastic and glass filters?**

A High-quality, glass photographic filters are made from optically pure glass. Plastic filters are made from resin, polycarbonate, or polyester. If you compare high-end, optically pure glass filters to most plastic ones, you'll find that the glass are generally of far better optical quality. However, this does not necessarily mean that one does a better job (warming a scene, for example) than the other. It only means that, in terms of optics, glass is superior. Also, there are different grades of plastic filters. Some resin filters are of extremely high quality, both optically and in their stated effect.

However, it takes a great deal of precision to grind a perfect glass filter, which is why they are expensive. I use B+W filters and it's easy for me to spend $100 or more on one (filters also get more expensive the larger they are in diameter). Why would I spend so much? For one thing, a premium-quality glass filter that is multicoated (to prevent glare and color shifts) doesn't affect sharpness to any noticeable degree. Also, glass is very durable and a well-cared-for filter should last a lifetime — although, some polycarbonate types are also very durable.

But remember: not all glass is created equal. Putting a cheap, uncoated slab of glass on a premium lens will almost certainly degrade sharpness. A good resin or other plastic filter is better than a poor-quality glass one. Something else to consider is how the filter is constructed. Some have the filtration material melted into the glass or plastic (called *dyed in the mass*), while others are a sandwich of glass or plastic with the filter material in between.

Unfortunately, there isn't a simple black-and-white answer to this question. You must take into account the quality of the brand. Also, it would be wise to take some time to read reviews, preferably in professional journals like *Photo District News (PDN)*.

Q

Are there filters available for compact and zoom cameras?

A

Very few compact cameras accept filters directly because they are not threaded to accept the screw-in-type filters or filter holders. Also, in the present market, there are no manufacturers that make filters small enough to fit compact cameras. However, at least one filter company (Cokin) has designed a unique filter adapter bracket that fits any compact camera — all that's required is a tripod socket on the bottom of your camera. The bracket screws onto the bottom of the camera and allows access to the complete line of square, drop-in filters.

Many advanced zoom cameras *do* have a threaded filter ring which allows them to either directly accept the screw-in filters or the drop-in filter holder. Because the diameters of most zoom lenses are smaller than dSLR lenses, you might still have trouble finding filters small enough. However, you can certainly use *step-down rings* to mount larger filters. Some zoom cameras also have a *lens tube* or *lens accessory adapter* that enables you to mount filters and other lens accessories. These tubes usually just slide over the front of the existing lens and have a threaded front so that you can mount filters of a specific size.

Even if you can't find a filter to fit your camera (or the camera doesn't accept filters or adapters) you can still use filters by simply holding them in front of the lens. Because almost all compact and zoom cameras use Through-The-Lens (TTL) light metering, the camera's exposure system sets exposure correctly even with a filter in front of the lens. However, one problem with this is that if you use a peephole-type optical viewfinder, you can't see the scene through the filter because you're not viewing your subject through it.

For creative effects, you can experiment by holding almost any colored, translucent material in front of the lens. For example, a piece of colored cellophane makes a great filter for abstract effects and a piece of window screen softens images.

Q Has the ability to change white balance in-camera and alter color balance in editing eliminated the need for corrective filters?

A If you do your own image editing, there is absolutely nothing that color-correction filters do that you can't do (and probably do better) with almost any editing software. Changes in color balance, hue and saturation, and color temperature can all be made in editing with a precision not available with filters alone.

For example, while you can buy warming or cooling filters for your lens, they are fixed at a certain color temperature. In editing (particularly if you work in the RAW format), you can change color balance in almost infinitesimal amounts. In RAW images, you can even change the color temperature of a scene by 1 degree K.

Q What is the purpose of a polarizing filter?

A The *polarizing filter* is a bit of a miracle in glass. While the effects of almost any other filter can be duplicated in editing, a polarizing filter can do things that you simply can't imitate. They come in a rotating mount and you alter the strength of the effect by rotating the filter (you can see the changing effects in the viewfinder). The following are a few of the many tricks this filter can do:

- **Darken blue skies.** By rotating the filter, you can adjust the richness of a blue sky, and the contrast between it and white, puffy clouds. The effect of this is strongest when the sun is 90 degrees to the direction you're facing. The filter has no effect when the sun is either behind or directly in front of you.

- **Remove reflections.** Polarizing filters remove surface reflections in any nonmetallic surface, such as water, painted surfaces, leaves, foliage, and so on. This is great for shooting photos of store window displays, because it lets you see beyond surface reflections.

- **Saturate color.** Because they remove surface reflections, polarizing filters are able to saturate color to a great degree. They are particularly well suited to subjects like autumn foliage, gardens, and other landscapes.

Q **What are the disadvantages of using a polarizing filter?**

A Compared to the many useful solutions that they provide (like darkening blue skies), polarizing filters have relatively few disadvantages. One is that polarizing filters soak up quite a bit of light — generally about 2 stops are lost when one is used at its strongest rotation. The Through-the-Lens (TTL) meter compensates for the loss, but if you are working with a marginal amount of light, you may be forced to shoot at very slow shutter speeds (requiring you to use a tripod) or increase the ISO setting.

Also, polarizing filters often oversaturate colors and dramatically increase contrast, particularly with blue skies and green grass or foliage. These highly-saturated colors may look nice on your LCD screen and computer monitor, but they are difficult to print. I used a polarizing filter to capture the Florida landscape shown here, but the contrast is so strong I haven't been able to make a good print from the file.

Using a polarizing filter on a very wide-angle lens can also result in a sky that appears darker in one area than another. This is because the effect is often stronger in one part of the sky than another — you can see it on the left side of this image.

Q

What is a neutral density (ND) filter, and why would I use one?

A

Neutral density filters (usually referred to as ND filters) are designed to reduce the amount of light entering a lens. They are called neutral because they affect all colors of light equally and have no affect on color balance. They are sold in various strengths, ranging from 1 to 10 stops or more, but the most popular are those that reduce the light anywhere from 1 to 4 stops.

One reason that you would use a neutral density filter is to enable the use of longer shutter speeds in bright light. For example, when photographing the carnival ride in bright sunlight shown here, the meter gave me a reading of 1/125 second at f/25 (the minimum aperture of the lens). In order to slow the shutter speed (to 1/15 second) so that I could exaggerate the motion, I used a neutral density filter that cut the light by 3 stops.

Similarly, neutral density filters allow you to work at wider apertures in bright light in order to reduce depth of field. For example, when taking flower close-ups on a clear, sunny day, the intensity of the light may prevent you from using a very wide aperture to use the selective focus technique. If you add a neutral density filter, you can open up the lens a few (or more) stops and substantially reduce the depth of field.

Q What is a graduated neutral density (ND) filter, and for what is it used?

A A *graduated neutral density (ND) filter* has the same effect as a regular neutral density filter, with the exception that only half of it has density. For example, when looking at a square graduated filter horizontally, the density begins lightly at the center and then transitions to full density by the time it reaches the top edge. These filters can hold back bright areas in half of a scene, but have no affect on the remaining parts.

Imagine that you're photographing a landscape that has a relatively dark foreground area (a row of mountain peaks, for example) and a very bright sky. If you expose for the foreground without a filter, the sky will completely wash out because it's getting too much light. Similarly, if you expose for the sky, you'll grossly underexpose much of the foreground detail.

By positioning the dense part of the graduated filter so that it only affects the sky (with the density beginning near the horizon), you can hold back exposure there, and balance it between the foreground and sky. Just as with the full neutral density filter, you can buy the graduated type in varying strengths. Some manufacturers also make graduated filters with a color tint so you can warm the sky in an image.

Q **Why do some filters vignette on my wide-angle lenses?**

A Because wide-angle lenses have such a wide angle of view, in some cases using a filter actually cuts off part of the image. This causes a circular dark ring at the outer edges of the frame that is typically most visible at the corners. You may not notice this effect on the LCD screen or in an optical viewfinder, but you will see it once you download and print the image. Drop-in type filters are an even bigger problem because the frame that holds the filters is deep.

While most screw-in-type, circular filters don't cause this problem, you occasionally run into it when using a very wide lens. Some manufacturers sell filters in thinner mounts made specifically to solve this problem. Some polarizing filters may create what looks like a vignette effect, but this is actually the result of the filter having a different effect on different parts of the sky.

BONUS TIP:

Many image-editing programs have an anti-vignette feature that enables you to remove the darker edge caused by a filter or lens shade.

Q What is a Lensbaby, and for what is it used?

A *Lensbaby* is an innovative, fun system of lens accessories for dSLR cameras. They enable you to manipulate image sharpness in some very strange and inventive ways. In its relatively short life, Lensbaby has become extraordinarily popular among creative photographers. I've been using one for about two years. I don't take it out every day, but I have a blast when I do use it.

The Lensbaby replaces your camera lens. Basically, the device consists of a pair of glass elements, each in its own separate collar, that sit in a ball-and-socket configuration. You move each of the elements independently and turn the focus ring manually until you

see the effect you want. The images that it produces have a very sharp sweet spot in the center surrounded by a field of blur. All of the results are abstract and it's impossible to recreate them from one second to the next. The best thing to do is shoot a frame any time you like what you're seeing in the viewfinder.

The Lensbaby has no electronics of any kind, so you must use the device in manual exposure. Also, the meter doesn't function, so you have to guess at exposure and then refine it as you see your results.

Q Which lens accessories extend the zoom range of a zoom camera?

A Although you can't change lenses on a superzoom-type camera, that doesn't always mean that you're stuck with the built-in zoom range. Many camera manufacturers (as well as third-party vendors) sell a variety of accessory optics that mount to the front of a lens either directly or via an adapter tube. Because you are just adding elements to the existing lens, all of the electronics (and usually even the zoom functions) continue to operate normally.

The two main types of accessory lenses available are those that extend the telephoto range or create a more extreme wide-angle view. For example, a telephoto extender might magnify the maximum focal length of the existing lens by a factor of 1.5X. This means that if the longest focal length was, say, 200mm (in 35mm equivalent), with the extension you would have a 300mm lens — a fairly substantial increase. A wide-angle adapter that has the common magnification factor of 0.75X can transform a 38mm lens (again, in 35mm equivalent) into, roughly, a 28.5mm lens.

There are also macro accessories that you can add to substantially reduce the minimum focusing distance so that you can get great macro magnifications, like the image shown here.

Q What is the best way to carry my camera gear?

A I've spent the last 30 years hauling photo gear around the world, and have concluded that the answer to this question depends on how much gear you have, how accessible you need it to be, and how much protection the equipment needs. Other issues to consider are how much weight you're willing to carry and how often you have to plead your case to the people in airport security. Here are some options for carrying a moderate amount of serious photo gear:

- **Shoulder bag.** Bags range from very small to large enough to carry a medium-sized dog. These are great for organizing gear, but bulky to carry (especially in a crowd), and not particularly friendly when it comes to accessing gear quickly. I carry one, but transfer most gear to a smaller bag or a shooting vest once I begin photographing.

- **Hard-shell case.** This option (like those made by Pelican: www.casesby pelican.com) provides the ultimate protection. Pros use them regularly to protect expensive gear on location and when forced to ship gear as luggage. The best are water-, dust-, and crushproof. Some have wheels and pull handles, which are excellent for navigating hotel lobbies and airports.

- **Backpack.** These are great for toting a fair amount of gear into both wilderness areas and the urban jungle. While not as convenient for accessing gear, they are less obtrusive in a crowd and far more comfortable when trekking or hiking.

- **Sling pack.** A morph between the backpack and shoulder bag, sling packs provide the portability of a shoulder bag with easier access to gear. They are good for event or travel shooting.

- **Chest harness.** A relatively recent innovation, chest harness carriers (www. cottoncarrier.com) keep gear close to your body and disperse weight nicely. They are excellent for fast access to gear while hiking and also leave your hands free — very helpful on rugged terrain or when cross-country skiing, hill climbing, or shooting wildlife.

Q Are there any user-friendly alternatives to carrying a shoulder bag?

A Carrying a shoulder bag is cumbersome. I've also never found them to be an efficient way to organize small photo accessories. The best alternative I've found for taking a moderate amount of gear into the field is a photographer's vest. A good shooting vest (which typically costs under $100), like the one shown here, has more than a dozen pockets in which you can stash a tremendous amount of accessories. In mine, I can carry two or three extra lenses, a small flash, filters, memory cards, airplane tickets, a bottle of water, and still have pockets left over.

Vests are a more comfortable way to carry gear because they distribute weight more evenly and there is no bulky bag sticking out from your hip. If you set up a system with the pockets you can stay very organized and reach for a piece of gear without even having to look for it.

BONUS TIP:

Some of the best photographer's vests are actually those designed for fishing and hunting. Check sporting goods and fishing shops when looking for one.

Q What are the essential accessories that should be in every photographer's bag?

A Photographers (myself included) are notorious packrats when it comes to stuffing their camera bags with photo accessories — you just never know when you're going to need an orange filter or a backup flash unit. However, the more I travel around the world shooting, the more I find that there are certain non-photography accessories that are essential to have, and I wouldn't think of going on a shoot without them. Here are five accessories you'll be glad you brought with you:

- **Your camera manual.** It's a terrible feeling to suddenly have a question about your camera (or flash) and realize that your manual is at home. I carry mine in a plastic zipper bag. I also carry 3 × 5-inch cheat sheet cards that I have laminated for quick reference — a list of shortcuts for setting custom modes, for example.

- **Plastic bags**. Having a few black plastic garbage bags can be a lifesaver. In a sudden downpour you can toss your whole camera bag into one and turn another into a makeshift rain poncho. Also, having several clear plastic zipper bags lets you continue shooting in the rain — just poke a hole for the lens and view through the open end of the bag.

- **Penlight flashlight**. These enable you to read tiny camera controls (and your manual) when the sun starts to set. They're also great for finding lost tidbits (like memory cards) that have fallen into the bottom of your bag.

- **A dry hand towel**. Spills and rain happen, and having a soft dry towel handy can actually save a camera from disaster. They also make a clean, dry surface for placing lenses on a picnic bench or rock while changing lenses.

- **A collapsible reflector.** Sold in most photo shops, pop-out-style reflectors are great for bouncing sunlight onto macro subjects or lightening shadows in a portrait. Look for a reversible model with gold on one side and white on the other.

Q

What accessory can I buy to make the image on my LCD screen brighter in sunlight?

A

LCD screens are a brilliant innovation in photography. They've literally changed the way that we take pictures because you can instantly review the results. The problem is that these screens are not easy to see in bright daylight, so it's tough to check things like exposure and critical sharpness. However, there are a few LCD screen viewing accessories available that shade a screen and make it much easier for you to compose and review images, and read menus. Some of these devices physically attach to the camera body, while others are held in place by pressing them against the back of the camera.

The simplest of these viewing aids is a collapsible pop-up hood. It attaches to the back of the camera, and has dark sides that enclose and shade the LCD screen. Some viewing hoods also have a magnifying lens that enlarges the viewfinder, making it easier to see details and fine focus.

The second type of viewing aid is an enclosed viewing hood, like the Hoodman Hoodloupe 3.0, shown here. It has a glass viewfinder and blocks out all extraneous light. While this particular viewer doesn't have any magnification and doesn't permanently attach to the camera, it does have a diopter adjustment for focusing the image on the LCD screen.

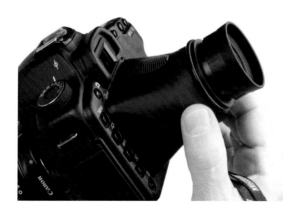

Q **Can I buy a larger accessory LCD screen?**

A One of the limitations of LCD screens on digital cameras is size — manufacturers can't add a built-in screen that's larger than the back of the camera body or the camera itself would have to be larger. The LCD screen on most MILC cameras already takes up nearly the entire back of the camera, and because the objective of that camera design is to make cameras smaller, an LCD screen larger than about 3 inches would be self-defeating. It's likely that this is about as large as on-camera LCD screens are going to get.

One solution that several third-party manufacturers have introduced to beat this size limitation is an accessory LCD screen that plugs into the camera via its electronic (typically an HDMI or USB) port. These screens were originally developed for the video industry, but because video has become such a big part of dSLR cameras, they are now being marketed to the still industry — and are becoming extremely popular. These jumbo LCD panels come in several sizes ranging from about 5 to 9 inches, with the most common and practical being a 7-inch screen. Typically, these screens either mount to your camera via the hot shoe or they can be used on a separate stand or bracket. Most also have their own battery source so they won't drain the camera battery.

Also, because in most cases you can mount the panel to a small ball head, you can aim it in virtually any direction. For example, if you are composing a close-up shot of an insect and need to manipulate reflectors or accessory flash units, you can stand near the subject (in front of the camera) and tweak your lighting to see exactly what the lens is capturing. Having an accessory LCD screen also makes it much easier to focus critically.

Q How do I remotely trigger my camera?

A There are two types of remote controls available for most cameras (made either by the camera's manufacturer or a third-party accessory maker): Wired and wireless. The only real difference is that with the wired variety, you are physically tethered to the camera, which limits your mobility a bit. On the other hand, I've had remotes with a 30-foot cord, so that's not a huge consideration. Cordless remotes operate using infrared technology, like a TV remote, and they generally have a range of about 16 feet. Wireless remotes also require a battery, whereas wired remotes do not.

One of the primary reasons for using a remote control device is to limit the amount of camera vibration during a long exposure. For example, if you're photographing a night scene and using an exposure of several seconds, just the act of pressing the Shutter Release button (even if the camera is on a tripod) may cause camera shake.

For certain types of wildlife photography, a remote control allows you to place your camera on a tripod (near a nest, for example), back away from it once you've composed, set focus, and exposure, and then fire the camera from a distance. This is what I did to get this shot of a great blue heron.

Q How can I trigger my camera with sound or motion?

A Using either sound or motion to trigger a camera can produce some startling photographs that you probably could not capture in any other way — or at least, not as accurately. Some examples of sound- and motion-triggered photos include a bat caught motionless in midair, or a balloon frozen in time, peeling apart as a dart pierces its skin.

By attaching your camera to a motion-triggering device, you can capture photos of birds landing at a feeder without having to sit there and snap the shutter. Instead, you use an invisible beam (typically an infrared, like the one that your TV remote control uses) aimed at the point where you want to monitor motion. Whenever something moves and breaks the beam, the camera fires. You can even attach flash units to illuminate the area of action.

Similarly, a sound trigger uses a small acoustic sensor (a microphone, basically) that fires the camera. For example, if you attach an acoustic sensor to a small board and a mouse jumps and lands on that board, it fires the camera. Probably the most versatile machine for doing this type of work is the Mumford Time Machine (www.bmumford.com), and it's a fascinating bit of technology.

Q How can I charge my digital camera's batteries in my car?

A What a dismal feeling it is to be out on the road and have the last of your digital camera's batteries go dead when the sun is still shining brightly. It always seems to happen to me when I'm far away from either a camera store or an electrical outlet. I clearly remember the sinking feeling of being in the Utah desert, 25 miles from the nearest charger, and watching as my last battery quickly drained. While no charger can give you an *instant* battery charge, having an auto charger with you is very convenient and can often save the day.

Fortunately, a number of companies make brand-specific chargers that either directly plug in to your camera and charge the battery via a USB charger port, or that accept specific camera batteries. I recently found an

AC/DC charger for less than $20 (www.bhphotovideo.com) that charges my Nikon proprietary batteries (that is, the batteries have to be removed from the camera and inserted into a battery-specific charging cradle) very quickly. If your camera uses more generic-type batteries, such as AAs, there are several companies that make universal chargers that charge NiCd and NiMH batteries from your car's cigarette lighter. Trust me: this accessory is worth buying.

Q Are solar chargers available for camera batteries?

A What happens when you're off in the wilderness without either your kitchen AC outlet or your car handy? Enter the greatest power source of all: the sun. Though they are relatively new to the market, several manufacturers are now making very efficient solar battery chargers that have accessories for accepting specific proprietary camera batteries.

How long a camera battery takes to charge with a solar charger depends largely, of course, on the intensity of the sunlight. Basically, the higher the wattage of the solar charger, the faster the battery will charge. For example, a 4-watt charger by Voltaic (www.voltaicsystems.com) can charge a typical 7.4V camera battery in about 5.5 hours, while an 8-watt solar charger can do the job in, roughly, half that time.

Photo courtesy of Voltaic Systems.

Most solar chargers have two necessary parts: A cradle that is designed to hold a specific make and model of the camera battery, and the solar panel. After you insert the battery into the cradle, all that you need to do is plug the cradle into the solar panel to begin charging. Again, the intensity of the sun is a major factor and it's important that you keep the panel aimed at the sun. Obviously, a spot in the Tucson desert is a better spot for charging than a northern forest. Most importantly, begin charging backup batteries *before* you need them to be sure they're ready.

Photo courtesy of Voltaic Systems.

Q What accessories other than a laptop can I use to download images in the field?

A In most situations, a few good-sized memory cards provide all of the image storage that you need for a day's shoot or even a weekend jaunt. However, there are times (when on a long vacation, for example) when having more storage is considerably important. Trying to juggle a lot of memory cards isn't very convenient — nor is hauling a laptop everywhere. That's when owning a portable hard drive comes in handy.

Pocket-sized hard drives, like the Epson P600 80GB shown here, hold thousands of images and allow you to quickly free up memory card space. Transferring images from your memory card to a hard drive is easy — just slip the card into the slot and download the images. You can then view and sort images, view EXIF data, create slide shows, and so on. You can also quickly attach most hard drives to a compatible TV so that you can view images back in the hotel room. On most units, you can also zoom in to check sharpness or look at the histogram for each image to check your exposure results.

When choosing a unit, bigger (screen size *and* capacity) is always better, as are download speed, and the ability to download and view RAW files if you shoot in that format.

Q Are there geo-tagging devices that record the location at which a photo was shot?

A *Geo-tagging* is an electronic function that enables your camera to record exactly where each of your photos was shot by using satellite data to record the longitude and latitude of where you were standing. Today, more and more cameras (particularly compacts) offer geo-tagging, but it's still far more common in cell phone cameras because phones already have that technology built in for other purposes.

The primary advantage of geo-tagging photos is that you don't have to write down where each picture was taken. If you travel a lot and aren't particularly adept at note taking, this is a huge benefit. Different cameras handle the tagging and review process differently. For example, with the compact Fuji FinePix XP30, locations can be displayed either as longitude and latitude, or by the name of the place (these cameras have a memory bank of more than a half-million specific place names from around the world). For example, if you're shooting the Eiffel Tower, that information becomes a part of the image's geo-tag data (not that you wouldn't recognize it anyway, of course). Another cool feature of this particular camera is that you can search all of your photos for that location, and then create an album (using a feature called PhotoBook Assist) of pictures of, say, Notre Dame in Paris.

Geo-tagging can also help you get back to a specific, but ordinary location such as a stream that you stumbled upon during an afternoon stroll. Again the Fuji navigation not only tells you how far you are from that particular spot, but it also shows you in which direction you need to travel to get back there. For someone like me, who rarely remembers where he left his car keys, this is a great feature. Finally, if you own a camera that does not have geo-tagging, there are external geo-tagging devices available that mount to your camera via the hot shoe.

Q Are there housings available that allow me to use my camera underwater?

A Depending on how deep you want to go into underwater shooting, there are a number of waterproof housing solutions available. The simplest are lightweight, flexible-type housings. These are little more than a clear plastic bag that protects your camera to maximum depths of around 15 to 20 feet. They provide very limited access to camera controls and range in cost from about $20 to $100 (see http://www.dicapac.com for examples). If all you need is something to protect the camera around the pool or when splashing in a waterfall, these are great.

If you want to dive a bit deeper, to a depth of around 60 feet (20 meters), there are more sophisticated PVC plastic bag units available. Many of these include an optically clear lens covering so that you're not shooting through a poor-quality layer of plastic (as you are with some cheaper housings).

The best underwater housings are hard-shell cases made of very strong, optically clear polycarbonate. These housings are designed for specific camera models and offer complete access to individual camera controls. The hard shells protect your camera to depths up to 200 feet, and some either accept accessory flash units or have a modular flash housing.

Photo courtesy of Brett S. Foster/Ikelite.

Q Are there any cameras available for sports helmet mounting?

A If you're into any kind of active or extreme sport, you've probably always had the desire to record what you're seeing as you're swooshing along the edge of a snowy mountainside or skimming through rapids in your kayak. The problem is — unless you have three hands — taking pictures while adventuring can be dangerous, not to mention awkward.

Enter the helmet cam! Several companies now make digital cameras (many of which take both still images and video) designed exclusively for mounting to a sports helmet.

Photo courtesy of Derek Doeffinger.

They mount to your helmet via a secure strap and mounting plates. The cameras are usually operated by remote control or (in the case of video) just by turning them on before you begin your adventure. Because the idea is to leave your hands free, some cameras (like the GoPro series: www.gopro.com) also have an interval timer for still shooting, so that the camera automatically fires off a frame at chosen intervals. Of course, most are water- and shockproof, and ruggedly built.

Surprisingly, many of these cameras are very affordable — in the $200 to $300 range — so they won't break the bank (and hopefully you won't break anything, either). Check out www.helmetcameracentral.com for the latest in helmet cameras, reviews, and sample videos.

Q

What can I use to secure my camera in unusual places, such as the handlebars of my bicycle?

A

Your grandfather would probably tell you that he can mount your camera anywhere you want with a bit of wire and some pipe clamp (and he probably could). However, just in case you don't want to ask too many favors of him, there are a lot of existing camera-mounting options. Look through any photo retailer's website, and you'll find a plethora of clamps and devices with which you can mount your digital camera on anything from the handlebars of your scooter to a tree limb — and almost anything in between.

For example, the Manfrotto Super Clamp (www.manfrotto.com) costs under $30, and is one of the most universal and rugged clamps around. It mounts to any round pipe from 0.50 to 2.1 inches, as well as almost any flat or oddly shaped surface you're likely to encounter. It features a built-in socket that holds a series of accessories that allow you to mount virtually anything from your camera to a lighting reflector.

If you perform a specific web search (such as, *bicycle handlebar camera mount*), you'll find tons of other creative mounting solutions. Your grandfather may feel a bit put out by all of the competition, but who knows? Maybe it will inspire him to invent a new mounting method.

Q Which household items make good photo accessories?

A If you were to tip over my camera bag and spill the contents on the floor (and I'll discourage that idea right now), you might be surprised to discover that, in addition to the expensive lenses and camera bodies, a lot of the accessories I carry were not designed for photography. Over the years, I've learned that some of the most useful photo accessories are things you probably already have in your kitchen drawer. Here are five items that you can always find in my camera bag:

- **A covered plastic soap dish.** Sold in camping supply and dollar stores everywhere, these are wonderful for storing small parts, including memory cards, bushings, filters, and so on. They're also good for carrying a few extra dollars, some postage stamps, and subway tokens.

- **A misting bottle.** Use this to spray roses and other close-up subjects with a fine, morning dew mist. This also works with models if you're going for a shiny or wet look. Just make sure you warn them before spraying away. These are also good for cooling your face on a hot day.

- **Mini bungee cords.** These are very inexpensive and excellent for keeping loose things, like A/V cords, together in your bag or fixing broken straps.

- **Electrical tape.** Stuff — like camera straps, shoulder bags, and those comfy old running shoes — falls apart at the absolute worst times. Electrical tape isn't elegant, but it can fix all of those things in a jiffy. It has most of the same qualities as duct tape, but comes in smaller and cheaper rolls (usually, less than $2).

- **Micro screwdriver set.** Hopefully, your camera won't fall apart in the field, but other things, such as eyeglasses, sunglasses, tripod heads, and even the occasional lens flange, do loosen up. You can pick up a set of micro screwdrivers at a dollar store or flea market, or you can spring for a nice set for around $10 on Amazon.

Q

How can I increase the impact of a photo?

A I've always found it interesting that some of the photos that move me the most are those of very simple and ordinary subjects: A rose in a vase, a pear ripening on a windowsill, or a cat napping in the sunlight. What makes a photo memorable is not the subject, per se, but the way that the photographer uses little tricks of composition to intensify the impact. Here are five simple devices that you can use to increase the impact of almost any photo:

- **Fill the frame.** There's an old adage that if you want to increase the power of composition, take a giant step closer to your subject. This is great advice — as long as you're not at the end of a dock! Filling the frame eliminates any doubt about what your intended subject is.

- **Use a simple background.** The less that your subject has to compete with its surroundings, the more obvious it becomes.

- **Find better angles.** Sometimes the angle that first attracted you to a scene or subject is the most powerful. However, in most cases, if you do a bit of exploring you can find a better, even more interesting vantage point. For example, try lying on your stomach to photograph your kids flying skyward on the swings, or hop up onto the picnic table to photograph your dog sleeping in the grass.

- **Use dramatic lighting.** Light is the elixir of photography — the more dramatic the lighting, the more impact the image has. Shoot early and late in the day when the light is at a lower angle, and has a more buttery, warm color. Look for subjects lit from behind and from the side.

- **Break rules.** Surprise is a huge element in good photography, so don't be afraid to do the unusual: Turn the camera on an angle, push the subject up to the edge of the frame, or intentionally blur the subject.

Q Do my photos need a center of interest?

A All photos work best when you are careful to include a single and well-defined center of interest that is immediately apparent to the viewer. If someone looks at one of your photos and has to pause and scratch his head while trying to decipher what you were shooting, then you've failed to communicate the message. The visual story that you're telling should be clear, simple, and obvious.

Making your center of interest stand out is much easier when you're photographing something that is immediately understood by the viewer — a close-up of a flower blossom or a person's face, for example. Things get a bit murkier when you're photographing a less precise subject, such as a scenic landscape or an urban street scene. It's at these times that you need to get bolder in revealing what you had in mind when you snapped the photo by using one of the techniques described in the next FAQ.

It is most important that you don't emphasize two (or more) competing subjects within a frame, such as a person fishing on a dock *and* a passing sailboat. It's fine to include both subjects, but it's also important to find ways to emphasize which one is your primary subject and which is just a supporting theme.

Q How can I emphasize the center of interest in a photo?

A As you consider a particular subject, try to put into a single sentence what it is that you're trying to convey, and be as specific as possible. Instead of: *This is a photograph of a French chateau*, try to share your emotional reaction, such as: *This is a photo of the romantic, fairytale-like tower of a famous French chateau*. That extra moment of thought helps you find ways to emphasize your subject, both visually and emotionally. Here are a few more tips to make your subject center stage:

- **Exploit perspective.** Exploit lines and vanishing points to draw the viewer into the scene. Roads, a row of lampposts, or an old stone wall all make good lines to lure the eye.

- **Use frames within frames.** Look for naturally occurring frames — a low-hanging limb or a garden gate — to accentuate and isolate your subject.

- **Manipulate focus.** Selective or restricted focus is a powerful way to focus attention on a particular subject. If you focus on a single flower blossom, you hint at a garden setting but call the viewer's attention to that one blossom.

- **Use contrast.** Stark contrast between your main subject and the background, as in the silhouette shown here, is a great way to clarify your main subject.

Q **Where is the most effective place to position a subject within the frame?**

A Placement of your main subject within the frame is a powerful, but often overlooked, aspect of composition. Because the primary focus indicator mark is at the center of the viewfinder, it's easy to get lazy and leave your main subject right in the middle.

The problem with centering a subject is that it's a very stagnant design choice. Leaving equal amounts of space around your subject prevents the eye from exploring the scene, and you also eliminate any element of visual surprise. Placing the subject slightly off-center (as shown here with the drinking fountain) not only introduces an element of surprise, but forces the eye to explore the entire frame. Off-center subjects tend to make the viewer visually curious, and they're also much harder to resist.

By placing your subject above the center-line of a composition (as shown here in the shot of the wildflowers), the eye tends to begin at the bottom and work its way toward the subject. If you place your subject at the bottom of the frame, the eye first looks at the main subject, and then explores its surroundings.

Q What is the Rule of Thirds?

A The *Rule of Thirds* is a compositional technique that artists have been using for centuries to help strengthen off-center subject placement. As much as I try to avoid any concept that contains the world *rule*, this particular design device works exceedingly well and, in fact, is fairly instinctive for most people.

Essentially, you create an imaginary grid over your composition that divides the frame into thirds both horizontally and vertically. By placing your primary subject where the horizontal and vertical lines meet, you create an off-center subject placement that has a natural sense of balance. For example, in the shot of the ibis shown here, the placement of the bird at an intersection of thirds helps to establish equilibrium of visual weights between the smaller, brighter area and the large, dark area of water. Also, by giving the bird room to move into, it helps create a feeling of impending action or tension.

The horizontal thirds lines are also useful in a landscape composition because they help you find a pleasing placement for the horizon. For example, placing the horizon at the top horizontal division emphasizes the foreground area; placing the subject at the bottom third calls attention to the sky.

Q How do I lock the focus with an off-center subject?

A After you find a good off-center placement for your main subject, locking the focus is simple. Many digital cameras provide a selection of focus-indicator marks. When you tell the camera which mark to use, and then place the subject behind that mark, the camera automatically focuses on that area. As long as you keep the Shutter Release button partially depressed — as I did when photographing this saguaro cactus — the camera maintains sharp focus on that point.

However, with cameras that have only a central focus-indicator mark, you must first focus using that indicator, and then recompose. The only way to do this and maintain sharp focus is to lock the focus by keeping the Shutter Release button partially depressed. On many dSLR cameras, there is a separate button that enables you to lock focus. Press it once to hold focus and it will remain fixed until you press the button again.

One advantage of a separate focus lock is that it frees you from having to keep the Shutter Release button partially depressed. Another advantage is that the exposure-lock feature is separated from the exposure lock (they are combined on the Shutter Release button-type lock) so that the camera corrects the exposure while you recompose the scene.

Q How do I know when to hold the camera vertically or horizontally?

A Because it's more convenient to hold a camera horizontally than it is to hold it vertically, most of us shoot a lot more horizontal (or landscape) photos. Even in my own photography, I notice that the vast majority of my photos are horizontal.

I sometimes have to force myself to consider a subject as a vertical (or a portrait) — even when I know that it would work better that way.

However, many subjects — such as trees, sailboats, and tall people — are vertical by nature and cry out to be framed as such. Vertical framing not only enhances the height of tall subjects, but it also helps lead the eye into the frame. Psychologically, people almost always study a horizontal photo from side to side and a vertical one from top to bottom (or bottom to top). So, anytime that you want to lead someone's attention vertically through an image, using that orientation will help.

If you're uncertain about which format would work better, remember that digital is free and it won't take anything but a few extra seconds to shoot a subject both ways.

Q What are artists and photographers talking about when they refer to the design elements within a landscape scene?

A Every scene, regardless of what the specific subject happens to be, is made up of certain *design* (or *graphic*) *elements*. Sometimes, these elements are the very thing that piques your mind's curiosity and makes you want to explore a subject further. The following are the five primary design elements found in most scenes:

- **Lines.** Roads, fences, trees, telephone poles, and even the spokes on a bicycle, are all examples of strong lines. Lines can lure the eye into the frame or direct it to different areas of a composition.

- **Shapes.** Shapes are very powerful design elements because you can often recognize an object based on its shape — a bicycle, a seagull, and a saguaro cactus are all excellent examples of shapes. Shapes work best when they are shown against a simple background — such as a silhouette.

- **Textures.** Whether it's the satin smoothness of a wedding gown or the splintery texture of worn barn wood, all objects have texture. Revealing textures gives photos a tactile quality.

- **Colors.** Colors, particularly the bold and brash, can be a very powerful design element. Often, just contrasting two bright colors — a yellow lemon in a bright blue bowl, for example — is enough to create a startling design.

- **Patterns.** Patterns exist all around us in nature and man-made objects. Isolating patterns by viewpoint and cropping can create very powerful compositions.

Q How important is it to emphasize one visual element within a scene?

A Although visual design elements rarely appear alone, one often dominates a subject or scene. By exploiting its strength, you can turn a mundane subject into a very powerful photo. One classic example of this is taking a close-up of tree bark to reveal its rough, tactile surface texture. By isolating a section of bark you exaggerate its coarseness, and people can almost feel the rough tree just by glancing at your photo. By focusing on a single graphic element, you leave no doubt as to what is the subject of your photo, and you delve past casual appearances to reveal the more graphic nature of your subject.

The trick to emphasizing one graphic element is to frame it tightly enough so that you carefully isolate that element and eliminate any clutter that might dilute its impact. If you want to draw attention to a pattern — such as when photographing a spider web — including anything that is not a part of that pattern draws the viewer's attention away from it.

With some graphic elements, you can exaggerate the impact by contrasting them with something else. For example, in the shot shown here of a woman's hand and the saguaro cactus, the roughness of the cactus accentuates the smoothness of the skin and vice versa.

Q What is a vanishing point?

A If you've ever stood on a train platform looking down the tracks, you've no doubt noticed the illusion that the parallel tracks seem to converge in the distance. The point at which they appear to meet is called the *vanishing point*. Although your brain knows that the lines don't actually meet (pity the poor train passengers if they did!), distance makes the lines appear to grow increasingly closer together. By knowing this, you can exploit that common illusion to establish a greater sense of distance. You can heighten the impact of converging lines further and make the vanishing point more obvious by using a wide-angle lens. I did this in the shot shown here by using a 24mm lens.

Q What is the difference between shape and form?

A The difference between shape and form is that shape simply describes the outline of an object: Is it square, round, oval, or organic? Shapes translate well to two-dimensional, photographic images. For example, you don't need anything beyond the profile of New Hampshire's iconic Old Man of the Mountain rock formation (which has now fallen, incidentally) to identify it. The shape is so familiar that anyone who has seen it recognizes it immediately.

Form occurs whenever you add a third dimension to a shape — plumping up the turkey so to speak and that is usually a result of using lighting to reveal the three-dimensional qualities of the subject. When people look at a photo that has a sense of form or volume, they often imagine that they feel the bulk of the object, or get a sense of heft and three dimensions.

Adding form to shape makes your photographs appear more realistic and tactile because you help the viewer imagine that he is handling the object. Whether to reveal form is often a choice that you make. It's fine to limit your image to two dimensions as a shape, and you are free to include form or intentionally obliterate it. In the photograph of the weather vane shown here, I took advantage of side lighting to add form to the distinctive shape.

Q **What techniques can I use to emphasize shapes?**

A All objects have a shape, but some are much more recognizable than others. For example, you know the shape of a house key in your pocket well enough to retrieve it unseen.

The first step in photographing a shape is to find an object that has a familiar and nicely defined outline that can easily be identified. You don't need anything more than the collection of shapes shown here to recognize that this is a family and their dog at the seashore. Without any hint of texture, color, or even form, a 5-year-old could quickly identify every shape in the composition.

The trick of photographing shapes is finding ways to isolate them so that they become the star of the show. One of the best ways to do that is to contrast it against a very plain background. You can do this in a powerful way by turning the object into a silhouette. By placing an opaque (non-transparent) object in front of a bright background, and then exposing for the background, you can reduce any object to its purest, two-dimensional outline. Silhouette artists are able to make recognizable paper cutouts of people just by capturing the shape of their profile.

Q How can I emphasize the volume and heft of a subject?

A Heft occurs whenever you fatten up the shape of an object to reveal its three-dimensional qualities. When people look at a photo that has a sense of volume, they imagine feeling the mass and bulk of an object. The best way to reveal those qualities in a two-dimensional photograph is with lighting. Lighting an object from an obtuse angle casts shadows on the surface of the object and reveals its true, three-dimensional proportions.

Easily, the best type of lighting for revealing form and volume is side lighting. Lighting coming from the side, particularly with round objects like the group of pumpkins shown here, reveals not only their familiar shape, but their plumpness as well. You get a sense of how heavy they might be to lift.

Similarly, in the shot of the Korean War Memorial shown here, I used late-afternoon light coming from the side of the sculpture to bring out both its fullness and texture.

The worst type of lighting for revealing form is front lighting because it eliminates all surface shadows and, instead, gives more emphasis to the object's flat, two-dimensional outline.

Q How can I emphasize surface textures and prevent them from disappearing in my photos?

A Textures in a photograph are created by myriad tiny (and not so tiny) shadows on the surfaces of objects. There are a variety of textures that you can exploit. The following are a few of the most common:

- **Surface details.** Every rough surface, from tree bark to sand on a beach, has a texture that can be revealed and exploited. Close-up photography is a great source of surface textures that are often overlooked in a broader view.

- **Environmental surfaces.** One way to reveal the true physical character of a place is to include large areas of texture, such as the rocky cliffs of the Maine coast or complex textures of a desert landscape. The more textures you reveal in a landscape, the more real the place feels to your viewers.

- **Comparisons.** Perhaps the most interesting way to use textures is to find a way to compare the various surface textures in a scene. For example, you could capture the contrast between a pair of weathered old hands sewing a piece of satin fabric.

The best way to reveal any type of texture is through lighting contrast. Whenever light strikes a surface at an obtuse angle, it produces a contrast between highlights and shadows that creates texture. Light from the side is particularly good for creating surface textures, and is best captured early or late in the day.

Q What is the best way to reveal patterns?

A Whether it's frost patterns on a window pane glistening in the morning sun or a spiral staircase winding its way up the side of a lighthouse, patterns are terrific subjects to discover and photograph. Whether natural or man-made, patterns are created whenever certain types of visual elements repeat themselves in some regular and recognizable way. Almost any type of repetition creates a pattern —

shadows, textures, shapes, colors, and so on. For example, when photographing the fronds of the fern shown here, I was fascinated by the amazingly formal repetition of spiral compartments within the shell.

The key to capturing dramatic photos of patterns is to isolate them from their surroundings. Anything that isn't a part of the pattern should either be eliminated or subdued so that the pattern itself takes center stage. The best way to isolate a pattern is to simply fill the frame with it, either by zooming in tightly or just moving closer to it. You can also heighten the impact of a pattern by choosing a viewpoint that contrasts it with its surroundings — such as positioning the intricate patterns of a spider web against a dark shadow background. Focusing carefully on only the pattern with a limited depth of field is another useful trick.

Q Why do photographers advise against dividing a frame exactly in half?

A One of the rules you often see in books about photographic composition is that you should never place the horizon exactly across the middle of a landscape photo. This is because a photograph that is divided exactly in half creates a stagnant composition in which neither the top nor the bottom has more visual weight. It also creates a photo in which the top and bottom halves compete against one another.

It's true that when you cut a photo in half, you also divide the viewer's attention in half. Often, you end up with a shot in which neither the foreground nor the background is particularly dominant. For example, when a scenic photo has a pronounced foreground or exaggerated sky area, natural curiosity draws the viewer's eye into the shot. Without that imbalance, the image becomes somewhat predictable.

However, there are times when creating a perfect balance of foreground and background — such as when shooting a landscape with a reflection — is actually dynamic and interesting in its own right because the eye is very attracted to symmetry. For example, in the winter pond scene shown here, I intentionally cut the frame in half because I like the mirror-like reflection. I thought it gave the scene a Norman Rockwell-like, illustrative feel.

Q How can I take good night photos without a tripod?

A The single best accessory that you can own to improve the quality of your night photos is a tripod. However, carrying a tripod around at night — especially if you're traveling — is not particularly convenient. Fortunately, you can get very high-quality night images without one if you choose the right settings and pay attention to a few other simple techniques. Here are some tips that can improve all of your handheld night photos:

- **Use night exposure modes.** By selecting the Night Scene or Night Portrait exposure modes, your camera automatically biases its exposures for night scenes. In the Night Scene mode, it sets a longer exposure to record city lights or other night lighting. In the Night Portrait mode, the flash fires to light your nearby subject correctly but also leaves the shutter open long enough to record some ambient lighting.

- **Select a high ISO speed.** If you are using the Programmed Auto exposure mode (or any other basic exposure mode), setting a higher ISO enables you to record even relatively dim city lights.

- **Use fast lenses.** While zoom lenses are very convenient during the day, fast (large-aperture) prime lenses with large maximum apertures are better at night because they let in much more light. An f/2.8 lens, for example, let's in twice as much light as an f/4.0 zoom lens, and four times as much as an f/5.6 lens.

- **Steady the camera.** Rest your elbows on (or place the camera directly on) a porch rail or a car fender to exploit longer shutter speeds. I've gotten sharp photos using exposures as long as 1 second this way.

- **Get abstract.** If you simply can't get a shutter speed that's fast enough to provide a sharp handheld photo and still record the night lights properly, forget sharpness and use long shutter speeds to create abstract visions of the night. Try using long exposures to let traffic patterns turn into bright, meandering streaks of light.

Q How do I know which ISO setting to use for night photos?

A The ultimate goal of setting the right ISO for night photography is to find a setting that provides a fast enough shutter speed to work handheld (if you are working handheld) and create minimal image noise. If the setting is too low, you get less image noise, but you may not get shutter speeds that are fast enough or at a small enough aperture to provide the depth of field that you need. On the other hand, if you set a speed that is too high, image noise may become a factor. It's a balancing act that must be solved through experimentation and studying your results.

One decision that you have to make is whether you want to let the camera select the ISO speed for you or choose the setting yourself. In the auto-ISO mode the camera measures the existing lighting and automatically sets the ISO speed. On some cameras, the chosen ISO is displayed, but unless you pause to look at it (and most of us rarely do), you're just going on faith that the camera has selected the optimum speed for the conditions. Therefore, you won't know until you see the results whether the camera made a wise decision.

The alternative is to enter a speed yourself and then examine your results on the LCD screen to see if *you* made a wise decision. The specific speed you need depends on the amount of existing light and the speed of your lens. A typical city street scene at night records well at ISO speeds between 800 and 3200, with speeds in the lower half of that range providing acceptable noise response.

If you are trying to manipulate motion, then the ISO speed may be dependent on whether you want to stop action with a high ISO (and therefore have access to faster shutter speeds) or exaggerate motion by using a lower ISO (and longer exposure times).

Q How do I expose for neon signs?

A There are few night subjects that are as colorful and fun to shoot as neon signs. You can find good neon subjects in almost any strip mall. Restaurants, bars, liquor stores — they're all great sources for neon signs.

Exposing a neon sign is fairly straightforward. In most cases, there is enough light to shoot at a relatively low ISO of 100 or 200, and still shoot handheld. Matrix metering does a good job of metering neon correctly, and there is usually enough latitude in exposure to get a good shot in almost any exposure mode. I've noticed when shooting lots of neon that the color intensity fades quickly if you overexpose the sign. I tend to use about 1 stop of minus exposure compensation to saturate colors.

If you're photographing a neon sign in a store window, try to wait until the store is closed. If there are interior lights on, it's difficult to get a black background for the sign. Design-wise, in addition to taking one overall shot of a sign, I also spend time investigating for interesting detail or abstract shots. Make sure that you ask permission to shoot if the business is open, so that you don't arouse any suspicions.

Q What is the best way to expose for fireworks?

A In many ways, how you approach photographing fireworks depends on what type of camera you're using and what exposure options are available to you. If you're using a dSLR that has Manual exposure and a *Bulb (B)* setting (that is, a setting that lets you open and close the shutter at will), the most flexible method with which to shoot fireworks involves a tripod and long exposure times. By opening the shutter as the rockets take to the sky, you can capture a series of bursts on a single frame, and then close the shutter when you feel you've captured enough. Use a low ISO speed of around 100 or 200, and a moderate aperture of around f/8.0 or f/11 to keep the bright explosions from washing out.

If you're shooting with a simpler camera that doesn't have a time-exposure mode, you can still get good shots. Manually set the ISO to a speed of 400 or 800 (the auto-ISO mode probably won't work because the bursts are too short for the camera to make an accurate brightness determination). Next, simply wait for a burst to appear in the sky and fire off several exposures in rapid succession. You'll get a lot of near misses, but you'll also get a few winners.

Q How do I create streaks of light from traffic?

A I first saw this night-exposure technique in a photo magazine when I was a teenager and couldn't wait to try it. All that you need is a dark location with a moderate amount of traffic, a steady tripod, and a good vantage point. I prefer high vantage points, like highway overpasses or a hill beside a busy road, because they allow you to look down on the pattern of light as it streaks through the frame.

To make this exposure, set your camera to Manual exposure mode (if it has one), and then set the shutter speed to Bulb (B). Again, in that position the shutter stays open from the time you press the Shutter Release button until you release it. It's helpful to have a locking cable release that lets you lock the shutter open for as long as you need because it reduces vibration and the risk of blurring the stationary parts of the shot. Keep the shutter open until you feel that you've captured a plentiful and interesting number of light streaks. Visually, it's usually best to open the shutter before traffic enters the scene and keep it open until it's passed all the way through the frame; otherwise, you'll have a lot of partial streaks in the shot.

Q How can I capture star trails?

A You have probably seen examples of this type of time-lapse photography in magazines like *National Geographic.* It can create some intensely interesting images of stars swirling through the night sky. The toughest part about photographing star trails is finding a sky that is dark enough to make the necessary exposures without any interference from city lights or traffic. Ideally, a wilderness location works best, but I've seen a lot of nice star trail photos created in suburban backyards. Also, you're better off working on a moonless night so that the moonlight doesn't make the sky too bright.

The first thing that you need to do is set your lens to Manual focus, and then focus the lens on infinity. Next, compose the shot. Even though what you are photographing here are the light patterns of the stars, these shots usually work best when you have some sort of terrestrial foreground frame — such as a hillside tree or a mountain peak. The final step is making the exposure. Typically, an exposure for star trails ranges from about 20 minutes to several hours depending on the length of the trails: a longer exposure time means a longer trail. The only way to keep the shutter open this long is to put the camera in the Manual exposure mode and use the Bulb (B) setting.

One thing (and probably the most important) that you should remember is to be cautious about the weather when shooting star photos. If you're planning on leaving your camera out in your backyard while you go inside to take a nap, make sure that it isn't going to rain. Also, because digital cameras require a battery to keep the shutter open, make sure that you start with a fresh one or the shutter will close when the battery dies.

Q How do I expose for carnival rides at night?

A Chills and thrills (and the occasional scream) aside, the three main ingredients that make carnival rides such a fun subject are light, color, and motion. While it's possible to simply bump up the ISO to 800 or 1600 and get stop-action shots of rides, it's even more fun to use a tripod and a long shutter speed to exaggerate their motion and turn the lights into streaks of swirling color. Because you must use a long exposure anyway, you get better quality if you leave the ISO at its default (slow) speed, and then set your camera to its Shutter Priority exposure mode.

The actual shutter speed that you should use depends on the speed of the ride and the degree of motion that you want. However, speeds ranging from 1 to 30 seconds produce interesting results. I used an exposure of 30 seconds to get this shot of a Ferris wheel.

BONUS TIP:

For the best results, shoot rides at twilight just as their lights are turned on or include more than one ride in the frame.

Q Why does the moon look so small in my night photos?

A Often, photos that include the moon (even when it's full) are disappointing because the moon appears much larger in person than it does in photos. Part of the reason is that the moon is, well, *far away.* It takes a big telephoto lens to make it look large in a photo. Also, when you see the moon in person, you're so focused on it mentally that it seems larger than it is. Here are a few tricks that you can use to make the moon look bigger:

- **Use a long lens.** A telephoto lens or zoom setting of 200mm makes the moon look four times larger than a normal lens; a 300mm makes it appear six times larger. Use the longest lens that you have. I used the equivalent of a 450mm lens to capture this shot.

- **Include a land reference.** Normally, the moon is viewed through tree branches, over a sandbar, and so on. Foreground land references make the moon seem closer and larger.

- **Fake it in editing.** You can enlarge the moon a lot in editing or crop a frame to make it look bigger. You can also blow it up and include it in a montage with another related scene, such as over a city skyline.

Q Why do my shots of the moon look like a white circle with no detail?

A The reason that photos of the moon have no detail and appear as a white hole in the sky is because they are being overexposed. Remember, even a very bright full moon is typically surrounded by a lot of dark sky, and that darkness fools the camera's metering into providing *too much* exposure. The solution is to meter the moon and not the sky. One way to do this is to switch to either the Center-weighted or Spot metering mode. Either of these modes can eliminate much of the dark sky and bias the exposure for the moon itself.

Another solution is to take a Matrix meter reading, and then use a few stops of minus exposure compensation. The actual amount of underexposure could range from 2 to 4 stops or more, and then you just experiment and check your results on both your LCD screen and your histogram. Also, if your camera has auto-exposure bracketing, try a custom setting that brackets it only toward underexposure, such as shooting a series of five exposures that are each 1 stop less than the previous.

Q How can I photograph a landscape using only the light from the full moon?

A Landscapes and other scenes illuminated solely by the light of the moon can be extremely pretty and ethereal looking, and they are fun subjects for experimentation. The best times to shoot are the two days prior to or after a full moon. It's also best to wait until the moon is at least 30 degrees above the horizon so that it illuminates the landscape evenly. Meter readings won't be very reliable, so it's often better just to guess at exposure times and make test exposures using ISO speeds of 800 or 1000, and a moderate aperture of f/5.6 or f/8.0. If you use higher ISO speeds, image noise will likely become an issue, and if you use apertures smaller than these, your exposure times will be excessive. Exposures will be anywhere from 10 seconds to several minutes (scenes that include water or snow will be somewhat shorter).

I prefer to work in Manual exposure mode and shoot in the RAW format so I can adjust white balance and exposure afterward. While a tripod is necessary for sharp images, it's fun to experiment handheld with long exposures and intentional blur. I photographed this fisherman by the light of the moon reflecting off of the sea and used a 10-second, handheld exposure.

Q How can I capture photos of lightning?

A My initial response to this may sound flippant, but it's the truth — you must photograph lightning *very carefully*. Lightning should only be photographed from a great distance (at least 6 or 7 miles), and never if a storm is actually upon you. Always photograph a passing or retreating storm rather than an advancing one. If a storm is advancing toward you, take cover and forget about photography.

Photographing lightning is similar to photographing fireworks in that you can never be certain exactly where in the sky it's going to occur. Also, it's nice to have a foreground of interest — such as a city skyline or a mountain peak. The following tips will help you increase your *keeper* shots:

- **Shooting at night.** Set your camera on a tripod, aim it at a likely area of the sky, and then — using the Bulb (B) exposure setting in Manual exposure mode — open the shutter as soon as a streak begins. Most lightning streaks last for a few seconds, so even if your timing is off by a second or two, you will likely still capture a good display. To capture a series of streaks in a single frame, slip the lens cap on between streaks (to subdue ambient light) or hold a sheet of black cardboard in front of the lens between flashes.

- **Shooting in daylight.** This is more complicated because you have more ambient light that washes out your photos. You are better off shooting single streaks and waiting until you see the streak begin before tripping the shutter.

- **Lens choice.** A wide-angle lens enables you to cast a wider net at the sky and improves your odds for capturing the streaks.

- **Lightning Trigger.** If you live in an area where lightning is particularly common and dramatic, there are also devices like the *Lightning Trigger* (www. lightningtrigger.com). This accessory mounts to your camera's hot shoe and automatically triggers the shutter when there's a lightning strike.

Q What is the best time to shoot city skylines?

A Although it's natural to look at most city skylines and think that they were shot in the darkness of night that is probably the worst time to shoot one. The problem with shooting skylines at night is that the contrast between the building lights and the surrounding darkness is far too intense. Essentially, all that you're seeing are bright city lights against a vast curtain of darkness.

The prime time for shooting skylines is just after the sun has set and the city lights are starting to flicker. Most city buildings have their lights on almost all of the time (people are working in them, after all) and so you really don't have to wait for the lights to turn on. By shooting at twilight, you moderate the contrast because the building facades are still illuminated by light from the setting sun (especially if the skyline is facing west) and, often, there is a pretty sapphire blue sky. I shot this view of Manhattan's financial district (from the New Jersey side of the Hudson River) just as the sun was falling below the horizon. You can see the pretty sunset colors reflecting off of the glass in the buildings.

Q How do I create the zoom effect at night?

A Photographers are, generally, clever and creative, and it probably wasn't more than a few moments after the first zoom lenses were introduced that they figured out how to create what has become known in photo lingo as the *zoom effect*. This technique turns whatever you're photographing into radiating streaks of color and light. You create it by changing the focal length of a zoom lens from one extreme to the other during a time exposure.

You can use this technique day or night, but I particularly like the look of city lights zoomed at night. It doesn't matter whether you zoom from wide angle to telephoto or vice versa. I prefer to change focal lengths with a twist-style zoom lens as opposed to a push/pull arrangement. It's best to use the Shutter Priority exposure mode because you want to dictate exposure times, and aperture and depth of field are arbitrary considerations.

Exposure times depend on the brightness of the lights, what ISO speed you're using, and how much you want to zoom the lens. Exposures in the 1/4 to 1 second range are good because shorter times won't allow you to zoom adequately, and longer times don't offer any creative advantage.

Q What does the term light painting mean?

A *Light painting* is a technique that photographers use to *paint* areas of a nighttime scene (or a studio shot) with a variety of light sources during a long time exposure. This technique is used partly for artistic reasons because it creates an interesting look. However, it also often solves the problem of selectively lighting very small areas of a scene that would be difficult to light any other way.

For example, when photographing the night-blooming cereus shown here, I tried using flash both on- and off-camera, but didn't like the results. Instead, because I was working in total darkness, I opened the shutter, painted the blossom with a penlight, and then popped my accessory flash briefly at the end of the exposure. It took a few tries to get a look that I liked, but all of the frames were somewhat interesting.

Light-painting results are entirely unrepeatable, but it can be used to illuminate anything from a friend sitting on the beach at night to large nighttime landscapes. Professional photographer Troy Paiva (http://lostamerica.com) is a master of light painting. He has taken thousands of photos of things like abandoned cars, motor homes, and even jetliners, and used various light sources to paint them.

Q **Why is midday the worst time to shoot most types of outdoor photos?**

A The problem with midday light is that it is harsh. Harsh lighting means unforgiving contrast, deep shadows, and, often, blown-out highlights. It depends, to some degree, on the season it is and on what part of the globe you happen to be, but the hours between about 11 a.m. and 1 p.m. are unquestionably the most challenging in terms of exposure. Often, the contrast during these hours exceeds the camera sensor's dynamic range.

For example, in the shot of a beach snack bar shown here, the shadow of the roof is almost totally black with virtually no discernable detail. Also, because of the extreme contrast, I had to expose to hold detail in the highlights. That, in turn, made the shadows even darker. Had I lightened the exposure even a single stop, the whites would have been completely washed out.

The other problem with midday light is that, because the shadows are cast downward, they provide no help in modeling with most subjects, and the lighting does little to reveal surface textures and details. Probably the worst subjects to shoot at midday are portraits because the overhead light casts very unflattering shadows under eyebrows, noses, and lips, and the brightness causes people to squint a great deal.

Q What are the best times of day to shoot outdoor photos?

A For almost all types of outdoor scenes — from landscapes, to portraits and close-ups — I find that the lighting during mid-morning and mid-afternoon is very attractive, and mercifully absent of the challenges presented by more extreme times of day. During these in-between times of day, the sun is neither directly overhead nor at too acute of an angle. Surface textures are more drawn out, and shadows add depth and interest to landscapes. However, these are not the extreme textures or shadows of the early morning or late afternoon. In portraits, skin tones during these hours are also warmer and give subjects a healthier, more relaxed look.

Also, the color of the light is warmer during these hours, but you don't have to constantly consider the extreme warmth as you do during the golden hours. Another thing that I like most about these in-between times of day is that the lighting changes much more slowly, in both direction and intensity, than it does very early or late in the day. For example, when photographing these garden steps, the slower pace allowed me more time to consider the composition and design, without feeling the need to rush to capture a fading, late-afternoon light.

Q How does the time of day affect the color balance of my photos?

A The color of daylight changes so imperceptibly, we rarely notice it as we go through our day. However, in photographs, those changes are much more obvious. As the color of daylight changes, so does the coloration of the landscape around us. A grassy meadow that glows with a pinkish hue at dawn may appear distinctly yellow or gold later in the day. At noon, that same scene would probably record as very neutral in tone.

The color of light is rated in degrees Kelvin, a system named after William Thomson, also known as Lord Kelvin (1824-1907). Color temperature numbers increase as the color of light goes from red to blue (from warm-toned to cooler) and vice versa. For example, daylight ranges from about 5000-5400K, depending on the time of day, and is considerably cooler (more blue) than tungsten lighting at about 3200K. You can manipulate the color balance of daylight in your photos by adjusting your camera's white balance to either enhance or reduce the colorcast caused by different times of day.

The color of daylight changes the fastest at the beginning and end of the day (and before or after a storm). During these times you can capture significant shifts in color balance in a fairly short period of time.

Q What is the golden hour?

A Photographers and artists often refer to the first hour after sunrise and the hour before sunset as the *golden hour* because of the strong golden color of the daylight at these times. This time frame is a favorite among landscape photographers because it tends to bathe scenes in a rich, romantic glow.

Sometimes, the golden hour can be extremely intense — the kind of light that makes you stop on the way home just to admire its lush beauty. Golden hour light is especially dramatic before or after a storm, when the warmth of the light is contrasted against a rich blue-gray sky. It's also particularly dramatic in areas like the Southwest, where it ignites the colors of red rocks.

> **Q** How does lighting direction change the look of a landscape scene?

A The direction of sunlight falling on a landscape has a profound affect on how things like distance, surface textures, and the general shape of the land are interpreted. Although you can't control the direction of daylight, often just waiting for the light to shift a bit from one direction to another can make or break an outdoor scene.

You can also walk around the subject to change your relative direction, or hop in the car and drive to a new vantage point. I often scout landscapes during the midday doldrums and, estimating the position of the sun later in the day, drive around until I find the best shooting position. Once the sun gets lower in the sky, the lighting direction shifts quickly, so having your shots planned ahead of time is very important.

The following are the four primary directions of light:

- **Top light.** This is easily the most horrid light for landscapes. The lack of shadows and glaring highlights offer few redeeming qualities. I accept top lighting only as a last resort when I can't return to the scene later. I'm almost always disappointed with the results.

- **Front light.** Light falling on the front of a subject can sometimes be attractive, but these scenes tend to lack depth because shadows fall behind your subject. There are a few advantages to front light that I discuss in the next FAQ.

- **Side light.** Light illuminating a scene from the side is wonderful for drawing out textures and revealing the three-dimensionality of outdoor scenes. I shoot most of my landscape photos with light coming from the side because I love the sculptural and nuanced appearance that the shadowing creates.

- **Backlight.** Light coming toward the lens adds a lot of depth to landscapes because elongated shadows extend toward the lens. Backlight is also good at revealing surface textures, though often important parts of a scene get lost in shadow if the lighting is too intense.

Q What are the advantages of front lighting?

A Front lighting is what your dad was advocating when he advised you to always shoot with the sun coming over your shoulder. For certain situations, he was right. Front lighting is most prevalent early and late in the day when the sun is low on the horizon. On clear days, when the light is bold and direct, it can positively ignite colors.

Because it casts shadows behind subjects, though, front lighting is not great for creating texture or form. It often gives subjects a paper-cutout look. However, this can be pretty with color shapes, like the lobster floats shown here. Also, because the light falls evenly on your subject it makes exposure a piece of cake — and that's exactly why dad gave you that advice.

Q Do backlit scenes require any special exposure techniques?

A Backlighting is one of the prettiest types of outdoor lighting if it's used with the right subject and metered carefully, but exposing for it can be tricky. The problem is that when light is coming primarily from behind your subject, that means that a significant part of your subject will be in its own shade. If you let the meter see the light coming from the background, you will almost certainly underexpose parts of your foreground. On the other hand, if you give the foreground too much exposure to compensate, then you run the risk of blowing out the bright areas in the background.

Backlighting looks particularly pretty with subjects that have a translucent quality. It tends to make those areas glow, as in the shot of the desert wildflowers shown here. I had to be careful exposing for this scene so that the yellow blossoms didn't disappear into a pool of highlights without any detail. The best solution is often to use your auto-bracketing exposure mode, and bracket by about 1 or 2 stops (both over and under) the metered exposure. Once you get a shot that is close to what you want, you can use exposure compensation to further refine the exposure.

Q How can I take pictures using only the light from a window?

A If you live in a house with many windows, keep your camera handy— window light often presents some pretty shooting opportunities. Light from north-facing windows is generally neutral, making it wonderful for portraits. Light from north-facing windows is usually pretty even, but you can use the white balance control (set to Open Shade or Cloudy Day) to warm it up.

The direct, warm light of south- and west-facing windows is great for still-life subjects. I spotted the holiday vignette shown here while sitting at my dining room table. You can moderate the warmth by dialing some blue into the white balance. As you can see in this shot, the way that light interacts with window blinds can add something interesting to a photo.

> ## Q
> ## To what is someone referring when talking about the quality of light?

A In addition to its color and direction, light is also often described by its *quality*. Quality refers to the hardness or gentleness of light. This is an important consideration because it has an impact on both exposure and the overall mood of a scene. For example, a brilliant summer sun is referred to as hard lighting and that's exactly how it affects outdoor scenes — by creating deep shadows and blistering highlights. Hard lighting has good qualities, too, though. It gives colors a neon-like illumination as in the shot of the young skateboarder shown here.

Cloudy days offer a softer, more diffused light and create a gentler, more alluring illumination. Soft light is far less stressful to expose for and also has, as you might guess, a quieter, more romantic persona. The quality of light is almost entirely dependent on three things: Weather, time of day, and (to a more limited degree) time of year. Early in the day when the sun is at a more oblique angle, light tends to be considerably softer in quality.

Soft light is particularly nice for portraits and close-ups, like the tulip shot shown here. Cloudy and hazy days create an even more placid mood. If you live in an area that has distinct seasons, the light is generally softer in the winter months when the sun lingers closer to the horizon.

Q Should I include the sun in photos of sunrises and sunsets?

A Because the sun is the star of the show in sunrises and sunsets, it seems almost obligatory to include it in these types of photos. However, it's completely optional. A lot of times, the sun is hidden behind cloud formations, and most sunsets are a lot more dramatic when there are clouds scattering the light, so deciding whether to include the sun is a nonissue. Because clouds tend to scatter the light and create more intense colors, I prefer to shoot when there are a lot of them — particularly just before or after a storm.

There are times, though, when the sun is setting in a clear sky and there's really no way to avoid including it. Incorporating the sun does introduce some exposure issues because, unless it's sitting in a very hazy sky, it's always going to be far brighter than your foreground. In these cases, the only way to meter the scene is to aim your camera just to the left or right of the sun, lock that meter reading, and then reframe the shot. If you were to read with the sun in the shot, your foreground would more than likely be grossly underexposed. Another option is to hide the sun behind some part of the foreground — such as a tree or a passing sailboat.

Q If I use the wrong white balance outdoors, will I ruin my pictures?

A If you regularly set the white balance yourself (as opposed to letting the camera do it automatically) it's easy to forget where you have it set, especially if it's been a few days (or weeks) since you last used your camera. You may not discover you've been taking photos at the wrong white balance setting until you're done shooting and notice that all of your photos have an odd colorcast. Ouch!

For example, if the previous time you were taking pictures you happened to be shooting indoors using existing light, your white balance was probably set for tungsten lamps. If you then shoot daylight photos, your pictures will come out very blue because the camera will supply additional blue to the images to compensate for the reddish color of the tungsten lamps.

Is it a disaster? Not if you do your own image editing. All image-editing programs have a color balance correction that allows you to quickly fix most lighting/white balance mismatches. Even if you don't do your own editing, you can always make a point of telling the lab about your mistake and they can easily fix the errors.

If you shoot in the RAW format, of course, white balance is not an issue at all because you can correct and fine-tune the white balance during the conversion process as you open the images.

Q What types of subjects photograph well on overcast days?

A As much as most of us get more revved up to take photos when there's a bright sunny day happening, there are some nice aspects to shooting on overcast days, both creatively and technically. Overcast days particularly benefit any subject in which light might present contrast problems on sunnier days. For example, light-colored, sandy beach scenes can be a contrast nightmare on a blue-sky day. On an overcast day, though, it's easy to get good detail in the sand without having to sacrifice shadow areas, like a rocky outcropping.

Overcast days also vastly reduce surface glare and reflection, enabling you to capture more saturated colors with certain natural subjects, such as the autumn leaves, shown here. On bright, sunny days these colors are often washed away by too much intense sunlight.

You'll also find overcast days useful when you want to intentionally make long exposures outdoors without resorting to neutral density (ND) filters. This is particularly helpful if you need to make multiple-second exposures of things like the surf crashing on the shore, or if you want to blur the motion of a mountain stream.

Q Why is dappled sunlight so difficult to expose correctly?

A *Dappled* lighting occurs any time that you have splotches of bright light and shadow next to each other in an outdoor photo. It's very common when you're shooting in a forest. The reason that it's such a difficult subject is because the entire scene is one of competing highlights and shadows. Dappled lighting pretty much defines *contrasty* lighting, and leaves you with limited options for capturing a good exposure.

Because you don't want to lose detail in the highlights, you're far better off exposing to record details in the brighter areas and letting the shadows fall into underexposure. If you choose to expose for the shadows, you lose all detail in the highlight areas. If I see a pretty dappled light scene, I'll bracket exposures and see which ones look best later. If I'm off by too much in either direction, I'll decide which is the simplest to salvage. I may even take note of the scene and come back at a different time or on an overcast day when the lighting is less contentious.

Dappled lighting is a great subject for experimenting with High Dynamic Range (HDR) imaging because that technique allows you to greatly extend the contrast range of your images.

Q **Do I have to travel to exotic places to take great landscape photos?**

A It's easy to look at the work of the master landscape photographers like Ansel Adams (my personal photographic hero) and imagine that the only places to find great photos are in dramatic and exotic locations. There is no question that photographing such spectacular locales is very inspiring, but wonderful natural settings are not the only worthy landscape subjects. In fact, nature need not even be represented.

A landscape photo can be described as any picture that describes a place, and that place can be anywhere from a national park to the local skating pond. The real test of a landscape photo is not how extraordinary the scenery is, but rather how creatively it depicts a particular setting and how well you are able to translate your feelings about that place. I photographed the drive-in restaurant shown here a few miles from my home, just days before it was torn down. It had been an icon in town since I was a kid, so it had more personal meaning for me than any shot from a scenic overlook.

Before you travel halfway around the world in search of grand landscapes, take a look around your hometown — even your own neighborhood. You might be surprised at the great landscape subjects you find.

Q **What is the best way to add a sense of scale to a landscape photo?**

A One of the most challenging aspects of photographing certain types of landscape subjects is finding a way to relate their true scale. For example, scenes taken in the American Southwest (or any type of mountain environment) are so vast that it's impossible to tell their true size by looking at a photo. Snapshots taken from the rim of the Grand Canyon are almost always disappointing because there is no way for anyone to comprehend its true vastness.

The secret to translating scale is for you to provide clues for the viewer by including objects of known size. Everyone knows, in general, how tall people are, so just have a friend stand in the frame. If you don't happen to have another person handy, you can include almost anything of a recognizable size. As long as the viewer knows the approximate size of the object you're including, it's easy to make a comparison. For example, to show the real size of the rock butte near Monument Valley shown here, I included a motel parking lot in the foreground.

Incidentally, scale also works with small subjects. By setting a tiny seashell in the palm of someone's hand, you clearly reveal its true size.

Q Should landscape shots always include the horizon?

A I was asked this question one night in a class that I was teaching and my immediate response was, "No, of course not." However — curious about how that answer was reflected in my own work, I glanced through several landscape folders. I was surprised to find that I had to view hundreds of shots before I found one that didn't include some portion of the horizon. Apparently, to my eye, the horizon does matter but that certainly doesn't mean that's true for everyone.

The horizon has some very practical uses in almost any type of landscape or scenic photograph. For example, it helps establish distance. Even if there is no other hint of scale in a scene, the horizon puts a finite distance on a landscape: here the land ends and the sky begins.

Excluding the horizon, however, focuses more attention on the immediate foreground and also on the content of your composition. The composition becomes somewhat less about space and more about the land and its texture. The two shots shown here (taken in Mexican Hat, Utah) are good examples of this. Although only a sliver of the sky is visible in the first photo, it has a much greater sense of spaciousness. The second image without the sky focuses more attention on the rugged geography of the scene.

Q How does where I place the horizon change the way that a scene is interpreted?

A The horizon line in a landscape photo influences which portion of the image gets more attention from viewers: the foreground or the sky. When people look at a photo that contains both sky and foreground, they are manipulated by the placement of the horizon into paying more attention to one part of the scene than the other.

The higher you place the horizon above the midpoint of the frame, the more emphasis you give to the foreground. Conversely, if you place the horizon low in the frame, you draw attention to the sky, which can be useful when capturing a sunset. In the photos shown here, the placement of the horizon doesn't vary a great deal, but the focus of the image shifts radically to the foreground in the first shot due to the higher horizon.

Placing the horizon higher in the frame is often just a matter of finding a vantage point that's a bit higher and pointing the camera slightly downward. To place the horizon lower, you can usually just kneel down and aim the camera upward at a slight angle.

Q How can I prevent the horizon from slanting in my landscape shots?

A As big and wide as the horizon is in most landscape photos, you would think it would be easy to keep it level. However, crooked horizons are one of the most common flaws in landscape photos. The funny thing is, the wider the horizon is in a shot, the more obvious it becomes — even if you're just a few degrees off kilter.

One way to keep the horizon level is to use a tripod that has a bubble level built into the head. There are also accessory bubble levels that slip into a camera's hot shoe — a worthwhile investment of a few dollars if this is a frequent problem. A bubble level tells you for sure whether or not the camera is dead level.

However, a level camera doesn't always guarantee a perfectly flat level horizon line. This is partly because certain lenses (particularly the very wide-angle ones) have an optical design that actually bends the horizon slightly. The wider the angle of view of the lens, the more likely you are to have some straight-line distortion. This is particularly the case with less expensive lenses.

Many cameras have a grid of horizontal and vertical lines that can be displayed in the viewfinder to help you keep things level, so see your manual. A few cameras even have a *level horizon correction* built in to their menus that can detect a crooked horizon and automatically fix it.

Most editing programs also offer a few different ways to fix a crooked horizon. For example, in Photoshop you can fix a leaning horizon using the Rotate tool. The simplest way to use this is to select the entire image, and then choose Edit→Transform→Rotate. You can then manually rotate the horizon up or down. If the distortion is due to a fault of lens design, you can fix it with the Lens Correction tool in Photoshop: choose Filter→Distort→Lens Correction.

Q How important is it for a landscape photo to be sharp from front to back?

A The decision about how extensive the depth of field (near-to-far sharpness) should be in a landscape depends largely on the type of subject that you're shooting, and whether you want the viewer examining the entire scene or just a portion of it. If you're photographing a rural scene that includes a dirt road leading to a pretty barn, chances are that you want a lot of depth of field so that a single area of the photo doesn't get more attention than another. You're trying to take the viewer on a journey, and you want it to be a smooth one from foreground to background.

However, there are times when you want to emphasize a certain element of a scene. In the image shown here, I focused sharply on the saguaro and used a moderate aperture of f/8.0, allowing the background to fall gently out of focus.

BONUS TIP:

When deciding how much should be in focus, ask yourself if the photograph is about the place or an object in that place.

Q How does lens choice change the look of a landscape photo?

A The focal length of the lens (or the zoom setting) that you use to photograph a landscape has several significant effects on the way that the landscape is presented. Often, the most important decision that a photographer makes when shooting a landscape is selecting the right lens for that particular scene (this is also one of the reasons that landscape photographers carry so many lenses with them).

The primary thing that the focal length of a lens dictates is, of course, the angle of view: the shorter the focal length of the lens, the wider the angle of view. Conversely, the longer the focal length of the lens is, the more narrow the angle of view. Therefore, using a wide-angle lens allows you to take in a much broader view (horizontally and vertically), and show more of a particular locale. A longer lens enables you to isolate details within a broader scene.

All other things (most importantly the lens aperture) being equal, wide-angle lenses also have inherently more depth of field at any given aperture than a lens with a longer focal length. This means that they can keep more of the image in sharp focus. More importantly, though, wider lenses tend to exaggerate the size differences between nearby and distant objects. This adds a great sense of depth and distance to a landscape scene. Even in a relatively shallow landscape, you can exaggerate the feeling of space by using a wide-angle lens.

Conversely, by using a longer focal-length lens, you compress space and make distant parts of a scene appear closer together. For example, by using a long lens to photograph a silhouette of a sailboat in front of the setting sun, you can dramatically increase the size of the sun in relation to the size of the boat. You can also shrink the apparent space between the two and make the sun appear substantially closer to the boat.

Q How can I exaggerate the feeling of distance in a landscape scene?

A Because all photographs only exist in two dimensions, any sense of depth that they contain is created entirely by illusions established (and exaggerated) by you. There are a number of ways to create the illusion of distance using what photographers and artists call *depth cues*. Depth cues are simple compositional devices that fabricate the feeling of a third dimension. The following are some of the most common depth cues:

- **Linear perspective.** One of the simplest and most direct ways to create a sense of distance is to include a leading line — a cue that artists refer to as a linear perspective. Lines work best when they start near the front edge of the image, go to the far horizon, and conclude at a single vanishing point. Highways, fences, rivers, and telephone poles are all things that can take the eye on a deep journey into your image.

- **Aerial perspective**. If you've ever stood at a scenic overlook gazing out at a mountain range, you've no doubt noticed that the rows of receding peaks seem to get lighter as they get farther away. That's a depth cue called aerial perspective. The buildup of haze (or mist or fog) as the peaks get more distant causes those farthest away to look lighter. The brain interprets this tone change as distance.

- **Upward dislocation.** Whenever a particular subject is higher in the frame than one that is nearby, it appears to the viewer to be farther away. For example, placing a sailboat on the horizon high in the frame makes it seem more distant.

- **Shrinking sizes.** Using common knowledge of object sizes is another great way to trick the brain into sensing distance. When you contrast objects of known size — such as, a person near the camera and a tiny lighthouse in the distance — you tell the viewer that there is space between the two. Everyone knows that the lighthouse is really much larger than the person.

Q How do I simplify the number of visual elements in a landscape photo?

A There is a tendency shared by many photographers (myself included) to try and squeeze everything they see into a frame. This may stem from the idea that the more you show, the more ideas you communicate to the viewer. However, exactly the opposite is true: The simpler your composition, the clearer your message, and the less doubt there is about your intent when composing the shot.

Being a child of the 1960s, I remember the old political adage: If you're not part of the solution, you're part of the problem. When I compose landscape photographs, I rigidly stick to that idea. If anything in the frame is not contributing to making it a stronger photograph, out it goes. Sometimes this means changing lenses to isolate the important elements in a scene. Other times, it means finding a better vantage point that enables you to streamline the design, or using selective focus to toss a cluttered background out of focus.

However, the most important tool you can bring to simplicity is a clear vision. Know what it is that you're trying to show and subtract anything that clutters that message. For example, when photographing the Japanese garden shown here, I consciously chose to include a minimal number of elements.

Q What are some of the best ways to add mood or atmosphere to a landscape?

A The things that are most effective when trying to add a particular mood or sense of atmosphere to a photograph are the same things that first draw a viewer's attention. Weather extremes — from the brooding mystery of a foggy day, to the dreary, melancholy tone of a rainy day — create wonderfully moody scenes.

A harbor scene that seems cheerful and lively on a bright, summer day might look forlorn, or even foreboding, under the shroud of a passing squall. Light, in both color and intensity, plays a major role in setting the mood of a landscape. The soft, yellow light of early morning lends an inviting, welcoming feeling to a rural landscape, and helps reinforce the pastoral nature of such scenes.

Q

How important is my vantage point in a landscape photograph?

A

One of the first things that you have to decide when it comes to landscape photography is where to stand when you shoot. If all that you're after is a snapshot of a place, then the spot where you stood when you first noticed the view will probably do — after all, something about the scene from that viewpoint caught your eye. Chances are, though, that if you spend a bit of time exploring, you'll likely find a vantage point that reveals more of the true character of the place. In fact, the place from which you initially spotted a potential shot is rarely the best possible vantage point.

When photographing this old lifesaving station in Lewes, Delaware, my first instinct was to shoot only the small white building. That's what I drove there to see, and it seemed like the best shot. However, as I walked back down the road leading to the station, I noticed the gathering of nautical items and found that by lying on the grass, I was able to frame the building through them. It turned out to be a far better viewpoint that told an interesting story about the history of the location.

Q Should I include the hand of man in my landscape photos?

A Serious nature and landscape photographers have long debated whether it is acceptable to include the *hand of man* — that is, any man-made structures or objects — in their photos. The question often comes up if you're photographing an otherwise natural scene and you suddenly notice something man-made that looks out of place.

For example, if you're photographing a pretty woodland scene and you spot a *No hunting* sign in your composition, you may wonder if it belongs in the shot. For some, the answer is absolute: nothing man-made should appear in a nature photo. For others, it's a matter of degrees: if the object is unobtrusive and seems to fit with the tone of the image, you might accept its presence. On the other hand, if you're photographing a small stream deep in the woods and there is beer bottle floating along, it probably should be removed.

There are also times when intentionally including something man-made in an otherwise pristine scene can have deep emotional significance. As a kid, I walked over the little bridge shown here thousands of times. Although it may seem a bit out of place in this otherwise pastoral view, to me it's really the centerpiece of the photo.

Q How do I create a white ribbon effect in shots of waterfalls and streams?

A One of the more interesting techniques that being able to adjust your shutter speed affords is the ability to creatively interpret the motion of moving areas of a landscape. Rather than freezing fast-moving subjects with brief shutter speeds, selecting longer exposure times enables you to exploit the motion of many subjects — such as grass blowing in the wind, waves crashing on the shore, or nighttime traffic.

One of the most familiar examples of this is the *white ribbon effect*. It is created by using long exposures to turn things like rapidly rushing water into patterns that resemble flowing, white satin ribbons. To create the effect, set your camera to the Shutter Priority mode, and choose a shutter speed long enough to let the water pass through the frame during the exposure. The intensity of the effect depends on how fast the water is moving and how long the shutter remains open.

A tripod is mandatory for this kind of shot because you may be using shutter speeds of 1 second or longer. I used a 1/2 second exposure to create the shot shown here. If you're working in bright light, you may need a neutral density (ND) filter in order to reduce the existing light enough to allow for such long exposures.

Q How can I use reflections as a creative tool in landscape photos?

A Any time that relatively still water — whether it's a lake or a puddle — is part of a landscape composition, the potential to exploit interesting reflections exists. Reflections (particularly those that are very clear and sharp in still bodies of water) often establish a pensive emotional quality from which most people have a hard time turning away — in life or in photos.

One interesting way to use a reflection is to run the horizon through the center of the frame to create a sense of symmetry, as I did when I photographed the brilliant colors of this sunrise in a Texas marsh. Dividing a frame into equal parts makes the reflection a major component of the composition, and the symmetry is often eye-catching and unexpected.

Still reflections are particularly pretty, and are usually more easily found very early or late in the day when there are no breezes, and the water becomes a perfect mirror. However, be cautious if the source of the reflection happens to be particularly dark — such as the water of a stagnant pond. You then have to be careful to meter the source of the reflection rather than the reflection itself. This is because the dark water will probably lead to overexposing the source of the reflection.

Q **Why do my pictures of fog and mist come out too dark?**

A Fog and (to a lesser degree) mist seem to be great thieves of light in photography. They do often come out much darker in images than they appear in person. However, the truth is that they don't absorb light, but rather, they reflect so much light they fool the camera's light meter. The camera meter, seeing what it thinks is an exceptionally bright subject, reduces the exposure and ends up underexposing the scene. Rather than the airy scene that you saw before you, you end up with a dingy, gray-looking version of it.

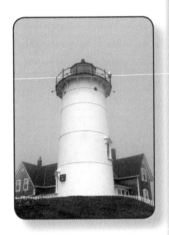

The solution for bringing fog back to life is to use your Exposure Compensation control to add extra light. Finding the correct amount of compensation to add is largely a matter of experimenting, and checking both the LCD screen and histogram. Typically, adding 1 or 2 stops of light restores the proper brightness.

BONUS TIP:

An incident-type, handheld light meter usually provides more reliable exposures because it measures the light falling on (rather than that reflecting off of) your subject.

Q How can I compose fog and mist scenes to make them more powerful?

A As pretty and mysterious as fog drifting through a landscape can be, it also presents certain challenges when trying to compose interesting photos. Because fog diffuses light so much, it also greatly reduces both contrast and color saturation. Often, this also erases shape and form. However, you can use the following tricks to get the most out of foggy scenes:

- **Include nearby objects.** Fog greatly intensifies with distance. The farther an object is from your camera, the less defined it becomes. Objects in the foreground reveal the contrast between near and far, establish depth, and exaggerate the fog.

- **Stress bold shapes.** Look for objects — such as a lone tree, a sailboat, a bridge, and so on — that have bold shapes to contrast against the fog.

- **Use pockets of color.** Color, like contrast, is significantly erased by fog, so look for strong colors that can hold their own within the design.

- **Include directional lights.** Street lamps, spotlights, and car headlights often create dramatic rays of light as they pierce the fog.

- **Give it time.** Fog tends to grow and dissipate over time, so if you find an interesting scene, work with it for a while. Capture it as the fog thickens and thins.

> **Q** Why does snow always appear to be washed out or gray in my photos?

A Even with the very sophisticated light meters found in most digital cameras, snow is sometimes tough to expose correctly. Often, it records as a medium-toned gray rather than white, and looks nothing like the pristine environment that you remember photographing. The reason that snow appears gray in photos is because the camera's meter is doing its job exceedingly well.

All light meters are calibrated to reproduce whatever they see as a medium-gray tone, so when you aim your camera at a snowy landscape, that's exactly what it does. Without some intervention from you, the camera will record the snow as what's known as *middle gray* — a value halfway between black and white. The solution is simple: add exposure using your Exposure Compensation feature, and you can return the snow to white. The amount of the increase is a matter of trial and error, but typically, about 1-1/2 stop should do it. Keep an eye on the histogram, though — if highlights bunch up along the right-hand border, reduce the exposure.

The opposite problem occurs if your scene contains large patches of darker subject matter. This fools the meter into thinking there is less light than there really is. This causes the meter to overexpose the snow because it wants to record the darker subject as a medium gray. The solution this time is to subtract exposure.

Q How can I increase the drama of a rainbow in a photo?

A Considering what a spectacular gift of nature it is, you wouldn't think that a rainbow needs much help from a photographer to look great. However, most can be improved upon (photographically speaking, at least) with a few tricks to increase their drama.

Because rainbows appear after (or sometimes during) a storm in a dark sky opposite the sun, it's easy for the camera meter to be fooled into overexposing the scene. To avoid this, aim your camera at a lighter area of sky to the left or right of the rainbow, lock that exposure reading, and then recompose the scene. This effectively underexposes the gray clouds a bit and makes the colors of the rainbow more prominent.

Also, a polarizing filter is great for photographing rainbows because you can rotate the filter to intensify the colors. This happens because you're cutting through some of the atmospheric reflections while retaining the colors of the rainbow. You can see the effect in the viewfinder as you rotate the filter, so just wait until you see the most intense colors, and then shoot.

I prefer to shoot rainbows in the RAW mode because it enables me to reset the exposure and white balance during editing without degrading the image.

> **Q** What is the best way to protect my camera in the rain?

A As you might imagine, water and digital cameras don't mix. While your camera can easily survive a few light raindrops now and then, heavy rain (or worse, a splash from a salty ocean wave) can potentially cause real damage. Rain, being the unpredictable event that it is (just ask a meteorologist), means it's always a good idea to have some type of protection handy.

The simplest (and cheapest) solution to this problem is an ordinary plastic zipper bag — an excellent form of protection for your compact or zoom camera if you find yourself trapped by a sudden downpour. You can even use them as an el cheapo, wet-weather shooting housing by poking a small hole through one corner for the lens to peek through.

There are also a number of commercially manufactured rain covers for both compacts and larger cameras. The simplest of these are, essentially, just plastic bags with a few innovations. The Rainsleeve from OP/TECH USA (http://optechusa. com/rainsleeve.html) is made of pliable plastic, has a drawstring front lens opening, and peephole access for an optical viewfinder. This type of protection is very inexpensive (under $10) and fits in a shirt pocket. They aren't particularly rugged, but they do allow you to continue shooting in heavy rain.

The next level of protection is a more durable rain sleeve, such as the Aquatech Sports Shield Rain Cover (www.aquatech.net). These are extremely tough, and designed to protect (mainly dSLR) cameras and lenses from all types of nasty elements, including rain, salt air, and sand. They're more expensive ($150 street price), but you can buy them custom-fit for specific bodies and lenses.

Finally, if you happen to live near the ocean or spend a lot of time at the beach, several manufacturers now make waterproof compact and zoom cameras. The Panasonic Lumix DMC-TS3 is waterproof to a depth of 40 feet (perfect for snorkeling), not to mention shock-, freeze-, and dustproof.

Q Should I photograph rain through the windshield of my car?

A Wherever I go in the world, I seem to attract rain, which means that I spend a lot of time sitting in cars waiting for a break in the weather. But, like most photographers, I get bored quickly if I'm not shooting pictures. Eventually, I get frustrated enough to start shooting through the windshield. Surprisingly, I have created some great photos this way.

One day, a sudden vicious storm made me flee to the car. I sat there for an hour cursing the rain and fidgeting with my camera. It was then that I noticed if I used a very shallow focus on the raindrops on the windshield, I could create a neat contrast between the drops and the scene beyond. As I experimented with this, another car approached and the headlights worked into my composition perfectly at the bottom of the frame, as shown here. I also inadvertently triggered the flash and created the bright random beads of light shown here in the first image. It pays to experiment in situations like this because you never know what you'll discover.

Q How can I create more exciting sunset photos?

A Sunsets (and sunrises for you early risers) are probably the most fun and popular form of landscape photography. After all, with a sky full of color and glory, it's hard not to take a good picture. However, below are some tricks you can use to increase the number of exciting sunsets that you capture:

- **Scout locations early.** Don't wait until the sun is almost at the horizon to find a good potential shot. Start looking while you still have an hour or so to plan your foreground.

- **Look for interesting silhouettes.** Sunsets are much more dramatic if you pair them with interesting foreground silhouettes — such as boats at anchor, a dock, a tree on a hillside, and so on.

- **Bring a compass.** Particularly if you're in a new location, a compass tells you exactly where the sun will set.

- **Watch your timing.** Once the sun gets close to the horizon it sinks very quickly. Try to capture it just before it touches the horizon. If there are any moving elements in the shot (like the boat shown here) try to time that subject's placement, as well.

- **Saturate color.** Use the Hue/ Saturation control in your editing program to exaggerate colors a bit — only you and the camera will know.

Q How do I take time-lapse sequences with my dSLR?

A Times-lapse sequences of landscapes can be a fascinating way to show how a particular place looks and evolves over a period of time. This can be as brief as a few moments (as a storm gathers over a harbor, for example) or it can be long enough to reveal seasonal changes in the landscape, such as one photo taken every three months.

The specific tools and techniques that you use to capture these sequences really depend on the amount of time you want to elapse between each shot. If you want a series of images that show how a tidal marsh changes as the tide comes or goes, you could simply sit beside your tripod-mounted camera for several hours and manually shoot a photo at regular intervals. As long as you don't fall asleep between shots, this isn't a bad way to shoot time-lapse images.

If you want to show seasonal changes, one trick that some pros use is to place a camera on a tripod and, after they've framed the scene, put inexpensive tent stakes in the ground so they can find the same position a few months later. For the images to be very precisely aligned, you can bring a print with you from a previous shoot and compare it to the image on the LCD screen. If you have a smartphone with GPS tracking, you can use that to get back to your shooting location with great precision.

If you'd rather not stand by your camera, you can purchase what's known as an *intervalometer* — a timing device that fires your camera at predetermined intervals over a specified period of time. Some dSLR cameras have built-in intervalometers — check the manual to see if yours does.

Incidentally, regardless of the interval, it's always better to shoot more photos (even if you don't want to show such brief transitions) because you can always edit the series and choose the interval later.

Q When is the best time to look for dramatic storm cloud formations?

A Storm clouds are usually at their most intense as a storm begins to break up, and the sun emerges and colors the clouds. The time to be out scouting locations is actually during the storm because it's impossible to tell when one will dissipate. However, always pay particular attention to warning sirens or listen to a weather radio when storm chasing.

I photographed the rare mammatus clouds shown here just a few moments after a thunderstorm passed. They put on a show for about 20 minutes, and then vanished. Often, storms that pass through during the night create amazing cloud formations at dawn. On stormy nights, I usually set an alarm clock and head down to the local beach to be there at sunrise.

Q What is the best lighting in which to capture autumn foliage?

A Because autumn leaves exist almost entirely in a warm palette of yellows, reds, oranges, and browns, they respond well to warm lighting. While fall foliage is almost always pretty to look at and photograph, the colors appear more electric early and late in the

day. This is because the sun's rays are warmer and considerably gentler at those times. I often scout interesting compositions during the middle of day, and then wait for the sun to get lower in the sky and the light to warm up.

The direction of the light also plays an important role with foliage shots. Because most leaves are translucent, they take on a pretty glow when there is a strong backlight. That being said, however, front lighting often creates dramatic contrasts, particularly when you have a radiant blue sky as a backdrop. I took both of these photos at midday because the colors were exhilarating against the

rich blue sky. However, even the muted light of an overcast sky often creates rich, saturated colors — an effect you can intensify by using a polarizing filter to subdue surface reflections.

Q ## How do I create panoramic photos?

A One of the most innovative things that digital cameras and editing have made possible is the ability to create ultra-wide panoramic photos. The results are often stunning, and they are simple to create. Basically, you create a panoramic by shooting a series of overlapping individual images, and then *stitching* them together in editing. The stitching is a largely automated process and the software does most of the heavy lifting for you. Some cameras have a built-in panoramic feature that merges the individual frames in-camera. Here are the basic steps for creating a simple panoramic shot:

1. **Choose a subject.** Wide or very tall subjects, such as seascapes, city sky-lines, and bridges work best.

2. **Set up your tripod.** It's very important that the horizontal attitude of your camera stays level.

3. **Set your camera to Manual exposure.** Auto modes could vary the exposures and they must stay consistent from frame to frame.

4. **Shoot several overlapping frames.** Each frame in the series should overlap the previous shot by about 30 percent.

5. **Make basic corrections in editing.** It's best to adjust each of the images for color, exposure, and sharpness before stitching them.

6. **Merge the images.** See the manual or Help menu for the software you're using for instructions.

Q What does frame-within-a-frame mean, and how can I use it to improve my landscapes?

A The term *frame-within-a-frame* refers to any type of visual framework that exists naturally in a composition, and frames it. Common examples of this include archways, windows, doorways, or almost anything that you can use to accent or isolate another part of your subject.

The fun thing about this type of compositional device is that it allows you to use one part of a scene to underscore another. It then becomes not just a visual reinforcement, but a thematic one as well, such as a natural stone arch framing a distant canyon. Frames are often most effective if they are slightly underexposed relative to the scene that they're framing. Subduing the frame emphasizes your subject.

Q How can I create a silhouetted landscape shot?

A Turning landscapes into silhouettes can be an effective tool for simplifying complex scenes and, when done well, it also creates a very dramatic look. Creating a silhouetted landscape requires only two things: A bright background and a foreground that can be converted to black shapes by simply underexposing it.

Finding potentially good silhouette subjects is easiest when you have a large area of either bright sky or water, or both.

Exposing for a silhouetted landscape is one time when you want the camera meter to be fooled by the bright background, and *not* to correctly expose for foreground subjects. If the difference between the fore- and background is substantial enough, this usually happens naturally. If you find that you're getting too much detail in the foreground, try taking a meter reading from the brightest part of the sky, and then lock in that reading using the exposure-lock function.

If the in-camera exposure isn't as dramatic as you'd like, it's easy to bump up the contrast in editing, which is what I did when creating both of the images shown here.

Q How is photographing the desert different from shooting other landscape subjects?

A The deserts of the American Southwest are among the most mystical, supremely beautiful places that you can photograph. No matter how much you read about the desert, until you walk into a forest of giant saguaro, you simply can't imagine how different the environment is from any other place you've ever photographed.

Taking pictures in the desert takes a bit of photographic acclimation, too. Not only are the plant life and terrain extremely unique, but the light also has a character all its own. Because there is little shade, and the ground is largely sand and light-colored rock, it's an intensely bright and contrasty place. This is not a place where early morning and late afternoon are the preferred times to take pictures — they're the *only* times. During the midday heat, the sun obliterates the subtle textures and nuances of color that exist at the gentler times of day.

Survival in the desert is nothing to take lightly. Make sure that you always have a trail map and enough water (one gallon per person, per day). Wear a hat and a long-sleeved shirt to prevent sunburn. Also, be sure to let someone know where you're headed and when you plan to return — cell phones rarely work in such remote locations.

Q **What is the best way to capture the vastness of a broad landscape scene?**

A The toughest landscapes to photograph are the broad, majestic vistas that seem to join heaven and earth. They're difficult to wrestle into a viewfinder because, while they're genuinely spectacular to look at, they don't provide much of a handle to grasp photographically — everything in the scene seems to be of equal weight and importance. Still, they're so downright beautiful that most photographers (myself included) can't help but fill half a memory card trying to capture the perfect view.

I approach such shots (like the western landscape and the panoramic view of Lake Winnipesaukee shown here) by imagining them as the opening frame of a movie — an establishing shot. After all, that is pretty much what a photo of a broad landscape is meant to do — introduce the place that you're exploring.

So, rather than defining a strong center of interest (which, in most cases, is a very good idea), or looking for unusual angles or detail shots, try to just document the view. Picture it as the opening or closing frame of your vacation slide show.

Q Why do tall buildings appear to lean backward in photographs, and how can I prevent this?

A Any time that you photograph a tall building while standing close to it (particularly with a wide-angle lens), you end up with a photograph in which the building appears to be leaning backward into space. The taller the building is and the wider the lens, the more exaggerated the effect. This is a phenomenon known as the *keystone effect*. It's a common problem when photographing architecture, but there are a few simple solutions.

One way to solve this is by backing farther away from the building and using a longer lens. Of course, sometimes you may not be able to back away and, even if you can, it doesn't always fix the problem — although it can moderate it considerably. Another potential solution is to shoot from a higher vantage point, such as an upper-floor window in a nearby building or parking garage. This way, you're shooting *at* the building, rather than *up* at it. If you can keep the camera back parallel to the façade of the building, this will eliminate the root cause of the keystone effect.

Also, most software programs have a tool for correcting architectural distortions. In Photoshop, you can use the Lens Correction tool. Another alternative is a perspective control lens, which I cover in the next FAQ.

Q What is a perspective control lens?

A *perspective control lens* is a specialty lens that enables you to shift the front element in relationship to the camera sensor, while still keeping it parallel to the sensor. In architectural photography, shifting the front element upward and keeping the camera back parallel to the face of a building raises the view of the lens. It can then see the top of the building without the photographer having to tilt the camera (and lens) upward.

This ability is exactly the same as raising the front standards on a studio *view camera* that has separate lens and focal-plane standards. The ability to raise the front element virtually eliminates the keystone effect. Some lenses (called *tilt-shift lenses*) also have the ability to tilt the front element so that the lens can remain parallel to receding image planes.

Perspective control and tilt-shift lenses come in a variety of focal lengths, but they are almost all in the wide-angle to moderate telephoto range. In addition to shooting building exteriors, architectural photographers also use them to correct perspective in interior shots and still-life work. Because the lenses have a sliding front element, they are, of course, all manual focus lenses.

Q Should photos of buildings always be architecturally correct?

A Unless you're a serious architectural photographer trying to shoot photos for *Architectural Digest*, being *architecturally correct* (that is, when all of the vertical and horizontal lines are exactly parallel, and the shape of a building is accurately depicted) is not necessarily mandatory. While such perfect pictures of buildings are admirable, it's rare that we have the time (or the tools) to create them.

If you're walking around a city and stop to admire a particularly interesting building, getting an architecturally perfect photo of it is no easy business. In fact, it's often more fun to take some creative license with the look of the structure. I took this photo of Notre Dame in Paris one autumn evening when the spotlights on the building and the sapphire sky created a pretty scene. I knew that the building was leaning back a bit, but without a perspective control lens, this was the best I could do.

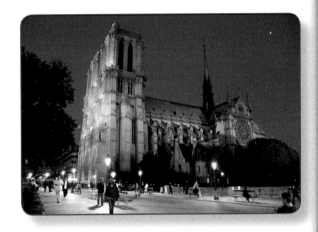

Often, when confronted with a building that looks a bit off-kilter, if I can't find a way to remedy the situation, I take the opposite path visually and look for ways to exaggerate its flaws. If you put on your widest lens and get very close to a building, you can get some eye-catching abstract shots.

Q How can I avoid getting things like power lines and street signs in my architecture shots?

A Power lines, telephone poles, and all types of signs are the bane of an architectural photographer's existence — professionals and amateurs alike. Sometimes, it seems like even the simplest of country churches has a spider's web of wires attached to it, and these can ruin an otherwise interesting photo. Because there's nothing you can do to eliminate the obstructions, the only solution is to be aware of them and try to subdue their presence.

The simplest way out is to look for a vantage point that downplays the worst of the distractions. Power lines, for example, are normally attached to one side of a building (if you're lucky, it is the rear), so if you shoot from the opposite side, it softens their appearance. Often, you can hide power lines behind a tree or the corner of the building. When photographing this local historical society in Connecticut, I found a viewpoint that hid the telephone lines behind a dogwood tree.

However, in more urban settings where street signs, traffic lights, or other buildings are a problem, getting close to a building with a wide lens is usually the only way to get an unfettered viewpoint. Another solution is to isolate details of the building, such as an ornate cathedral door.

Q How can I remove power lines and other distractions in editing?

A There are times when no amount of clever composing can eliminate all of the utilitarian clutter from an architectural shot. However, there is still one possible solution, and that is editing. You have several software options available to you that can work wonders when it comes to cleaning up shots of buildings and their environments. Here are some quick tips for magically erasing unwanted human artifacts:

- **Cropping.** This is the quickest way to tame unwanted areas of a composition, particularly if they're on the periphery of your scene. Often, you can do a better job slicing off bits of a composition when it's on your computer screen instead of in the viewfinder. Additionally, you can always press the Undo key to rescue the file if you get a bit too aggressive.

- **The Clone tool.** Another option is the Clone (sometimes called the Rubber Stamp) tool. It allows you to copy and paste pixels from one part of a composition to another, and completely hide what was under them originally. For example, cloning bits of blue sky over a power line magically erases any trace of it. Using the Clone tool is very simple. For example, say that you want to hide bits of graffiti on the side of a brick building. Simply copy a bit of the clean part of the wall from one area, and then lay it over the part that you want to hide. It takes a bit of practice to make your handiwork invisible, but in time you'll be astounded with the results.

- **Patch tool (Photoshop).** This tool is a fast way to remove intrusions, like a bicycle parked on the grass in front of an old country church. Simply draw a ring around the object you want to remove, and then drag it over to an area of even texture (like the grass). Poof! The object then disappears and is replaced by whatever was located where you dragged it.

Q How can I use the lines of a modern building to create interesting graphic designs?

A Whenever I'm in a city that has interesting modern buildings, I always try to take a few shots of the most outlandish architecture. I particularly like to shoot details of the more graphic-looking aspects, like window patterns or bold structural lines, like those in the image shown here. I'm not necessarily trying to capture great stand-alone photos of those buildings; rather, I'm looking for bits of buildings that I can later transform into interesting and dynamic abstract patterns or graphic designs. I often compose very tightly so that I'm only including isolated pieces of the buildings.

After I import the photo to Photoshop (my preferred editing program), I crop even more aggressively if necessary, so that the lines and shadows become more dominant. I then use one of the exposure and contrast adjustments (Levels, Curves, or Contrast

and Brightness) to bump up the contrast. As soon as I see a design pattern emerge I begin playing with bold, very graphic colors — often starkly contrasting one bright color against another. For me, this is very much like playing with a huge box of crayons when I was a kid. In most cases, the more I experiment and the further I get from reality, the harder it is for me to quit.

Q How can I get good interior photos in the low light of a church?

A Whether it's a grand European cathedral or a small Spanish mission church in the Southwest, places of worship are fascinating photographic subjects. However, the one challenge they all tend to present is that they are exceedingly dim inside. To compound the issue, it's also rare that you're allowed to use a flash or a tripod.

The most obvious solution is to raise the ISO to at least ISO 800 or 1600 — preferably higher if the room is very dark or large. Image noise at such high speeds is a problem for many cameras (more so with compacts), but it can be reduced in editing. You can use slower ISO speeds, but this requires the use of longer shutter speeds. It also introduces the problem of camera shake. However, if your camera has Image Stabilization (IS), you can shoot handheld using slower shutter speeds.

A fast lens is an asset in dim interiors because, in addition to providing a brighter viewfinder, a lens of f/1.8, for example, is 2 stops faster than a lens of f/4.0. Those 2 stops, combined with the 2 or 3 stops gained from stabilization, give you a net gain of about 4 to 5 stops. When composing, try to avoid including any stained glass windows when metering because they can grossly mislead the meter.

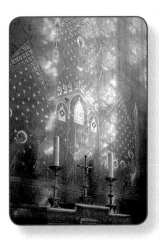

Q How can I use flash to light up a large interior space?

A The problem with trying to light a large space, such as a church hall or even a big living room, with a single burst from an on-camera flash is that it has a very limited distance range. A built-in flash is designed to illuminate subjects that are only 12 feet or less from the camera. While a more powerful accessory flash might double that distance, it may still be too weak to light a large space and, even if it does, the lighting will be one-directional and very flat.

You can, however, light virtually any size space with a single accessory flash unit by keeping the shutter open and firing the flash multiple times. This is a technique called *light painting*. It can be used not only to light big spaces, but also to make the lighting far more interesting and three-dimensional. Follow these steps to paint a large space with a single accessory flash unit:

1. **Using a wide-angle lens, place the camera on a tripod so that you have a pleasing view of the room.**

2. **Put the camera in the Manual exposure mode.** Set the lens to a very small aperture (such as f/22). Set the shutter speed to Bulb (B) so that you can leave the shutter open as long as necessary.

3. **Walk around the room and fire the flash using the Manual (or Test) Flash button.** As long as you wear dark clothing and don't pause too long in one spot, you should be invisible in the final image.

4. **Position yourself so that each burst of light partially overlaps the previous flash.**

5. **Have someone hold a small piece of black cardboard in front of the lens between flashes.** This gives you more time to choose your positions without overexposing the scene.

Q How do I correctly expose stained-glass windows?

A Stained-glass windows are one of my favorite subjects because each one is a work of art unto itself, and many have an enormous amount of history attached to them. For example, the South Rose Window in Notre Dame Cathedral, shown here, originated in the 1200s.

One of the difficulties encountered when photographing stained glass is that, while it is pretty to the naked eye at a distance, a photo works best if you can fill the frame with only the window. To fill the frame, you either have to get physically close or use a relatively long telephoto lens. Also, rather than shooting up at the window, it looks better if you can find a vantage point (such as a choir loft) that allows you to shoot it straight on.

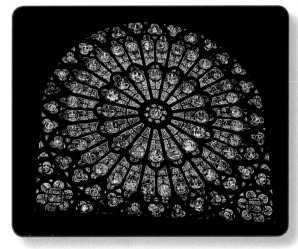

Because most windows are in dark settings, you have to be careful to exclude the darkness and meter just the glass. The best way to accomplish this is to set the meter to its Center-weighted mode. In most cases, a straight meter reading of only the glass provides a good exposure. In order to keep the colors accurate, set the white balance to either Auto mode or Daylight, or shoot in RAW and adjust the white balance in editing.

Q What is the best type of lighting and time of day for photographing the façade of a building?

A If there is one distinct advantage of choosing a building for a subject, it's that you usually have the luxury of waiting for good lighting. In fact, you can watch as the lighting develops and changes.

As contrast is always a constant consideration with any outdoor subject, I try to photograph buildings on slightly overcast days. The light is still quite bright even with a thin layer of clouds, yet there are fewer hard shadows with which to contend. If necessary, you can always set your white balance to Cloudy and add extra warmth to the light.

On clear days, I try to work early and late in the day, partly because the contrast is softer, but also because the light is naturally warmer, and this brings out the colors of buildings nicely. Warm lighting is particularly kind to older stone buildings, such as the Barnum Museum in Bridgeport, Connecticut, shown here.

Front lighting acts as a spotlight that helps set buildings off from their surroundings. Also, because the shadows are falling behind the building, there are fewer distracting shadows on the façade. However, the price you pay for using front lighting is that, while the shape and colors are nicely defined, there is no sense of depth.

Q What is the best way to shoot an estate or castle?

A We all have a vision in our heads of what it must be like to live in a castle or a centuries-old estate. What those daydreams conjure is different for everyone. For some, the idea of living in such a grand abode is about romance and fairytales; for others, it's about history and power; but for a lot of people, it just seems like a cool place to live.

When it comes to photographing such settings, try to imbue the photos with your own majestic fantasies — and that's easier done than it might sound. For example, I'm personally swept up by the whole storybook fantasy atmosphere that pervades the grand chateaus of France. When I first saw the magnificent Chateau de Chenoneau in the Loire Valley, I was drawn immediately to the towers and moats that brought those fantasies to life. I took those ideas even further in editing by adding a sepia tone to the shot of the moat to invoke a feeling of history and a gentle Gaussian Blur to the second shot to bring out the romance.

Q What are the best architectural details to photograph?

A They say that the devil is in the details, but with architecture, much of the beauty is found in the details. Some buildings, particularly older ones, provide a visual feast of fascinating details. Architectural details can be divided into two categories: Those that are a necessary part of the structure and those that are simply ornate. However, both make fascinating photographic subjects. Here are some details to look for when you're shooting:

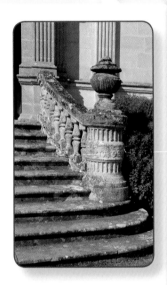

- **Stairways and handrails.** A century ago or more, the front steps to a building were more than a functional entrance — they announced the grandeur of the building with carvings and expensive details.

- **Relief carvings.** Many older buildings seem to have been decorated by stone carvers that had a bit of the storyteller in them. These stories in stone often hover on exteriors just above the first-floor level.

- **Gargoyles.** Look closely and you might find some amazing creatures staring down at you. They're often up high, so look for vantage points from neighboring buildings.

- **Structural details.** Cathedrals are a particularly rich source of ornate structural details.

Q What are some tips for showcasing architectural details?

A The way in which you approach architectural details really depends on the size of what you're shooting and whether it's a flat piece of decoration or a more three-dimensional accent. For example, if you're photographing fancy painting details on the front of an art deco hotel in Miami Beach, the trick is to find an interesting section to shoot and get close enough to fill the frame. Here are some other things to look for:

- **Flat details.** Composition isn't much of an issue with flat details, like tile work or painted decoration. What you want to do is fill the frame as much as possible. Lighting on an overcast day works well — or just wait for the detail to fall into open shade.

- **Relief carvings and gargoyles.** Definitely work early or late in the day, and find a vantage point where the light is coming from the side. Side lighting brings out the surface details and creates a realistic, 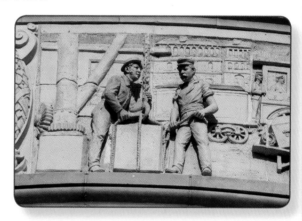 three-dimensional feel to the scene, as shown here. Use a long telephoto or zoom lens to isolate small areas.

- **Large structural details.** Keep compositions simple and tight. If you're shooting a public building, by all means take a scheduled tour to gain access to many more vantage points.

Q How can I take pictures through a window without getting a reflection of the room from which I'm shooting?

A Windows provide some great views, even if you're not lucky enough to be on the Las Vegas Strip or a beach in Honolulu. Looking down at a street from an upper floor can be fascinating. The difficulty, though, is that windows are often heavily tinted. Even if they're clear, you're apt to get a lot of internal reflections unless you take some precautions.

The first thing that I suggest doing is cleaning the window. Also, shut off all of the lights in the room and pull back any light-colored drapes. It's also a good idea to wear dark clothing so that you're not the source of the reflections. If you're shooting at night, of course, you have a much easier job because once the room is dark, it's dark. During the day, though, you have to be more careful because light coming in through the window bounces off of your clothes and creates reflections.

Finally, it's important to put the lens as close to the glass as possible. In fact, if you can press the lens right up to the glass, you can eliminate virtually all internal reflections. You might also ask a companion to hold a dark towel or black t-shirt behind you to block light entering from the sides.

Q How can I take good close-up photos with my compact camera?

A Many compact cameras are able to produce surprisingly high-quality close-up photos without any special accessories. This is because the lens design of many compacts enables them to focus within a centimeter or two of the front lens element. This means that the camera can produce 1:1 ratio (life-sized) images at those distances. Also, because of the smaller size of the sensor, compacts have extensive depth of field.

However, in order to take close-up photos with a compact camera, it's important to remember to put it in the Close-up or Macro mode. This mode is indicated by a tulip icon on the Mode dial or in the Exposure Mode menu. In this mode, the camera automatically sets a small aperture for maximum depth of field and puts the lens in its close-focusing position. Some cameras may also turn on the flash (check your manual to see if yours does this and if you can shut it off).

If your camera has both an optical viewfinder and an LCD screen, it's important to use the LCD screen when shooting close-up photos. When using the optical viewfinder, there is a slight difference between what it shows you and what the lens sees. When using the LCD screen, you see exactly what the lens sees.

Q What are some of the benefits of using a dSLR camera for close-up photos?

A When it comes to serious close-up photography, the dSLR is unparalleled in both quality and flexibility. While I expect mirrorless cameras to eventually catch up, the dSLR is, at present, the leader of the pack when it comes to macro work.

Here are some of the reasons why:

- **No parallax.** Although many types of digital cameras display the image that is seen by the lens via their LCD screens, the dSLR is the only camera that has a true optical viewfinder that shows you what the lens sees. In bright surroundings, an optical finder is a huge advantage.

- **Lens variety.** There are many specialty close-up and macro lenses available for dSLR cameras.

- **Close-up accessories.** There are many accessories for interchangeable-lens cameras that aren't available for others, such as extension tubes, macro bellows, screw-in close-up lenses, and so on.

- **More powerful flash.** A lot of close-up work requires using a flash that is not only more powerful than a built-in flash, but that can also be removed from the body and fired remotely, either wirelessly or via a PC cord.

Q If I'm using a dSLR, is a macro lens the best choice for taking close-ups?

A When it comes to taking close-ups, a dSLR gives you a lot of options to help you get closer to your subjects. However, in terms of sheer optical quality, nothing surpasses a good macro lens. A true macro lens is one that is designed to reproduce subjects at a 1:1 ratio (life-size) or greater on the focal plane. Many lenses on other types of cameras (and some made for dSLRs) that are described as macro lenses are not actually true macros. It's important that you read the specifications of a lens and find out what its true reproduction ratio is before you buy it and take the claim that it's a true macro lens with a grain of salt.

There are two types of macro lenses: Zooms that have a macro setting and *primes*, which have a single focal length. While zoom lenses are convenient and their quality can be very high, a prime macro lens is always sharper, usually smaller, and almost always has a faster maximum aperture. If you do a lot of close-up photography, owning a true prime macro lens is a good investment. Prime macro lenses come in several focal lengths (50mm, 105mm, and 150mm are common), but they all share the ability to close-focus on small objects.

Q What are some cheaper alternatives to a macro lens?

A If you own a dSLR (or MILC) but only take occasional close-up photos, you may not want to invest several hundred dollars in a dedicated macro lens. Fortunately, there are a few inexpensive alternatives, and most do a very respectable job.

Some of the following items make excellent accessories to use in conjunction with a macro lens, and most pros probably own all of them:

- **Extension tubes.** Just as their name implies, these are spacing tubes that go between the camera body and the lens. They reduce the close-focusing (from lens-to-subject) distance, and can be used with any lens that fits your camera body. They are useful with both prime and zoom lenses.

- **Screw-in filters.** These are sold in sets of three or four, and in increasing levels of magnifying power (a typical set includes four filters: +1, +2, +4, and +10). They are sold to match the front diameter of your lens. They're also inexpensive (you can buy a kit of four for under $10 on Amazon) and the whole set fits in a shirt pocket.

- **Lens reversing ring.** This is an adapter that allows you to mount a prime lens backward on your dSLR body. Turning the lens around greatly reduces the near-focusing distance and, thereby, increases subject magnification.

Q How do extension tubes work, and what effect do they have on image sharpness and exposure?

A Extension tubes increase the distance from the rear lens element to the camera's sensor plane. The longer the tube is (and the farther the lens is from the sensor), the closer the lens is able to focus, and the more your subject is magnified.

Tubes are generally sold in kits that include three levels of increasing length. You can use them individually or in any combination. The actual minimum focusing distance is based on both the length of the tube and the focal length of the lens. I almost always use two of the three together — particularly if I'm shooting something very small, like an insect. Extension tubes also work nicely with zoom lenses, which add a lot of framing flexibility.

Because extension tubes contain no glass, they have no effect on image sharpness. However, because you are focusing much closer to your subject, the depth of field is going to severely decrease. Also, you lose some light due to the extra lens-to-sensor distance, but if the tubes are coupled to your camera's electronics, the camera automatically compensates. Therefore, it is important that you buy a set of extension tubes that is designed for your particular camera body.

Q What is an extension bellows, and how does it work?

A An *extension bellows* works on the same principle as an extension tube — it allows you to extend the distance between the lens and the sensor to increase subject magnification. The primary difference between the two is that you can continuously contract and expand the length of the bellows within its range. Also, using an extension bellows saves a tremendous amount of time because you don't have to constantly remove and change tubes to adjust image size. Generally, an extension bellows also provides much greater magnification than a set of tubes. In addition, some bellows, like the Novoflex unit shown here (hpmarketingcorp.com), also enable you to shift and/or tilt the angle of the lens plane much as you would with a studio view or field camera.

Photo courtesy of Novoflex/HP Marketing.

Q Do screw-on type, close-up filters provide good image quality?

A Screw-on filters are pretty much the low end of close-up lens accessories. However, while some photographers might sneer at their inexpensive quality (I've seen them for under $10 on Amazon and eBay), they actually do a pretty good job. Screw-on filters are nothing more than glass magnifying lenses that, when attached to your lens, reduce the close-focusing distance and increase effective magnification.

There is no question that these filters do reduce sharpness, and they tend to be sharper in the center than at the edges, but you can gain much of that sharpness back by stopping down your lens. I've had a kit of these in my shoulder bag for the last 30 years, and I consider them well worth the tiny investment.

Q Why do some of my close-ups taken with flash have a dark shadow across the bottom?

A The first time that this happened to me, I was photographing bees and butterflies in my garden and not paying particular attention to the images on the LCD screen. The bugs were being far too cooperative, so my attention was on them rather than camera settings.

When I started to review my images, I found that *a lot* of them had these strange black foregrounds. I wasn't using a lens shade or thick filter, so I knew that it couldn't be my lens vignetting. Then I realized that what I was seeing was a shadow caused by something blocking the built-in flash. Finally, it dawned on me: I had all three extension tubes stacked together (something I rarely do), and they were so long they were actually blocking the flash.

The only option was to switch to an accessory flash that, because it's mounted to the camera's hot shoe, is a few inches higher than the built-in flash unit. So what you're seeing in this awful shot is the result of the flash being blocked at the bottom. The thistle blossom is also extremely overexposed because the camera's Through-the-Lens (TTL) metering is trying to compensate for the light lost by the blocked flash.

Q How can I maximize sharpness in a close-up photo?

A While most of us would like to blame not owning a top-flight macro lens for flaws in the sharpness of our macro shots, the reality is that there are a lot of other things that detract from sharpness. You can fix most of these by being more methodical in your technique. Before you spend the kids' education fund on lenses, try the following solutions:

- **Use a tripod.** Use one every time you shoot close-up photos and you'll see an instant quality gain.

- **Use a self-timer.** As long as your subjects are not moving (seashells, coins, paw prints on a muddy path, and so on), then using a self-timer or remote control will stop vibration caused by pressing the Shutter Release button.

- **Use flash.** Electronic flash fires at speeds that are usually far more brief (thousandths of a second) than your shutter. The closer you are, the more brief the exposure.

- **Use small apertures.** Depth of field is very minimal in close-up photos, so you need all that you can get. Just remember that, as you switch to smaller apertures, you are also using longer shutter speeds, so there are diminishing returns if you are shooting a moving subject.

Q How can I get close to ground-level subjects?

A If you're going to get involved in close-up nature photography, and particularly if your subjects are going to be insects and plants, one thing you learn quickly is that you'll be spending a lot of time on your belly. It comes with the territory. The problem with shooting subjects that are close to the ground — even if you don't mind lying down a lot — is that it's hard to not only keep the camera steady at such odd angles, but also to see the viewfinder. Here are some ideas for making your life on the ground easier:

- **Use an articulated LCD screen.** If your camera has an articulated (tilting) LCD screen, life is good. By flipping it away from the body, you can compose far more easily.

- **Use an accessory LCD screen.** Several companies make accessory view-finders that provide a screen up to 9 inches (diagonally). They can be placed at any angle, or even mounted on a small light stand or mini tripod. With an extension cord you can place them just about anywhere.

- **Invert your tripod's center post.** Many tripods have a reversing center post that allows you to put the head of it close to the ground.

Q **What are some alternatives to tripods that are useful for taking close-ups?**

A One of the problems with getting good, close-up nature photos is that nature doesn't always exist in areas where it's convenient to bring a tripod. I've found myself climbing trees, hanging over rocks, and kneeling on muddy stream banks trying to get good photos. As much as I love my tripods, I've had to devise other ways to support the camera.

One of my favorite alternatives to a full-sized tripod is a goofy-looking line of mini tripods called GorillaPods (http://joby.com). They are tiny, multi-jointed tripods that cling to rock surfaces, wrap around tree limbs, and pretty much go anywhere a tripod won't.

Photo courtesy of JOBY.

A rolled-up sweater also makes an excellent camera support. Simply create a little nest in the sweater to cradle the camera body. Make sure that you leave free space around the lens so that it can autofocus.

Another great steadying device (and one that most photographers take on safari in Africa) is a beanbag. You can buy one, or make your own by filling an old wool sock with dried beans and sewing it closed. I've used a homemade one with a 400mm lens resting on a log, and it works great.

Lastly, clamps like the Manfrotto Superclamp (www.manfrotto.us) can also be adapted to secure a camera almost anywhere.

Q What is the best time of day to photograph insects?

A The time of day that you choose to photograph insects (and we'll throw spiders into this group, as well, even though they are really arachnids, not insects) really depends on how active you want them in your photographs. Most insects — especially those that fly — are much easier to find and photograph shortly after dawn or a light rain because their wings are laden with dew. Actually, until the sun burns off the extra weight of the moisture, they can't fly at all. It doesn't take more than a few minutes of strong sunlight to dry their gossamer wings. However, once it does, they're off on a nonstop ballet. Insects tend to settle down again just before sunset, which is also a nice time to shoot because the light is softening.

Some insects, like bees and butterflies, tend to be active in and around gardens on hot sunny days. This is when I do most of my photography because I like some action in my photos. Finally, don't forget that many insects (like moths and many spiders) are active at night, so just pop on your flash and you'll get some great insect photo opportunities. I scout around for webs during the day since it's kind of tough to spot them at night.

Q What are some other tips for photographing flying insects?

A When it comes to getting good, sharp photos of flying insects, there are two issues that you have to confront: They're small and they fly. Once you get past these two obstacles, it's a piece of cake. Here are a few tips to make the job easier:

- **Study.** Getting closer is largely a matter of both patience and knowledge. Read as much as you can about the particular insect that you want to shoot.

- **Observe.** There is no better way to learn what an insect does than sitting and watching it for a few hours. I've been watching dragonflies for years, so I know that they tend to come back to the same spot to rest over and over — and I also know which plants they favor.

- **Wait, don't chase.** A dragonfly returns to the same flower blossom hundreds of times in a few hours to get every last drop of nectar. Find one in good light (or set up a flash unit on a light stand) and wait for them to come to you. I was able to take more than 50 frames of the dragonfly shown here in less than an hour without moving my camera an inch.

Q How can I prevent the flash from overpowering a close-up and make it look more realistic?

A Flash is a wonderful thing for illuminating close-up photos, but when it is too obvious it becomes a distraction. As with spice in a recipe, a little bit tends to go a long way. Too little flash is almost always better than too much, and getting rid of the harshness and excessive brightness of a flash in editing is not easy.

The best way to prevent the flash from appearing too obvious is to create a natural-looking, flash-to-daylight ratio. In order for flash in a close-up to look natural, it should provide less light than the ambient light. Most built-in flash units have a compensation control so, if you see that the flash is overpowering a shot, you can dial it back by 1 stop or so. In general, flash looks best when it provides about 1 stop less light than the existing daylight.

Also, I almost always use some type of diffuser when I shoot close-up photos, particularly if I'm using an accessory flash. I actually use a small section of a white plastic milk carton held in front of the flash head, and it works nicely. Softening light in this way makes it less directional and, as a result, more gentle and natural-looking.

Q When shooting close-ups, in what situations should I use autofocus?

A The decision whether to use autofocus when shooting close-up photos depends on how critical the focus must be, the subject you're shooting, and how much depth of field is available. For photos like the peony blossom shown here, I generally use autofocus, but only if there is enough light to provide the aperture that I need for sufficient depth of field.

With insects or other subjects with which I am using extreme magnification (and I know that I am not going to have enough depth of field to keep the subject sharp), I usually switch to manual focus. That way, I can focus more precisely on a particular part of the subject — such as the head of a dragonfly.

Q What are the advantages and disadvantages of a built-in flash?

A The most obvious advantage of a built-in flash is, of course, that it's built in to your camera. Where your camera goes, your flash goes. Having a flash that's always at the ready means that the instant the light gets too low, the camera provides its own. If you're in the green mode on many cameras, it detects the low light and turns on the flash without you even having to ask.

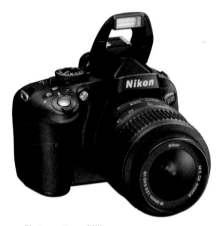

The biggest disadvantage of a built-in flash is that it has a limited distance range — rarely more than 12 feet or so. Another is that, because the flash is attached to the camera, you can't vary its angle at all. So while it might be nice to light a subject with the flash raised above the camera, or to the left or right, you can't do that with a built in flash.

Photo courtesy of Nikon.

While you can't use advanced techniques (like bounce flash) with a built-in flash unit, at least one company (www.lumiquest.com) makes a small diffusion screen that allows you to soften the quality of light for portraits and other nearby subjects.

Photo courtesy of LumiQuest.

Q How does the flash know how much light is needed for a scene?

A Virtually all digital cameras use a system of flash exposure called Through-the-Lens (TTL) flash, and both the flash and the ambient-light exposures are controlled by the camera. The beauty of this system is that the light from the flash is actually measured at the camera's sensor plane (not at the flash unit as it was with many older flashes) and this makes it exceedingly accurate. Also, because the flash and ambient exposures are measured behind the lens, any lens accessories — like filters, extension tubes, or diffusers — are already taken into consideration.

The moment that you press the Shutter Release button, the flash (whether built-in or an accessory) is activated, the camera's light meter measures the ambient light, and then the flash fires a few very brief test flashes. The camera uses these test flashes to determine how much flash power is going to be needed to illuminate the scene. However, these pre-flashes are extremely brief and impossible for you to see. The camera then combines the information from the pre-flashes with the info from its ambient light meter readings, and determines how much flash power to use and how best to balance it with the existing scene light.

Many cameras also use additional information — like the distance to the subject (based on information provided by the AF system), and even the color of the subject — to determine how much flash exposure to provide.

Once the flash hits the subject, the light bounces off of it and back through the lens. The camera then determines when a sufficient amount of light from the flash has hit the subject. When a correct exposure is achieved, power to the flash is killed. All of this, of course, happens in a fraction of a second, and often the duration of the flash is measured in thousandths (even ten thousandths) of a second. Is it any wonder that camera manufacturers are anxious to recruit students from schools like MIT?

Q **Why do subjects that are close to the camera often appear washed out in my photos?**

A Despite the sophistication of the Through-the-Lens (TTL) flash system, there are a few limitations that you must honor in order to get a good flash exposure. One of these is the *minimum flash distance*. All flash units — especially built-ins — have a minimum distance (typically around 6 feet, but see your manual) at which they can provide a good exposure. If you get inside that limit, your subject will be overexposed and look washed out. On some cameras (and with most accessory flashes), you may be able to reduce the power and shorten that distance, but there is still an absolute distance for getting good exposures.

All flash units also have a maximum distance range. Once your subject is outside that range, your photos will be underexposed (though the drop-off from good exposure to underexposure is gradual). You can increase the maximum distance by increasing the ISO speed, and you can double the maximum distance of the flash by multiplying the ISO by a factor of four (it's a physics thing). If you want to extend the flash range from 20 to 40 feet, just multiply the ISO by four. For example, if the camera is at ISO 100, you would increase it to ISO 400.

Q How does the Red-eye Reduction flash mode work, and are there any disadvantages to it?

A Red eye is a phenomenon caused by an electronic flash reflecting off of the rear retinal surface of the human eye (and it happens with animals as well, although the colors are different). With animals, what you are seeing is the flash bouncing back from a reflective layer in the retina. When shooting humans, you are seeing a reflection of the blood vessels that feed the eyes, thus the red color.

The *Red-eye Reduction* flash mode is designed to eliminate the scary red look in your friends' eyes and — in concept, at least — it's a wonderful idea. In reality, it's a little less than perfect. The way that this mode works is by firing a series of rapid pre-flashes bright enough to cause the pupil of the eye to contract and hide the rear portion of the retinal surface. The problem is that the pre-flashes are very visible to the human eye. Also, they last what seems like an interminably long time — long enough to make your subjects (including little bunnies) turn away if they don't want to be photographed.

Red eye is really only an issue when you aim your flash (and lens) directly at your subject. You can eliminate it by simply shooting your flash portraits at a slightly oblique angle, or by bouncing the flash into a diffuser or off the ceiling.

Q What is fill flash, and when would I use it?

A If you've ever been to a wedding where the official photographer was shooting photos with flash in bright sunlight, you've probably wondered why she needed to use flash outdoors. The answer is simple: contrast. Direct sunlight, particularly toward the middle of the day, is very harsh and causes less than flattering shadows on people's faces — especially in eye sockets, and under noses and lips. By firing a small burst of what is called *fill flash,* the photographer opens up those dark shadows.

You can (and should) do the same thing with your outdoor portraits. Most digital cameras offer either a specific fill-flash mode or an option for you to turn on the flash whenever you need it. Because fill flash looks better when it is a touch less bright than the ambient lighting, your camera automatically gives the flash about 1 stop less exposure than the daylight is receiving.

BONUS TIP:

If your camera has a Flash Exposure Compensation feature, dial the compensation down. This creates a more pleasing balance between daylight and the flash.

Q

What is Slow-Sync flash mode, and in what situations is it used?

A

If you're in a really vibrant place at night, like the Las Vegas Strip, you may want to shoot some pictures of your friends. The problem is, if you use the flash in a normal mode, the camera will most likely expose your subjects nicely, but the background will fall into darkness. Many cameras solve this issue with a flash mode called *Slow Sync flash*. In this mode, the camera fires the flash normally (at the beginning of the exposure), but then leaves the shutter open long enough to capture the surroundings.

I used Slow Sync flash mode to take this photo of a wandering human Statue of Liberty in Times Square. I shot a few frames in the normal flash mode, but the background came out too dark. In Slow Sync flash mode, the camera left the shutter open long enough to record the neon madness.

BONUS TIP:

If your camera doesn't have a Slow Sync flash mode, you can probably create the same effect by choosing the Night Portrait exposure mode.

Q

What are the benefits of owning an accessory flash?

A While a built-in flash is convenient, easy to use, and works well in basic photo situations, to get the most from flash, you need a more powerful accessory unit. Most accessory flash units only cost several hundred dollars, and owning one opens a whole new world of photo opportunities and techniques. Here are some good reasons for putting an accessory flash on your next birthday list:

- **More power.** A built-in flash has a maximum distance range of about 12 feet. A good accessory flash can light up a subject up to 40 feet away — even more if you raise the ISO. While you may not find a lot of subjects that are 40 feet away, an accessory flash also enables you to use techniques like bounce flash in situations where power and distance are factors.

- **More flexibility.** Many accessory flash units have heads that tilt and swivel. This allows you to do things like bounce flash off of ceilings and walls. Also, because the flash can be removed from the camera, you can use professional light modifiers, like umbrellas and softboxes.

- **Multiple modes.** An accessory flash gives you a choice of several operating modes that can be custom fit to a particular subject. Specialty modes, like Front- and Rear-curtain sync, as well as Manual mode, allow you to create a variety of special lighting effects.

- **Special effects.** Many accessory flash units are capable of creating special lighting tricks, like stroboscopic motion sequences and high-speed motion stopping.

- **Zoom control.** With many flash units, you can match the output of the flash to the focal length of the lens that you're using. The spread of the light also automatically adjusts to zoom lens changes.

- **Wireless flash.** Many advanced flash systems, like the Nikon Speedlights, enable you to fire one or more flash units wirelessly. You could, for example, set up several units for a portrait shot without any physical wiring between them.

> ## Q What features should I look for when purchasing an accessory flash?

A Purchasing a quality flash unit is a fairly big financial investment, so it's worth a bit of studying before buying. You can buy a flash unit made by your camera's manufacturer or from a third-party company — the latter are often a bit cheaper and probably operate just as well. Most flash units within a certain price range share similar features, but it's worth your time to compare several units and match one to the types of pictures that you take.

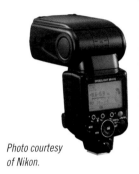

Photo courtesy of Nikon.

The following are some features worth considering:

- **Power.** The power of a flash is measured by its Guide Number. The higher the number is, the more power the flash provides. Power equals distance when it comes to flash, and more is always better.

- **Tilt/Swivel capability.** In order to get the most from any accessory flash, the ability to tilt (up and down) and swivel (side to side) is important. This allows you to bounce light off of walls and ceilings.

- **Wireless capability**. The ability to control one or more flash units from behind the camera without any wires is priceless. However, there is a literal price for it.

- **Mode flexibility**. Specialty modes, like Rear-curtain sync (which is useful for creating realistic images of moving subjects, like the one shown here) provide a broad range of creative options.

Q What is the simplest way to soften the light of my accessory flash for portrait shots?

A While flash is a very efficient source of lighting photos, it's also unforgiving unless you modify it in some way. Flash is essentially a very small light source, and the smaller a light source is, the more direct and harsh it is. Portraits, in particular, almost always look best when shot with a softer, more diffused light source.

There are a number of ways to soften the flash for portraits and other subjects, or still-life pictures. In a studio, photographers often use things like umbrellas or softboxes. With an on-camera flash, though, your options are a bit more limited. One method is to bounce the flash off of a ceiling (see the next FAQ for more details), but that requires both a ceiling and a flash that's powerful enough to do the job — and you can't count on always having both of those.

A better option is to use a small diffuser, such as the Pocket Bouncer from LumiQuest (www.lumiquest.com), shown here. This type of diffuser mounts directly to the flash head and provides a bounce surface that you can use anywhere. Not only does it spread the light evenly, but it is also extremely efficient and wastes almost no flash energy.

Photo courtesy of LumiQuest.

Q

What is bounce flash, and how does it work?

A

Bounce flash is a method that you can use to soften the light of a flash when shooting portraits if you are lucky enough to have a white ceiling or wall nearby. It creates softer, more attractive lighting. Instead of firing the flash directly at your subject or into a diffusion device, you tilt the head of the flash to bounce it off of the ceiling or wall. This technique works because the larger a light source is, the softer the light it produces will be. Also, because the light is coming from above (or from the side), it creates a gentle shaping or modeling to faces that you won't get with direct flash.

Using bounce flash is easy if you're using a Through-the-Lens (TTL) flash/camera combination because the camera automatically cuts off the flash when there is enough light for a good exposure. It is important that you use a white bounce surface because the flash picks up the color of the wall or ceiling.

Also, the flash has to travel much farther — first, to the bounce surface, and then to the subject. As a result, batteries run down much faster if you're doing a lot of bounce flash. For example, if your subject is 10 feet away and you use direct flash, it only has to travel 10 feet. If you bounce it off of the ceiling, though, you have to consider the distance from the flash to the ceiling, and then add the distance from the ceiling to the subject. This often dramatically increases the total distance, which is why a powerful flash is a very handy thing to have.

Whenever you are using bounce flash, set the angle of the flash head carefully so that the beam of light from the flash falls precisely on the front of your subject, rather than in front of or behind them.

Q What effect does the Flash Exposure Compensation control have on my built-in flash?

A *Flash Exposure Compensation* is an incredibly useful feature in almost every flash situation because it enables you to adjust the ratio of the flash illumination as compared to the ambient lighting. This is particularly helpful with built-in flash because, unlike when using an accessory flash, you have almost no other options available to control the amount or intensity of the light.

When taking an informal portrait, adjusting the intensity of the flash so that it's 1 stop or so less than the ambient lighting can create a more natural look between the two light sources.

I often use Flash Exposure Compensation with macro subjects as well. It allows me to illuminate dim subjects, and create a more natural-looking ratio between the daylight and the flash.

Flash Exposure Compensation is usually controlled by a combination of pressing a button on the camera body and adjusting a dial. Typically, you can either decrease or increase the level of flash over a range of several stops in 1/3 increments (see your camera manual for the exact range).

Q How do I avoid flash glare from glass and mirrors?

A If you've ever tried taking a photo through a window with the flash turned on you get an instant reminder of something you learned in fifth-grade science: light always travels in a straight line. If you turn on the flash when standing directly in front of any flat, reflective surface (such as a mirror, a window, a shiny car fender, and so on), the light goes right back where it came from — the camera. What you end up with is a big, glaring glob of light in the middle of your photo and, usually, a very underexposed scene behind it.

The reason this happens when shooting through windows is because the flash is fooled by the dimness of the room that you're in and turns on automatically. The simplest way to beat this is to just turn off the flash. But what if you want to shoot a photo in a room with a lot of glass and you need the flash? As long as you stand at an angle (usually 45 degrees works) from the reflecting surface, the light bounces away from the camera. You may still have to adjust the exposure, however, because the camera's meter may see the flashback anyway and be fooled into underexposing the scene.

Q **What is the purpose of taking the flash off of the camera?**

A Whether you are using your flash in direct mode (that is, it's aimed directly at your subject), or bouncing it into a diffuser or off of a ceiling, the light is always essentially coming from the same origin: the camera. While this angle is fine for illuminating your subject, it's hardly the most natural or creative-looking lighting. In the real world, light often comes from many directions — such as, behind you or your subject, or from the side. The more natural your flash looks the less obtrusive it will be in your photos.

In order to imitate the light of the sun a bit more and to provide a wider variety of lighting angles, many photographers choose to take the flash off of the camera. There are two ways to do this: The simplest is to connect the flash to the camera body with an off-camera extension cord. One end of the cord plugs into the flash and the other into the camera. The only limitation of using an off-camera cord is, of course, its length (and the fact that you now have yet another cord in your life). The other option is called *wireless flash.* I cover this in more detail later.

Wedding and outdoor portrait photographers often take the flash off of the camera because holding the light above and slightly to one side of a subject provides a more natural-looking light. It also prevents obvious flash reflections in the eyes. Holding the flash at arm's length and aiming it down at the subject's face a bit mimics the light of a low-angle sun, creating a very pretty look.

Macro photographers also use off-camera lighting to light small subjects from the side, add a bit of form to them, and bring out surface textures. You can even hide a light behind some subjects to create a backlight.

Q What is wireless flash, and for what is it used?

A One of the most popular innovations in flash photography in recent years has been the introduction of wireless flash systems. This technology uses either a radio signal or a beam of infrared light emitted from a Master, camera-mounted controller unit (or an accessory flash that has the capability to act as a controller) to fire remote flash units without being connected to the camera in any way. In order for your camera to use such a system, however, it must be compatible with wireless flash technology.

The ability to not only fire, but also to adjust the power of the flash output from the camera without the physical limitations of a PC cord, means that you can change (or tweak) your lighting to an almost infinite degree without leaving the camera position. For example, a studio photographer can set up a number of flash units around the studio, and then adjust the output of each one from behind the camera. He can then fire test shots and immediately check the results on his LCD screen or tethered computer.

Photo courtesy of Nikon.

The opportunities this has created for sports and wildlife photographers are equally amazing. For example, if you mount a flash unit over the backboard at a basketball game, you can use the action-stopping power of flash while shooting from anywhere around the court.

Photo courtesy of Nikon.

Q How many wireless flash units can be used simultaneously?

A The exact number of flash units that you can fire simultaneously depends on the system that you're using and, to a large degree, your budget. In practical terms, though, unless you're doing serious still-life work, two or three flash units is probably enough to handle a lot of different types of shots.

For example, many fashion photographers use one on-camera flash as their main light source and controller, and two more units close to the model. Also, unless you're skilled at placing individual lights, you can sometimes end up creating more problems than you solve if you're using more than a few. Remember that each unit in a setup is casting both highlights and shadows. Unless they are positioned with great care, you spend much of your time tracking down errant bits of light and shadow.

In macro work, because the subjects are usually so close to the lens, one way to mount the extra units is in a ring around the front element of the lens (as shown here with the Nikon R1C1 system). This setup provides a quick approach to lighting small subjects, but still gives you control over how much power goes to each unit.

Photo courtesy of Nikon.

Q

What is the best focal-length lens to use for individual portraits?

A

Traditionally, the preferred lenses for taking individual head-and-shoulders portraits (or even waist-up portraits) are medium telephoto prime or zoom lenses in the 70 to 135mm range (in 35mm equivalent). In fact, if portraits are something that you like to shoot, a zoom in the 70-150mm range (again, in 35mm equivalent) is an ideal second lens.

A medium telephoto lens works well because the slightly long focal length enables you to stay a few feet away from your subject and still fill the frame. Nothing intimidates a subject more than a camera pushed up a few inches from her nose. Photographer Jennica Reis shot both of the photos below using a Canon 50mm lens that, with the 1.6X cropping factor of her camera, was (roughly) equal to an 80mm.

Photo courtesy of Jennica Reis.

Photo courtesy of Jennica Reis.

Lenses in this range also tend to create a very pleasing facial perspective and avoid exaggerating facial features (noses and chins) the way that a wider lens might. Medium telephoto lenses also have an inherently shallow depth of field, which is good when it comes to using the selective-focus technique. A longer-than-normal focal length combined with a wide aperture (f/5.6 or wider) creates a very shallow depth of field that, in turn, enables you to toss the background gently out of focus.

Q What are the biggest mistakes people make when posing subjects for portraits?

A Probably the biggest mistake that photographers make when posing portrait subjects is just that — they *pose* them. Formally posing one or more people is a skill that takes a lot of years to learn. It's also something that most subjects don't enjoy (when was the last time you enjoyed stiffly posing for a camera?). Rather than posing your subject, try to find a position in which she feels naturally comfortable, such as sitting at a piano or kneeling in a garden.

Photo courtesy of Jennica Reis.

Another mistake that photographers make is *telling* (not asking) people to smile. Personally, I hate smiling for pictures (Grinch that I am). The moment that someone asks me to smile, I start making faces. Often, it's better to allow your subject's mood to create her facial expression. This is especially true for kids, whose faces are always a good barometer of their true feelings. Unlike adults, children haven't yet learned how to disguise what they're experiencing.

If you're photographing more than one person, try just allowing them to interact with each other rather than mugging for the camera. This idea works especially well with children. Also, it's very important that you have your act together before you begin your portrait session. Trying to get someone to relax while you're setting up a tripod or fussing with a lens is a sure way to lose their interest.

Photo courtesy of Jennica Reis.

Q **What are some simple creative changes that I can make to improve my portraits?**

A Turning an informal picture opportunity into a truly fun and interesting portrait is not magic — it's more about making your subjects feel like they're a part of the process and revealing something about their unique personalities. In the shots shown here, photographer Robert Ganz has taken ordinary moments and turned them into iconic portraits of youth.

Here are some simple tips:

- **Use humor.** This is particularly important if the person that you're photographing is someone who has a funny streak. Some kids are born comedians, and if you bring that out in the photos, they'll cooperate endlessly.

Photo courtesy of Robert Ganz.

- **Use a prop.** With kids and adults it's much more relaxing for them to be photographed doing something with their hands — even if it's just holding a fishing pole, like the timeless portrait of summer shown here.

- **Make eye contact.** The eyes are the most emotive part of the human body. Therefore, getting your subject to make eye contact with the lens (and, in turn, the viewer) is very important. Whether your subject's mood is happy, sad, mirthful, sexy, or just plain goofy, the eyes reveal it.

Photo courtesy of Robert Ganz.

- **Keep it simple.** Don't overcomplicate portraits: Keep your focus on the person and her personality.

- **Choose a plain background.** Clutter or busy backgrounds compete with your subject for attention — and often the background wins.

Q Is it okay to break the rules of composition to increase interest in a portrait?

A Rules, they say, are meant to be broken. This is especially true when it comes to portraiture. Every person that you photograph is unique. Your subject's personality and mood — rather than conventions — should guide you when composing photos. There probably isn't a photography book in existence that recommends that you push your portrait subject to the far edge of the frame, yet this technique works beautifully in this charming shot by Jennica Reis.

Photo courtesy of Jennica Reis.

There's something about the empty space surrounding the subject that draws your attention to her face. Do whatever it takes to make a photo work: Get too close or far away, or face your subject out of the frame. When you experiment, both you and your subject have a lot more fun.

Q What is the best lighting for shooting outdoor portraits?

A Though it's certainly not a rule without exceptions, when it comes to outdoor portraiture, the best light is the softest. The reasons are obvious: Soft light is gentle, and it helps create form and modeling, without introducing the fierceness of contrast and shadows. It's also easy to meter. The best soft light is found on slightly overcast days and in areas of open shade.

Lightly overcast days are a blessing in many ways. Firstly, the illumination on these days tends to be very constant. Unlike brilliant sunny days, working with a light cloud cover means that you're not continually readjusting exposure or trying to figure out how to grapple with things like facial shadows. Open shade offers the same opportunities. The nice thing about shade is that it's usually easy to find even on the sunniest of days. Shade tends to be a bit dimmer on a sunny day than on an overcast one, but it is also cooler.

Photo courtesy of Robert Ganz.

Of course, a sunny day also has its own cheerful beauty and warmth — particularly early and late in the day. The problem is that, as the sun gets lower in the sky, shadows get longer, and the color and intensity of the light shift much more quickly.

Q How can I get adults to relax for portrait photos?

A In many respects, adults are harder to pose than kids because they are a lot more self-conscious about their looks. Also, whereas kids often love being the center of attention, most adults despise it. The following are a few tricks that you can use to get adults to relax:

- **Sit them down.** Whether they're at the local beach or in front of the Eiffel Tower, adults look horribly nervous when they're standing. Give them a beach towel or a park bench to sit on and they'll relax.

- **Give them a prop.** Adults never seem to know what to do with their hands when they're being photographed. Hand your father a golf club or give your grandmother a ball of yarn and some knitting needles. They will instantly look more relaxed and in their element.

- **Tell them what you're doing.** To non-photographers, everything that you're doing is a mystery, and digital cameras are still new to a lot of older people. Tell them why you're changing lenses, or that it's time to change memory cards because one is full.

- **Get away from the camera.** Invest $15 or so in a wireless remote for your camera and put it on a tripod. If you pose a friend sitting in a lawn chair, and then sit down yourself, you can fire loads of good pictures when your friend doesn't even know he's being photographed.

- **Show them the LCD screen.** If your photos are coming out nicely, pause for a minute to show the subject your results. Once she sees that you know what you're doing (and that she looks okay) she'll relax.

- **Keep it short.** Don't torture your subjects. A portrait session of 10 or 15 minutes may not seem like enough time to you, but to someone on the other side of the lens it's an eternity. Keep your sessions short and sweet and your subjects will pose for you more frequently.

Q How can I get kids to cooperate when having their picture taken?

A When it comes to getting their pictures taken, there are two types of kids: Those who run and hide when the camera comes out, and those who run further and hide. Actually, after children have a few good experiences with photography, they are generally very good about being photographed. The advent of digital cameras and the ability for kids to instantly see themselves seems to make them feel more like they are participating in the process.

Probably the simplest way to get kids to cooperate is to get them involved in some kind of activity: Drawing on the sidewalk, talking quietly with a friend in a tree house, or just reading by a sunny window. The more that kids feel in charge of their world, the more confident and happy they are. This is especially true when being photographed.

Photo courtesy of Jennica Reis.

Another way to make children comfortable is to pose them together. They usually gain courage (and then some) in numbers. Also, the natural interactions between them often solve the dilemma of finding a good pose.

Photo courtesy of Jennica Reis.

Q What is the best way to get candid photos of kids?

A Most of the best photos of children are taken when they have no idea they're being photographed. Candid photos capture them doing what they do best: being kids. The hardest part about getting candid photos is that children are smart little critters — they know what you're up to almost before you do.

The only defense against this is to keep them busy doing something that they enjoy, such as swinging in the backyard or washing the dog. This way, what they're doing trumps their curiosity about what you're doing. Distance also helps, so a good medium telephoto zoom lens (70-300mm) is useful. Younger children, especially, think that if you're more than a few feet away, you can't possibly be taking their picture.

Photo courtesy of Robert Ganz.

Q Should pictures of people always include faces?

A Although most of us think of a portrait as an image that includes a face, there are times when including a subject's face is simply not important. For example, this stunning photo of a mother's hands gently cupping a baby's head tells a story that is universal in theme and emotional content.

Photo courtesy of Lisa Aliperti.

There are actually many situations in which a face is superfluous to a portrait, such as when photographing someone in silhouette or shooting a subject from behind. For example, a portrait shot from behind of two fishing buddies sitting at the edge of a lake tells the story of the moment just as well as one that includes their faces.

Q How do I create that bright rim light that I see in some outdoor portraits?

A A hair light or *rim light,* as it's often called, is an effect that you frequently see in studio portraits. Photographers create it by aiming a bright studio flash right at the back of a model's head. The bright rim occurs because the light passing through the hair that frames the face is brighter than the light on the subject's face, and it's intentionally allowed to overexpose.

You can create the same look outside by using the sun as your backlight. Place your model so that the sun is coming from behind her head (or slightly to the side, as shown here), and then meter for her face. The light coming through her hair will automatically overexpose. You must be careful, though, to exclude the sun and even the hair area when metering (either by getting close or by using Center-weighted metering) so that you don't inadvertently underexpose the face.

Photo courtesy of Jennica Reis.

BONUS TIP:

If you're having trouble getting a good exposure on someone's face, turn on the fill flash or reflect some sunlight with white poster board.

Q How can I use the white balance control to warm up outdoor portraits taken in the shade?

A Areas of open shade make a great place to shoot portraits, especially on otherwise very harshly lit days. This is because they provide a nice soft, even light that is absent of any deep shadows or contrast. The only downside to this type of light is that it is very cool and, for most complexions, coolness is somewhat unflattering. The solution is just a simple adjustment of the white balance.

If you have the white balance set to automatic, your camera detects the coolness of the light and warms it up a bit automatically. However, if you leave the white balance set in the normal Sunny Day mode, your pictures are going to come out far too blue. Instead, look to see if your camera has an Open Shade setting. This setting enhances the red bias of your shots and warms them up nicely.

Alternatively, if you set your camera to Cloudy Day this does the same thing. Some cameras also have a color-temperature range (or even a graph) that enables you to fine-tune the color temperature. If you're shooting in the RAW

format, you can pretty much forget about the white balance because you can reset it (down to 1 degree K) during editing.

Q How can I preserve window light in portraits and open up the shadows a bit?

A Windows provide beautiful light for portraits. You can actually vary the quality and color of the light you're using depending on which side of the house you're in. For example, north-facing windows produce a gentle, even lighting, although the color tends to be on the cool side for much of the year. East and west windows provide gentle, warm light early and late in the day (respectively). For much of the day, any window facing south provides a relatively strong, warm light.

However, (with the exception of those facing north), light coming through a window can be quite bold and contrasting. One way to handle this issue is to have your subject face out of the window, and then shoot him either in profile or, if you have room to maneuver, slightly from the front. Doing this turns the window light into a front light, and illuminates the important parts of the face.

Alternatively, you can seat him sideways to the window, and then use a sheet of white poster board to bounce the light back into the shadow areas. Just aim the reflector so that it bounces light from the window back toward the dark side of your subject.

Photo courtesy of Robert Ganz.

Q What accessories do I need to take more professional-looking indoor portraits?

A Professional portrait photographers have a great advantage because they work in an environment in which they have 100 percent control over the lighting. They can create or eliminate things like contrast or lighting drama, alter the angle and position of the lighting, and even determine what time of day they want their shots to resemble. I've worked a lot in a studio and it's great fun to have that power.

Interestingly, with the possible exception of the very expensive studio lights, a lot of the tools that pros use are also available to consumers. Many are not that expensive or too complicated to use. Here are a few:

- **Bounce diffuser.** These small bounce adapters mount to an accessory or built-in flash using hook-and-eye fasteners (or an elastic band) and soften the light by slightly diffusing it. They're useful in almost any indoor situation in which you need softer light. They can also be used outdoors for fill flash.

- **Mini Softbox.** A softbox is a kind of enclosed diffuser. The flash is fired out through a translucent fabric to soften the light. Pros typically use very large softboxes (2 to 3 feet across, or more), but you can buy a smaller version, like the LumiQuest SoftBox III (www.lumiquest.com). It mounts right over your accessory flash. You can then mount that light on your camera or on a light stand.

- **Lighting Umbrella.** Umbrellas are mounted on a stand and soften the light from a flash unit. There are two types: Those that reflect the light (you aim the flash into them and the open end faces your subject) and the shoot-through type (with which you fire the flash through a translucent umbrella). With the latter, you aim the point of the umbrella at your subject and the flash points at the subject. You'll need a light stand, an umbrella, and a clamp for your accessory flash. The total cost for everything is under $100.

Q How can I take indoor portraits using the existing artificial lighting?

A Using electronic flash indoors is pretty much the norm these days and most people rely on it without giving it a second thought. If you use light modifiers with flash and are careful with your technique, you can get some very professional and natural-looking effects. Still, flash always looks like flash — it's nearly impossible to mimic the intimate, ambient light of the tungsten lamps in your living or dining room with flash, no matter how skilled you are.

If you are shooting indoors during the day, it's probably best to close the blinds or shades if they're not in the picture. Otherwise, you end up with blue light from the daylight and reddish light from the tungsten.

Taking photos by room lights is much easier in the digital era because of the high ISO speeds common to most cameras. If you bump the ISO up to 1000, 1600, or higher, there are almost no rooms in which you can't get a good exposure. It's still best not to use too high an ISO if you can void it, however, so that you minimize noise issues.

You can also help your cause by turning on all of the room lights to boost the light level. Otherwise, you have to raise the ISO and that introduces image noise. It is generally a good idea to turn off any overhead lights (such as the one over the dining room table) if they are particularly bright because these tend to create a lot of shadows in eye sockets and under noses.

Finally, because most of us are (or soon will be) using what I call squiggle bulbs (those screw-in fluorescent tubes), finding a white balance is not as simple as it was in the days of tungsten lamps. The best place to start is to set your white balance on automatic and monitor your results. If you notice an unattractive colorcast, try another balance.

Q What is environmental portraiture?

A The term *environmental portraiture* usually refers to taking photos of people in their workplace or a setting that instantly identifies their profession, such as a potter throwing clay on a wheel or a carpenter framing a house. Environmental portraits are a lot of fun because you usually get an inside look at what someone else's job or hobbies are like.

The key to making good environmental portraits is to include enough clues about what the person does so that no one has to guess. I photographed well-known Connecticut radio programmer Nick Jacobs while he was on the air. He is shown here wearing headphones and framed by hundreds of music CDs — the tools of his trade.

Q Which dSLR lenses should I take with me on a trip?

A Not that long ago, if you saw a travel photographer on the road he probably had so many camera cases it looked like he needed a Sherpa just to get to the airport. This was me. There were times when I had as many as 10 lenses with me all of the time (and the sore back to prove it).

Zoom lenses have drastically changed this scenario. Today, you can take an African safari and be well equipped with three or four lenses, or less. In fact, you could easily travel the world with just one 18-200mm zoom lens and never miss a shot.

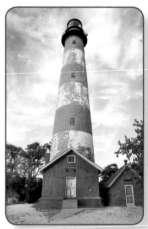

Personally, I like having more than one lens just in case one is dropped or has a mechanical problem. The following are three lenses that should cover just about any photo situation:

- **10-20mm Wide-angle zoom**. I love the extra width of a super-wide zoom when it comes to shooting big subjects, like a lighthouse or a cruise ship.

- **18-70mm Medium telephoto.** This is a great range for walking around a city or a formal garden.

- **70-300mm Telephoto zoom**. This is the lens that I use the most, for everything from candid portraits to wildlife shots. Combined with the 1.5X cropping factor of my Nikon cameras, it provides an effective telephoto range of 105-450mm.

> ## Q
> **What is the safest way to pack my camera gear for air travel?**

A Getting photo gear safely around, particularly with air travel, is almost never easy or convenient. After decades of flying, I've never lost a piece of gear to theft or damage. However, I've had a few near misses and I'm obsessive about packing my equipment. The following tips should help you get your equipment through airports safely and with little hassle:

- **Never check cameras.** Your camera gear should always travel with you on the plane. The only exception would be when using a professional (and expensive) hard-shell case made to withstand luggage handling.

- **Check airline measurements.** Buy shoulder bags or backpacks that you are *certain* fit under the seat or in the overhead compartment. Smaller airlines or airlines in other countries may have different size limitations, so be sure to check.

- **Wrap your gear.** I wrap each lens and each body in bubble wrap inside my case. I keep filters and lens accessories in soft old socks. It may take longer at security, but I know my gear will arrive safely.

- **Put your name on everything.** A company called trackitback (www.trackitback.com) sells tracking labels. You place these on your gear and then trackitback provides a reward for anyone who finds it. Over 85 percent of lost items are returned.

Q Will the metal detectors or X-ray machines at the airport harm my camera or memory cards?

A Unlike film (which is *definitely* susceptible to damage from airport X-ray and metal detector equipment), it's never been shown that such equipment harms digital cameras or memory cards. This quote comes directly from the TSA (Transportation Security Administration) website:

"None of the security equipment — neither the machines used for checked baggage nor those used for carry-on baggage — will affect digital camera images or film that has already been processed — slides, videos, photo compact discs, or picture memory cards."

However, there are concerns mentioned on some discussion boards that the stronger handheld wands could potentially harm digital media. Theoretically, you could ask for a hand inspection of your photo gear, although personally I think the security lines are long enough already.

Q Should I carry receipts for expensive photography gear when traveling overseas?

A This is a situation in which it is always better to be safe than sorry. That is, it's better to have the documentation than not. If you're traveling with an inexpensive compact or older-looking dSLR camera and a few lenses, no one is likely to question you about them — everyone travels with a camera these days. However, if you recently bought the latest, top-of-the-line dSLR and several shiny new lenses, I would absolutely bring receipts.

For United States citizens, there is no fee or problem with taking cameras out of the country. However, it is possible (although very unlikely) that you could be forced to pay duty for the gear when you return if you can't prove that you owned it before the trip. You can, of course, legally buy and bring gear back home if you want, but you are subject to paying duty on that gear if it exceeds your standard exemption. The exemption varies depending on the country that you visit, but it's typically $800 per person. For more info, see www.cbp.gov.

Q Can I buy memory cards overseas that will fit my camera?

A Memory cards, like film, are universal to all cameras — as long as you buy the right type of card for your camera. For example, an SD card bought in Beijing works just as well as one bought in New York City. However, as memory cards are so cheap these days, bring twice the amount that you think you'll need.

Check your camera's manual for a chart that shows how many images you can fit on a particular card size based on the file quality that you're using. If you run out of cards, there are a lot of Internet cafes (particularly in Europe) where you can download your cards to DVD. Alternatively, you may wish to bring a portable hard drive with you.

> **Q** What are the best ways to research good locations and interesting shooting opportunities on a trip?

A The more time that you spend researching a place, the more time you'll spend shooting, and the more interesting, off-the-beaten-path locations you'll find. The following are some of the best places to look for shooting ideas:

- **Photo-sharing sites.** Websites like Flickr and Picasa are great places to see what other people have shot. Just enter the name of a destination and you'll find thousands of photos. Be sure to read people's comments for clues about nearby attractions or the best times (of year or day) to visit. Flickr is often my primary pre-trip research tool.

- **Google image search.** This is an extraordinary asset for travel research. Image and video searches turn up a treasure trove of good visual ideas and links to useful websites.

- **Personal blogs.** People blog about everything and travel is a hot topic.

- **YouTube.** I love to see through-the-windshield videos of places where I'll be driving, and YouTube has tons.

- **Official tourism sites.** Almost every major city or historic landmark around the globe has an official site (in addition to the many unofficial ones). They also usually have links to all of the major attractions in the area.

- **Local library.** Libraries aren't the focal point of as much research as they used to be, but you can still find most of the good city guides and, often, a good map collection.

Q How can I quickly find the best shooting locations once I've arrived at my destination?

A It's tough to arrive in a place for the first time — whether it's just across the state line or another country halfway around the world — and come away with a nice album of interesting photos in a relatively short amount of time. Even if you've done a lot or pre-trip research, you still have to get to those places, and hope that the lighting and weather will cooperate.

One of the best ways to get your bearings (and you can often do this in the hotel lobby) is to spend some time perusing the postcard racks. Postcard photos not only highlight the best of the local sights and scenes, but they usually feature extremely good photography.

After all, who would publish a bad photo on a postcard? Don't just look at the cards, but buy a dozen or so; if you're in a place where you don't speak the language, you can always hold up a postcard for a cab or bus driver.

The hotel concierge is also usually a fountain of information. She can often help you map out a good walking or driving route to the best scenic views, as well as give you the operating hours of almost any attraction.

Q **What are the biggest mistakes people make when photographing a vacation?**

A The worst mistake that I've heard in a long time was a friend who left her camera in the limo on the way to the airport. We all make mistakes, though, and the more you shoot the more you make. However, as long as you learn from them, mistakes can be a good thing.

Probably the most common mistake is buying a new camera right before a trip, and not learning how to use it or (he said in his stern teacher's voice) reading the manual. It takes a good month or more to really get to know a camera and shoot enough test shots to feel comfortable, so don't buy a new one the day before you leave.

Another thing that I think everyone is guilty of is not shooting enough. Digital is free so there is no reason not to fill up a lot of cards. You can sort the photographic wheat from the chaff once you're back home. Also, if you're in a city, don't quit shooting when the sun sets. Not every place is Times Square at night, but there are still lots of interesting night subjects.

Exploring is important, too. Most of us are so intent on bringing home the traditional views that we forget to poke our noses off the beaten trail, but that's often where the best photos are waiting. I have a photographer friend who refuses to use maps because he just wants to let his instincts guide him.

Often, too, I think a lot of us forget to unleash our inner artist. Going beyond your comfort zone, both creatively and technically, is a great way to grow photographically. For example, if you're not used to making long exposures of waterfalls, try it. If you don't have a tripod, lean against a lamppost. The worst that can happen is that you end up with some blurry pictures of a pretty waterfall and a good story.

Q How do professional travel photographers get so many interesting photos in such a short period of time?

A As romantic and fun as it sounds, professional travel photographers have an exceedingly difficult job. Often, they land in a new city or attend a major festival somewhere and have to come back with enough photos to fill a magazine spread with exciting photos in just a few days.

Take a look at the sites of legendary travel shooters, like Bob Krist (http://bobkrist.com), Eric Meola (www.ericmeola.com), and Ron Niebrugge (www.wildnatureimages.com), and you'll see just how tough their job is — and how consistently they come home with winning images. However, as brilliant as their photography appears, it all comes down to hard work: Carrying lots of gear, constant exploration, and working around the clock. Most travel photographers are in the field before the sun is up and stay out long after dark.

The other quality that all good travel photographers have in common is curiosity: They never stop exploring, asking strangers questions (*What's the best local beach for great sunsets?* or *Where is the best weekend flea market?*), or looking for the next picture.

Q Should I wander around looking for interesting subjects in an unfamiliar place or stay in one area?

A This question depends on where you are, as well as your personality. Some people are sitters and lookers (that's me, in a nutshell) and others are eternal wanderers. Both methods work, but they also have drawbacks.

The reason that I like to sit and stare is that I like to feel the rhythm of a place and see how the people live their lives. I find harbors, like the one shown here in Stonington, Maine, endlessly fascinating. I can sit there for many hours shooting photos and never get bored because interesting things always seem to happen. For example, on the day this image was shot, a beautiful schooner pulled into the harbor and dropped sail. The downside of the sit-and-stare method is that, sometimes, nothing happens and you feel like you've wasted your time.

The wandering method is great because you never know what is around the next corner and that's kind of fun. Exploration is a huge part of travel photography. On the other hand, because you're constantly on the go, cool things can happen two minutes after you leave.

Probably, the best solution is to mix things up: Spend one day wandering to find new and interesting locales, and then go back the next day if you have the time and just let the place happen.

Q How can I put new visual spins on familiar landmarks?

A We all want to photograph the famous landmarks we see in our travels — what would a trip to Athens be without a photo of the Acropolis? The trouble is that these places are famous for a reason: they've been photographed to infinity and back. The real fun is coming home with a new twist on an old familiar face.

Here are some ideas for injecting a new spin on familiar landmarks:

- **Unusual vantage points.** These add a lot of surprise and the goofier they are, the better they work. Try lying under the St. Louis Arch or shooting it popping up over the skyline from 1/2 mile away.

- **Shoot through things.** Don't wait for the perfect view of the Golden Gate Bridge from the classic overlook viewpoint. Instead, shoot it from the back window of your cab. And nothing says London like a view of the London Eye through the window of a pub.

- **Look for reflections.** I spent the better part of a 1/2 hour one day shooting the Chrysler Building reflected in a rain puddle. I got a lot of curious stares from strangers wondering what on Earth I was shooting.

- **Play in Photoshop.** I have some wonderful straight-on images of the Statue of Liberty that I love, but I still get a kick out of reinventing them in Photoshop.

Q

What can I shoot when it's raining?

A

When it rains all day on a trip you have two choices: Stay in the hotel and curse at the Weather Channel (my first choice), or go out and hope for a rainbow. The latter is unquestionably the better idea. Rain itself can actually add an interesting twist to a lot of shots. Almost everyone comes home from the Grand Canyon with a nice sunny shot of that big hole, but how many shots do you remember of people admiring it from under an umbrella?

If you're lucky enough to have a companion (and umbrella) handy you may want to venture out and look for some offbeat weather shots. Big cities are pretty in the rain, especially around twilight when the neon signs come on and glitter in the wet pavement.

Rainy days are also a nice time to explore indoor venues, and sometimes they present unexpected opportunities. I took the somewhat ironic shot of a water garden shown here through the rain-spattered window of a greenhouse. One bonus: this was the only time that I saw that particular area without a crowd of people.

Q What is the best way to approach a stranger if I want to take her picture?

A Other people are one of the most difficult things to photograph. It gets even more complex when that person is a total stranger and you're on her turf. As outgoing as I am with friends and the locals around town, I'm relatively shy with strangers — especially when I want to take their picture. The following are some tricks to make the experience more comfortable for you and your subject:

- **Honor local customs.** If you are traveling in another country, assume that they have different cultural or religious customs regarding casual photography. Ask your hotel concierge or a local what is appropriate, and if there are any places or moments that you should avoid photographing.

- **Ask permission.** If you're traveling in a place where you speak the language and see someone is doing something interesting that you'd like to shoot, you should ask his permission. Tell him you're a traveler (it sounds so much nicer than tourist) and you'd like a photo for your personal collection. Consider memorizing the phrase *a photo please?* in the native language, or perhaps writing the request out on an index card before you go.

- **Point and smile.** Pointing at your camera and smiling goes a long way in almost any language. In tourist areas, especially, locals are used to being photographed but never shoot first and ask later.

- **Offer to pay.** But never offer to pay unless you've been told it's appropriate; in some places it's expected.

- **Show the subject your LCD screen.** The LCD screen is an amazing ice breaker. Any time that you're able, show someone the first few photos that you've taken — odds are that she'll encourage you to shoot more. This is also a great way to make new friends. If you're willing to follow through, offer to send a print or two. Make sure that you keep your promise, though — if you don't, you poison the well for the next group of travelers.

Q Why do my shots taken from scenic overlooks seem so bland?

A The interesting thing about scenic overlooks is that they are, well, very scenic. They often provide a broad overview of an area from a somewhat dramatic vantage point. The problem with such views is that there is no particular center of interest, and no way to explore or get creative with your compositions. You have one viewpoint and that's it — everyone gets the same shot.

There are, however, a few ways you can enhance the view. One is to include a foreground of some type. Another is to include people looking at the view. People not only add a sense of scale to the scene, but they also add human interest. Putting a person in that shot gives viewers something to emotionally latch onto.

Q How can I capture the flavor and feeling of a local marketplace?

A Whether it's a street flea market or one of the exotic floating markets of Bangkok, the places where people buy and sell their wares are fascinating to photograph. In fact, few places offer such an interesting mix of faces, brilliant colors, and endless textures.

The best way to get good shots of a marketplace is to experience them. If you want to get good photos of fresh produce, there's no better way to do so than by purchasing a lot of small samples as you walk down the aisles. Buying products from vendors is also the surest way to get permission to shoot lots of photos. No one who sells you a basket of fresh-picked strawberries is going to deny you a shot of his display.

Also, people who tend to work in markets are, by nature, outgoing and friendly, so markets are a great opportunity to meet people and take fun pictures. One good technique is to ask a vendor about her particular wares and keep your camera in front of you during the conversation. Eventually, most people will ask if you want to take a photo of their booth, giving you an open door.

Photo courtesy of Derek Doeffinger.

> **Q**
>
> **What are the advantages of carrying a tripod with me when I travel?**

A Carrying a tripod on a trip — especially if you're going by air or some other form of public transportation — is inconvenient, at best. It's just one more piece of luggage that you have to look after, lug around, and sometimes even pay extra to bring. Still, it's rare that I make a trip anywhere in the world without a tripod; I consider it an essential accessory. Here are some of the reasons why traveling with a tripod is a good idea:

- **All exposure options are available.** For example, it's impossible to make multi-second exposures of a waterfall without a tripod. The same is true if you want to use very small apertures (and the corresponding long shutter speeds) to maximize depth of field in a landscape.

- **You can shoot macro and wildlife photography.** No matter where you are in the world, you're likely to encounter interesting wildlife parks and public gardens that weren't in the travel brochures. While traveling in Florida, I came across a small public garden that had a very rare flock of pink flamingos. The only way to get good close-ups was with a 400mm lens — tripod required.

- **Night photography is an option.** Whether it's neon signs, fireworks, or city skylines, all great night subjects are much simpler with a tripod.

Q What is the best zoom lens range for getting good sports photos with a dSLR?

A As you can see by looking at the photographers working along the sidelines at any pro football game, most sports photographers work with very long telephoto lenses. The obvious reason, of course, is that most sports happen fairly far away. Fortunately, telephoto zoom lenses are getting more affordable, not to mention lighter and smaller.

The focal-length range that you need really depends on the sport and what kind of action you like to shoot. For swim meets or high school baseball games where you can get pretty close to the action, a medium telephoto zoom in the 70-150mm range would probably do well. But if you're photographing an open-field sport, like soccer or football, a lens in the 50-300mm range is probably a good investment.

The good news is that if your dSLR has a cropping factor (that is, less than a full-size sensor), then the effective focal length of your lenses is longer. For example, with a cropping factor of 1.5X, you multiply the stated focal length of the lens by 1.5 to get its effective focal length. I shot the soccer photo shown here with a 70-300mm Nikkor zoom lens, but with the 1.5X cropping factor of my Nikon D90 body, it is, essentially, a 105-450mm lens.

Q

How can I get good close-up action shots with a zoom camera?

A

Interestingly, there are a lot of zoom cameras around these days that have a telephoto, zoom lens range longer than anything the pros are using on their dSLRs. Nikon recently introduced the Coolpix P510, which is a compact zoom with a 24 to 1,000mm optical zoom. That kind of range allows you to get close to any sport — no matter how high up you are in the stands.

However, assuming that most people have more moderate zoom lenses, there are still some ways to get closer to the action. The best way is to know the sport. If you follow baseball, you know that the most exciting plays happen at first and third base, and home plate.

There are other sports where it is relatively easy to get close because things happen near the edges of the field. At a football or soccer game, you can stand near the end zone and get terrific action shots. A few times, I've even had to switch to a wider lens when shooting youth soccer because I was too close to the action.

Also, keep in mind that with some sports it's not as much about lens power as it is about timing. A shot of your daughter coming off the diving board is more about timing than filling the frame. In fact, some space around her adds to the drama of the dive, and it's also nice to see both the pool and the diving board in the frame. There are also sports (such as basketball, if you can position yourself very near the backboard) where you can shoot up at the action with a relatively wide-angle or normal (18-70mm in 35mm terms) lens.

Whatever sport you're shooting, get there early. If you can stake out a position on the sidelines of a soccer game, you will be literally inches from the action. Just make sure that you ask permission if necessary and maintain a safe distance from the action.

Q

What camera preparations should I make before photographing a sporting event?

A

Because it's the nature of sports that things happen quickly and unexpectedly, it's very important to have both your mental game and your camera gear ready. One of the first things that I do the night before shooting any sporting event is spend an hour or so online doing a Google image search on that sport. I also flip through issues of *Sports Illustrated* to see what professional sports photographers have been shooting lately. You learn a lot and get some great ideas by looking at photos of, and reading about, a sport.

It's also important to get in touch with your gear and the various sports-oriented exposure and focusing modes, especially if you haven't shot any action or sports subjects in a while. Before photographing a very high-speed subject, like an air show or a car race, I always reread my camera manual to review the high-speed shooting modes. I also test the camera bodies to see how many frames per second I can shoot before the memory buffer slows down or stops.

Also, it's important to have extra blank memory cards so that you don't miss any shots while you format a full one. This has happened to me several times and it's enormously frustrating because it's my own fault. I also make sure to have my fastest memory cards ready first because, obviously, they are able to receive images faster.

Make sure that your batteries are freshly charged. When it comes to shooting most sports, you focus and zoom almost constantly, and that drains battery power fast. Sports is also one subject with which JPEGS might be the better file format to use as they transfer to memory cards much faster.

The final thing that I do before any sporting event is the same thing most athletes do: I mentally run through the event in an almost meditative way. I try to imagine the players in action and the photos that I'd like to capture.

Q

What effect does the direction of the action have on my ability to get sharply focused photos?

A

Several factors affect your ability to stop action, including the speed of the action, the shutter speed that you're using, the focal length of the lens, and the direction that the action is moving in relation to the camera. Knowing how the direction of action relates to the shutter speed is important because it helps you choose the best vantage point when your goal is to totally freeze subjects in motion.

All other things being the same, it's simplest to stop action that is moving directly toward or away from the camera. You can freeze action at a substantially slower shutter speed by positioning yourself so that the action is heading either into or away from your lens, such as when shooting a track runner. This is particularly useful information when the light gets low and you are forced to slow your shutter speeds just to keep shooting.

It's toughest to freeze action when it's moving parallel to the camera's sensor because the sensor sees the action for a longer period of time. This provides more time for the image to blur.

Action moving diagonally across the frame can be stopped with shutter speeds that are between those necessary to freeze head-on or parallel action.

Q What is the peak of action?

A In all types of action, there is an instant at which it reaches its apex and has not yet begun to decline. This is called the *peak of action*. For example, if you watch a pole-vaulter, there's that instant during which he seems suspended above the bar and hasn't started his descent. At this moment, the action slows briefly and enables you to get very sharp photos at relatively slow shutter speeds. I was able to freeze this boy running on the beach with both feet off the ground at a moderate shutter speed of 1/250 second because I waited for the high point in his stride.

Knowing when the apex will occur is largely a matter of studying the event a few times. I've put in many hours playing with my cats and I know when their leaps are reaching their peaks — even so, I still miss a lot of shots. One way to simplify capturing the absolute zenith is to set your camera to its highest capture rate, and then blast off a series of shots in rapid succession.

Q How important is it to fill the frame when shooting action subjects?

A The closer you are to any subject, the more it fills the frame and the more power it has. This is particularly true with action subjects. The closer you bring viewers to the subject, the more they feel like part of the moment. You experience the same thing in life: Imagine that you are watching a race car and it's almost upon you. Even if you're safely in the stands as the car gets closer, you can feel the sense of power and energy building.

You can further heighten feelings of proximity by using a very long lens to condense the space between you and the subject, and the subject and the background. This is what makes football wide receivers look like they've missed a ball by inches when, in fact, they were probably 10 feet away. TV cameras use powerful zoom lenses to help you *feel* the action while sitting at home.

BONUS TIP:

If your dSLR or zoom camera has 12 or more megapixels but you can't get close enough to fill the frame, crop it in editing.

Q How can I make action shots seem more dynamic?

A One way to heighten the feeling of power in action shots is to choose a very low vantage point and shoot up at your subject. Shooting at such an extreme angle creates a very strong energy dynamic.

That's exactly the technique that I used to capture this action shot of a youth soccer match. By using a very wide-angle, 24mm lens and setting a small aperture, I was able to capture a very close and sharp image. This preserves a lot of the intimacy of watching a soccer match from the sidelines. Also, by intentionally cutting off the player's upper bodies, I force the viewer to concentrate on the essence of the sport: feet kicking a soccer ball.

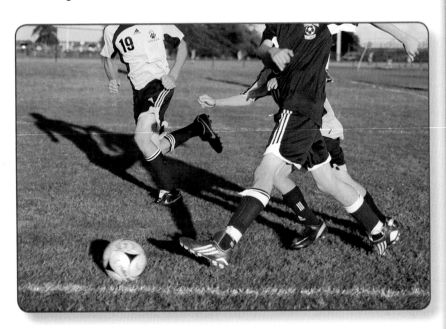

Q How do I create an action shot in which the subject is relatively sharp but the background is a blur?

A One of the most effective methods for revealing a sense of motion and speed is a technique called *motion panning*. You can create this effect with any subject that is moving parallel to your shooting position — either side-to-side in front of you or (more rarely) up and down, such as a high jumper. The technique is a bit experimental and it's impossible to repeat the same shot twice. However, with a bit of practice, you'll get some good shots and the pictures look very professional. Follow these basic steps:

1. **Position yourself so that the action is moving parallel to your camera back.** You should be (roughly) in the center of the action's left-to-right path.

2. **Use a medium telephoto lens.** A shallow depth of field helps with this technique.

3. **Set your camera to the Shutter Priority mode.** Choose a shutter speed that provides enough exposure time to blur the action. Between 1/30 second and 1/2 second is probably good, but it depends (in part) on the speed of your subject.

4. **Set your lens to Manual focus.** If you leave the lens in autofocus (and you can), be sure it's in the Continuous-focus mode so that it shoots regardless of whether the subject is in sharp focus. If you leave the camera in autofocus but have it set to single shot, it won't fire because it's unlikely it will be able to lock focus.

5. **Begin tracking the subject well before you plan to press the Shutter Release button.** Keep moving the camera steadily and smoothly as the subject passes in front of you. Gently press the Shutter Release button, and then keep tracking the subject until you hear the shutter close.

6. **Shoot several frames and review them.** Adjust the shutter speed slower or faster until you get the degree of background blur that you want.

Q How can I turn action shots into interesting abstracts?

A It's a great challenge to try and freeze the action of any fast-moving subject — and quite an accomplishment when you start getting good results. However, after awhile, it's fun to let go of the sharpness obsession and see what you can do creatively by moving into the realm of abstraction. The simplest way is to just reverse the concept: intentionally use a long shutter speed with a fast-moving subject and see what happens.

I took this photo in Times Square one hot summer night by making a 1.6 second handheld exposure while I pivoted my body in the opposite direction of the traffic. As the traffic flowed left, I turned toward my right, elongating the streaks of color and light.

Q

How can I overcome the lag of the electronic viewfinder (EVF) on my zoom camera?

A

Rather than an optical finder, many zoom cameras have an electronic viewfinder (EVF) where the optical finder would normally be, and an LCD screen. However, because this is not a true optical viewfinder, what you're seeing is, in fact, a video display of what the lens is seeing. In most situations this works fine, but with motion subjects there is often a slight delay, or lag, between the real-life action and what the viewfinder shows you. Shutter lag has improved a great deal in recent years. However, it can still be annoying because the subject moves slightly between the moment that you press the Shutter Release button and the moment that the picture is actually taken.

Overcoming lag is really only a matter of anticipating it while you're shooting. One way is to pre-focus on the spot where you expect the action to take place rather than tracking it — such as focusing on third base and waiting for a runner to slide into it. Because action is easier to stop coming toward or going away from the lens, photographing action in those directions minimizes lag. In the shot of the kayaker shown here, I waited until she was heading away from the camera.

Q **Where are the best places to photograph wildlife?**

A Whether you live in the suburbs, the heart of the city, or far out in the wilderness, there is a lot of wildlife closer than you think. In many respects, photographing the wildlife near your home is a good place to start because those animals are probably more used to human interaction.

You can get started in your own backyard. I live in a very suburban part of Connecticut, but I've seen everything from rabbits and red foxes, to coyotes in my backyard — and I've photographed most of them. Nearby rivers and streams are also good places to investigate. I photographed this mute swan mother and cygnet on a river just a few miles from my house. They're used to being fed, so they were relatively easy to get close to.

State parks and local Audubon refuges (www.audubon.org) are also good places to find animals. However, it takes considerably more patience and skill to photograph animals there because they have a far greater area to roam, and they know the woods and marshes much better than most humans.

If you're want to venture farther afield, there are more than 550 National Wildlife Refuges (www.fws.gov/refuges) comprising more than 150 million acres across the country.

How can I get close enough to photograph the animals in my own backyard?

A Taking wildlife photos in your backyard is a lot of fun because you can pretty much do it in your bare feet with a cup of tea in the morning. Also, it really doesn't require a lot of special equipment: A good zoom lens (70-300mm is a good range) or zoom camera is all that you need. It's also a nice way to document the critters with which you share your property.

Most animals are in your backyard for two reasons: Shelter and food. So find out where they like to hang out (or nest) and what they like to eat, and you'll gain great insight into their habits. For example, the bunnies in my yard think of yellow dandelion flowers as gourmet eating, so I know that when those are in bloom, the bunnies will be there.

I also have a variety of bird feeders and baths in the backyard, which not only keep birds coming, but also the small varmints, like mice and raccoons, that come to clean up what the birds miss. The real secret to getting backyard photos, though, is just spending time in your yard so the animals get used to your presence.

Q How do professional wildlife photographers get close to animals?

A The toughest part of getting good photos of animals is getting close enough to them. There are two ways to do that: Use a very long lens or get physically closer. Long lenses are nice, but they're also expensive and you still have to get pretty close to your subject. A much better way is to become skilled at getting closer to animals, and there are some tried-and-true methods for doing so. The following are some tricks that experienced photographers use to get close to wildlife:

- **Know your subject.** There is no substitute for knowledge of natural history when it comes to photographing animals. Read and watch (the PBS show, *Nature,* is a great source) everything you can find about the specific animal: What does it eat? When does it feed? What time of day is it most active?

- **Talk to hunters.** Most are walking encyclopedias of animal behavior, and have a lot of knowledge of local wildlife and habitat.

- **Bait your subject.** Consider using a salt lick or hay to attract deer, for example, as long as you don't put them at risk.

- **Volunteer at a refuge.** Most local refuges are underfunded and under-staffed, and always in need of volunteers. You'll get an insider's look at the refuge and unparalleled access.

- **Take wildlife walks.** Most refuges, sanctuaries, and state parks have ranger-guided walks. These are an excellent way to find out more about the animals in your area. It's not likely that you'll see too many animals if you're in a group, but you'll get lots of good info.

- **Take workshops and wildlife tours.** Organized wildlife photo workshops, tours, and vacations are a great way to get close to exotic animals. Master bird photographer Arthur Morris (www.birdsasart.com) and African wildlife photographer Boyd Norton (http://wildernessphotography.com) teach excellent workshops and host trips that are both educational and fun. This is a great way to combine your vacation time and wildlife photo hobby.

Q What is a blind, and how can it help me get closer to wildlife?

A A *blind* (or *hide* as they call them in Great Britain) is any type of cover that you use to disguise yourself in the field to get closer to animals without alarming them. There are a lot of blinds available in hunting supply stores, like Cabelas (www. cabelas.com) that work perfectly for photography. A company called GhostBlind (http://ghostblind.com) makes a really interesting one that uses mirrored panels to reflect your surroundings and hide your presence.

Most of these resemble tents with several ports through which you can poke a long telephoto lens. Blinds work because animals get used to their presence over time and don't see you moving around as much. However, for one to work effectively, it has to stay in (roughly) one place for at least a few days in order for the animals to ignore it, and it's best if you come and go as little as possible.

Blinds work particularly well in areas where animals come to eat or drink, such as beside streams and ponds. Geese, deer, and other animals also graze in recently-plowed farm fields, which makes them good, active locations in which to shoot wildlife.

Q How can I use my car as a blind on a wildlife drive?

A Most animals don't see automobiles as a threat, so you can get much closer to them if you shoot from inside your car. Fortunately, many wildlife sanctuaries also have wildlife drives that traverse wildlife areas. The photo of the buffalo shown here was shot on a wildlife drive at the Neil Smith National Wildlife Refuge (www.fws.gov/ midwest/nealsmith/) in Iowa. Using only a 70mm lens, I was able to fill the frame with this bison, which got much closer to the car than I expected. More importantly, I was able to photograph the herd for more than half an hour from the front seat of my car.

The key to using your car as a blind is to find an active area, shut off the car, settle in, and wait for the wildlife to come to you. The longer your car sits in the same spot and the less movement there is, the more comfortable the animals become. Of course, most animals are distracted or frightened by noise, so it's a good idea to talk as little as possible and turn off the radio while you're shooting.

ENTERING
BUFFALO AREA
Buffalo Are Wild And
Unpredictable Animals
Stay In Your Car And On The Road

Q How can I steady my camera while shooting from the car?

A Because a lot of wildlife photography shot from cars still requires a long telephoto lens, you have to find a convenient way to steady the camera while sitting comfortably inside your car. One trick I've used for many years is rolling up a towel or sweater, and laying it on the window frame.

There are also several companies that make inexpensive beanbags (you can buy them empty, and then fill them with sand or beans) that serve the same purpose. If you really get into shooting from your car, you can buy a window tripod. I use an odd looking window pod called the Groofwinpod made by L. L. Rue (www.rue.com), and it easily holds my 400mm lens.

Q How can I practice wildlife photography at the zoo?

A Odds are that wherever you live, there's a zoo nearby. Zoos are not only a great place to observe animal behavior up close, but they're also a great venue for honing your shooting skills between safaris. I recently interviewed photographer Laura

McElroy about her zoo photos for my column in *Popular Photography* magazine. Here are some of her tips for shooting at the zoo:

- **Take advantage of cloudy days.** This helps you keep contrast and deep shadows at bay. Also, animals look best bathed in a soft, even light.

- **Shoot early and late.** Animals, like humans, get stressed in midday sun. Feeding time is great but you have to compete with crowds — stake out a location early.

- **Don't fight crowds.** Ask courteously if you can step forward to get a shot. For popular animals, like giant pandas, be there when the zoo opens.

- **Pick a favorite animal and specialize.**

- **Devote large blocks of time to one species.** McElroy said that she often spends four or five hours with the gorillas.

- **Wait for emotions and intimate behavior.** "I photographed one of the mother gorillas at the San Diego Zoo nursing her baby," said McElroy. "And she leaned down and kissed the top of his head."

Q **What is the best type of camera for shooting birds and other wildlife?**

A A year or two ago, if you had told me that you were serious about pursuing wildlife photography, I would have suggested that you buy a dSLR. That's probably still my advice if you think this will be a lifelong hobby. However, there is now another option: the new group of superzoom cameras with zoom ranges of 42X or more. These cameras give you a previously unheard of optical range and if you buy one with a 1,000mm lens, you'll be capable of shooting any kind of wildlife photography.

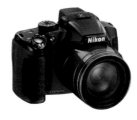

Photo courtesy of Nikon.

The real decision that you have to make is how much you want to invest in lenses and other accessories, and how much gear you are willing (and able) to carry. If you want something lightweight but with a somewhat incredible zoom, then check out the zoom cameras. If you have the energy (and the

money) to invest in a body, a few lenses, and other accessories, you can't beat the quality or flexibility of a dSLR. The truth is that either will do a good job.

What is the best time of day to photograph animals?

A Almost all animals are very active at the beginning of the day because, like us, they have to make up for a whole night of not eating. Animals also tend to be more social early in the day — ducks gather in flocks on ponds, deer wander in larger herds, and even squirrels seem to chase each other around yards a lot more in the morning.

If you're looking for animated shots, early morning is definitely a productive time to work. Often, if you hike along the shore of a pond or a marsh early in the day, you see animals that seem to all but disappear by midday — particularly in the summer when they hide from the heat.

At the end of the day, animals are busy again because it's time for their last snack, but they're also beginning to wind down. I especially enjoy shooting during this quiet time because birds and other diurnal animals are tired and, as a result, somewhat less active. On the other hand, nocturnal animals, like coyotes, are just starting their rounds, so they will be a lot more active. If you have a good flash and are willing to venture out, twilight is a great time to shoot.

> ## How can I get close-ups of birds at a feeder?

The best way to get photos of birds at a feeder is to make sure that lots of birds are coming there. This means keeping the feeders clean, well stocked, and providing water nearby. Once the birds discover your feeders, they'll be regular visitors.

The key thing to remember when photographing birds at a feeder is allowing them to get used to your presence. One way to do this is to gradually move some of your gear to the area where you'll be shooting, and then leave it there for a few days. For example, on the first day, leave a lawn chair within shooting distance. The next day, add a spare tripod (or a couple of rakes leaning on each other). For a few days after that, just sit in the chair and watch. After a very short time, the birds will completely ignore you.

If you are very patient and ambitious, you might try to train the birds to eat from your hand, as photographer Derek Doeffinger did with this black-capped chickadee. Place a gardening glove full of birdseed on a homemade wooden stand and, after a few days, substitute your hand for the glove.

Photo courtesy of Derek Doeffinger.

Q What are the advantages of using flash when shooting animals?

A Electronic flash is a very useful tool when it comes to photographing small birds and animals because it provides a ready source of light where it's needed — even in pitch blackness. I photographed the tiny owl shown here sitting on a handler's leather glove during a demonstration at a state fair, but it was dark, so without the flash there would be no picture.

Flash has several uses when shooting in broad daylight, as well. It is particularly useful when you want to freeze action — such as a hummingbird's wings — because the duration of a flash firing is extremely brief. I often use flash when shooting birds at my backyard feeders because the flash not only stops the action a bit but, if I'm close enough, it also allows me to use a smaller aperture so that I get more depth of field.

BONUS TIP:

You can double the range of your flash by setting the ISO four times higher or buying a Fresnel lens device.

Q What techniques can I use to get good action shots of animals?

A Images of animals in motion are almost always more interesting than photos of animals just sitting there, but they're also the toughest to capture. Not only do you have to know your subjects' habits well enough to predict activity, but you also have to know your gear well enough to get shots off without delay. Here are some easy tips to help you catch these elusive moments:

- **Use the Shutter Priority mode.** In this mode, you set the shutter speed to stop action and the camera automatically selects the corresponding aperture.

- **Use Continuous focus.** This is the best focusing mode for action subjects because it allows the camera to fire whether or not it has achieved precise focus. This increases your odds of getting one sharp frame.

- **Use the fastest shooting mode.** If your camera has a choice of shooting speeds, select the highest frames-per-second rate. This allows the camera to fire several shots in rapid succession, and provides a much better chance of capturing one perfect frame.

- **Use accessory flash.** Because flash fires for a very brief time, it acts like a high-speed shutter that freezes nearby subjects.

- **Exploit intentional blur.** Experiment with slower shutter speeds. Often, intentionally blurring action enhances the sensation of movement.